Susan Hiller

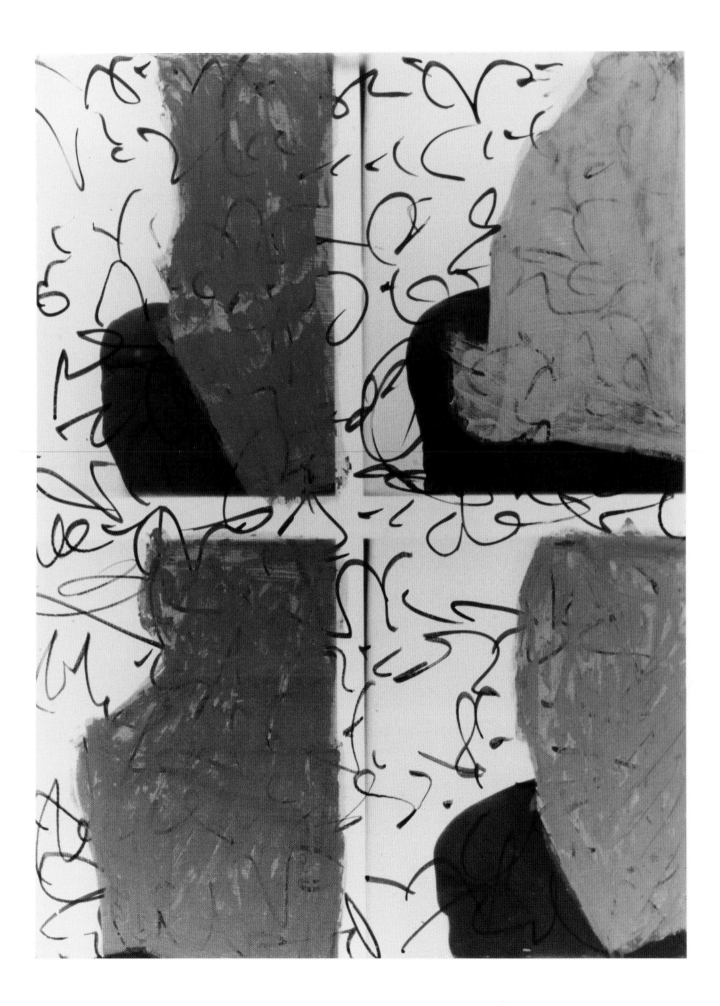

Susan Hiller

Edited by Ann Gallagher

WITH CONTRIBUTIONS BY

Yve-Alain Bois, Guy Brett, Jörg Heiser,
Alexandra M. Kokoli and Jan Verwoert

TATE PUBLISHING

First published 2011 by order of the Tate Trustees
by Tate Publishing, a division of Tate Enterprises Ltd,
Millbank, London SW1P 4RG
www.tate.org.uk/publishing

on the occasion of the exhibition

Susan Hiller

Tate Britain
1 February – 15 May 2011

The exhibition is supported by

The Andy Warhol Foundation for the Visual Arts

A catalogue record for this book is available from
the British Library

ISBN 978 1 85437 888 0

Distributed in the United States and Canada by
Harry N. Abrams, Inc., New York

Library of Congress Control Number
2010940867

Designed by Philip Lewis
Colour reproduction by DL Imaging Ltd., London
Printed in Spain by Grafos

FRONT COVER Susan Hiller, *Auras: Homage to Duchamp* 2008
BACK COVER Susan Hiller, *Auras: Homage to Duchamp* 2008
(detail, pp.122–3)
FRONTISPIECE Susan Hiller, *Sometimes I think I'm a Verb
Instead of a Pronoun* 1982 (detail, p.76)
PAGES 36–7 Susan Hiller, *Magic Lantern* 1987, installation at
Tate Liverpool 1996

Measurements of artworks are given in centimetres,
height before width

Mixed Sources
Product group from well-managed
forests and other controlled sources
www.fsc.org Cert no. SGS-COC-005160
© 1996 Forest Stewardship Council
FSC

5

Contents

For over forty years, Susan Hiller's work has steered a course that has both anticipated and reflected many of the ways in which we have come to understand contemporary art today. Multi-media integrating new technologies with old, installational, site-specific, immersive, participatory – all these terms that we now take for granted describe Hiller's work from its beginnings.

Curated by Ann Gallagher in close collaboration with the artist, this exhibition brings together a selective grouping of Hiller's work from 1973 to the present. Displayed across a dozen galleries, the exhibition seeks to highlight key video and audio installations and to interweave these with quieter image-based works, to represent the breadth of the artist's remarkable output.

Taken as a whole, the exhibition at Tate Britain brings together a range of works that have, over time, been shown across London – in galleries that no longer exist such as Gallery House, in experimental galleries such as Matt's and Delfina, in museum settings such as Freud's house in Hampstead and in unconventional spaces such as an abandoned Baptist chapel off the Portobello Road. Here, for a few months, the east, west, south and north of a disparate city are brought together.

Hiller's work is very much about the forgotten or overlooked in our culture, about the memories we share as well as those we inhabit privately. The way in which we access those memories, through sound and image, and share in their performance, can be a magical experience, and Hiller succeeds in finding those points of break-through, giving form to private experience so that it can be shared publicly.

Beginning with the artist's early homage to the 'unknown artists' whose work is always around us, the exhibition ends with recent homages to four 'known' artists. This double appreciation accords with Hiller's place inside and outside art, aware of its particular vocabularies, while bringing these into play with those of other material and cultural milieux. Within Tate's own collection we are pleased to be able to represent the artist with a number of these key works from across her career to date.

Foreword

The present catalogue not only documents the exhibits, but other works too, and where possible also reunites them with texts written at the time. In this way those who have spoken about Hiller's work in the past are brought to share a space with those who have written about it more recently. Similarly, the newly commissioned texts and three-way conversation juxtapose two different generations of critics. We are very grateful to Yve-Alain Bois, Guy Brett, Jörg Heiser, Alexandra Kokoli and Jan Verwoert for their thoughtful contributions.

Any exhibition that seeks not only to edit an artist's oeuvre, but also to show it at its fullest, is by definition challenging. Tremendous credit must be given to the artist, who has given so generously of her time in the planning of this exhibition with Ann Gallagher, Head of Collections (British Art) at Tate, with the support of Sofia Karamani.

The support of a number of important donors has been critical to the successful realisation of this exhibition. In particular we are indebted to the tremendous generosity of The Andy Warhol Foundation for the Visual Arts. I should also like to thank Nicola and James Reed and Francis H. Williams for their invaluable support.

Tate Britain is concerned to play its role in expanding the received notions of British art, and Susan Hiller helps us do that in more ways than one: as an American who has made her entire career as an artist in London, as a woman whose practice was informed by feminism, as a critical voice which has been forged both collaboratively and independently, and as an artist whose work has inspired several younger generations. We are delighted to present this important review and its accompanying publication.

Penelope Curtis
DIRECTOR
TATE BRITAIN

For the stimulating discussions over many years, before we even embarked on this project, my heartfelt thanks go first and foremost to Susan Hiller. Those discussions helped shape the content of this exhibition and prompted the ambition of the catalogue, to place in context the works shown in the galleries at Tate Britain. Emma Dexter has been a frequent contributor to our deliberations and has greatly aided us in refining our ideas during the selection process. My special thanks to her and to Sofia Karamani.

The enthusiasm and support of many colleagues enabled this exhibition to take place, in particular Nicholas Serota, Judith Nesbitt and both Stephen Deuchar and Penelope Curtis. For the coordination of the project I am very grateful to Carolyn Kerr and Sionaigh Durrant, to Andy Shiel, Juleigh Gordon-Orr and Mikei Hall, and to the advice and expertise of conservation teams, especially Piers Townshend, Vanessa Griffiths and Tina Weidner. Adrian Fogerty deserves special mention for the technical knowledge of Susan's work he has brought to the planning and installation of the exhibition.

For their genorosity and the enthusiasm they have communicated for the project I would like to thank the lenders, the institutions and individuals who were unanimous in their agreement to lend works. This exhibition has been made possible with the assistance of insurance through the Government Indemnity Scheme. Tate would like to thank the Department for Culture, Media and Sport and the Museums, Libraries and Archives Council for providing and arranging this indemnity.

For her complete dedication in overseeing the catalogue Rebecca Fortey should receive both thanks and congratulations, as should Philip Lewis for the sensitivity

and flair he has demonstrated in designing this very rich publication, as well as the exhibition graphics. The production and picture research have been expertly handled by Emma Woodwiss and Deborah Metherell respectively. Guy Brett has been a support throughout and I am immensely grateful to him and Yve-Alain Bois for the time they devoted to their fascinating conversation with the artist, and to catalogue authors Jörg Heiser, Alexandra Kokoli and Jan Verwoert, for their unique contributions. Thanks also to the authors who allowed us to print extracts from previously published texts in the section illustrating key works by the artist, and to Gabriel Coxhead for his assistance with the bibliography.

In addition to the input of Emma Dexter at Timothy Taylor Gallery, the generous assistance of Andreas Leventis and warm support of Timothy Taylor have been invaluable. Lastly I would like to thank the many other individuals who helped us along the way, including Martin Barnes, Laura Battle, Kirstie Beaven, Helen Beeckmans, Lynne Cooke, Rachel Crome, Anna Cutler, Hanne Dahl, Volker Diehl, Caroline Douglas, Diana Eccles, Fiona Fox, Claire Gill, René Gimpel, Mark Godfrey, Simon Grant, Richard Grayson, Duncan Holden, Anne-Marie James, Cármen Julia, Robin Klassnik, Cristina Locatelli, Billie Lindsay, Amy McKelvie, Friedrich Meschede, Frances Morris, Ann-Sofi Noring, Susie Orbach, Janni Perton, Ellen Seifermann, Kat Sapera, Andrew Tullis, Kate Vogel, Vicky Walsh and Nikki Young.

Ann Gallagher
HEAD OF COLLECTIONS (BRITISH ART)
TATE

There is something elusive, uncanny, fascinating, beneath the surface of what at first seems easy to understand, or ordinary, or banal. I like to work with materials that have been culturally repressed or misunderstood, what's been relegated to the lunatic fringe or what's so boring we can't even look at it anymore. Postcards and dreams, séances and systems of classification, the human aura and a box of desert fossils, automatic writings and bedroom wallpapers, trance states and clips from Hollywood movies, collections of intangible things like shadows and collections of tangible things like toy plastic animals – all these items are artefacts of our culture that I've worked with. I particularly like the way the mundane becomes special as soon as you pay attention to it; I particularly like the way we hide the depths of things from ourselves; I particularly like the way the shapes of things shift when you look hard at them.

Susan Hiller, 'The Provisional Texture of Reality: On Andrei Tarkovsky'[1]

Susan Hiller's repertoire of assembled images, objects or sounds embodies a delicate balance of the familiar and the unexplained that draws the audience into becoming participants in creating meaning. A compulsive collector of things that intrigue her, Hiller amasses ordinary and readily available material from which she selects to construct a mise-en-scene. Over the decades, she has consistently sought to give physical presence to her ideas in ways that have employed whatever materials and technology would best represent them. From early experiments with painting and performative events, many subsequently recycled into new works, through unexpected arrangements of found materials and objects, to an innovative use of video and sound in pioneering multi-media installations, Hiller's work has retained an extraordinary consistency in its exploration of overlapping themes. The associations and memories contained within and provoked by artefacts and rituals; the infinite possibilities of meaning contained within language; and the unexplored powers of the human imagination are all immensely complex subjects that are nevertheless rooted in our everyday and made accessible in Hiller's work. It is from a shared culture that all her material is amassed and, given subjective form, her work is intended above all for collective contemplation and engagement. The selection of works in this exhibition does not represent the entirety of her extensive oeuvre but seeks to demonstrate the unfolding and development of a number of lines of enquiry and provide a fascinating insight into one of the most innovative and influential contemporary artists working in Britain.

Born in the USA in 1940, Hiller has been based in Britain since the early 1970s. In 1973 she had an exhibition at London's Gallery House, where she showed two

**Auras: Homage to
Marcel Duchamp** 2008
detail, see pp.120–3

Shape Shifting

Ann Gallagher

Transformer 1973
details, see pp.44–5

12

works, one under her own name and one using the pseudonym Ace Posible. The Spanish 'makes it possible' suggests an affirmation of belief, a necessary stance for an artist at any time but particularly for a woman in the early 1970s, a foreigner in another country whose original training and early career was in anthropology. An artist's gender, the place of her birth, the details of her upbringing or the type of education she pursued may provide useful background to the development of her work, while the labels she has been assigned or the movements with which she has been associated also aid the reader in placing her in context. In Hiller's case her status as a female artist and her background in anthropology are both significant factors in an understanding of her practice but have perhaps overshadowed her singular contribution and position within a wider discourse of art.

Working as an artist during the period of an emergent women's movement in the late 1960s and 1970s, she was fully engaged with the language of Feminist politics. She recently featured in the US touring survey of this significant period in the history of female art, *Wack! Art and the Feminist Revolution*, with works such as *10 Months* 1977, which lyrically documents the period of her pregnancy in word and image. Her exploration of self-representation has been extended in other works that have made use of her own body and voice, notably the image of her face and torso in the series of works using automatic photobooth portraits (see pp.74–5), and her voice in several sound works, but alongside those of family and friends, and also unknown or random individuals. This was the development of a vocabulary that has produced an ever-broadening variety of recycled images, objects, words and sounds.

Hiller's use of comparative analysis and her focus on cultural artefacts could be attributed to her academic background, as could an interest in oral and behavioural traditions, but her approach is to subvert and disrupt normal categories, using so-called scientific methods to create new structures out of the familiar. As Lucy Lippard has commented:

Hiller brought with her from anthropology a methodology rather than any specific theory. When she uses cultural artefacts, from potshards to postcards, she does not project meanings onto them but retains their 'idiosyncratic nature' which affects the way they are perceived and illuminates their significance in relation to our own culture – something most anthropologists ignore and of which most artists are ignorant.[2]

The taxonomic method of presentation found in many of Hiller's works, most particularly but not exclusively in *From the Freud Museum* 1992–7 (pp.86–9), can also be perceived as indicative of Hiller's interest in museological traditions of display. She has described her role in the selecting and classifying process within her work as that of the curator, and on occasion she has accepted invitations to select thematic exhibitions of other artists' work. She brings to the task not just an ability to draw together works with hidden or unexpected connections but also to utilise her characteristic mode of arranging and ordering to select and display artworks to which she has been drawn.

Hiller began working as an artist at a time when Minimalist and Conceptual practice provided an alternative visual syntax to the grand gestural statements of the recent past. Artists' books were central to the development of Conceptual art and by the early 1970s began to be recognised as a distinct genre. Hiller was originally drawn to the form for the possibilities it provided to create new objects from earlier works, such as *Big Blue* 1973–6 (p.42), assembled from the cut-up segments of a painting, which was documented in its original form in a slide inside the book's cover. She also recycled the hanging paper installation *Transformer* 1973 into leaves bound into an edition of the artist-run magazine *Wallpaper* in December 1974 and retitled it *Transformation* (p.44). She has continued to return to the book form throughout her career and made book editions of many of her works, either as an alternative version with written commentary, as in *After the Freud Museum* (1995, reprinted in 2000), or more often as accessible, portable versions of large-scale works or installations.

Transformer (below), a delicate composition of hanging coloured tissue-paper sheets, was one of the works shown in the 1973 Gallery House exhibition and represents one of two distinct strands that thereafter began to coalesce in Hiller's work. Dissatisfied with painting as the final point of the artistic process, Hiller, unlike many of her contemporaries, was also reluctant completely to eliminate materiality or

any suggestion of craft from the artwork. She began to develop strategies that reconciled these opposing impulses. A collector and hoarder of materials of every kind, all potential components of future works, it is unsurprising that Hiller has frequently returned to previous work as a source. The reincarnation of *Transformer* as *Transformation* in 1974 was a starting point for future series of recycled works such as *Painting Blocks* 1970/1–84 and *Work in Progress* 1980 in which Hiller's early paintings were cut up, bound and numbered or unravelled thread by thread and recycled as small sculptures, or *Hand Grenades* 1972 and the ongoing *Measure by Measure* begun in 1973, in which works from her *Hand Painting* series were burned and stored as ashes in labelled glass phials (pp.38–41).

As James Lingwood has observed: 'To enquire, and to transform – these have been the two recurrent leitmotifs of Hiller's practice … In a remarkably consistent way, Hiller has sustained an open-ended enquiry into the nature of our selves, the forces at work in the making and remaking of subjectivity and its potential for transformation.'[3] The second of the two works shown in Hiller's 1973 Gallery House exhibition, *Enquiries*, consisted of projected slides featuring a series of texts, 'facts' photographed from the pages of a British encyclopaedia. This apparently authoritative version of collective knowledge was revealed to be highly subjective and culturally specific, a fact emphasised a few years later when she produced a version from a similar American publication, subsequently showing the two versions together as *Enquiries/Inquiries* 1973–5. Presented in the dual version *Enquiries/Inquiries* made an overt reference to Hiller's position as outsider, an American-English speaker in British-English speaking London. This is an important work in the development of Hiller's artistic vocabulary, introducing language in the form of printed words as a material to be given focus in such a way that meaning is scrutinised anew.

This fascination with language, words, writing and voices, which has come to form part of Hiller's enduring enquiry into the nature of reality, can be traced back to the experiments with automatic writing that she conducted in the early 1970s, and to which she has returned frequently in her work. There is a long history of the use of automatism in art and Hiller has described her work with automatic writing as being linked to the 'socially-motivated investigation of mark-making initiated by the Surrealist group'. Her first experience of using automatism occurred spontaneously as part of a group investigation around the notion of ESP and the transmission of ideas and images. When she later exhibited the pages of the experiment in *Sisters of Menon* 1972–9 (pp.62–5), the curious messages that emerge in the writing also became a vehicle to reflect on issues of identity. The multiplicity of voices, and the

14

Works from the **Hand Painting** series, a collaborative painting event, 1969, later burnt to make new work, see pp.38–43

answer the sisters offer to their own question ('who is this one? / we are this one'), suggests the possibility of a divided or plural self. In addition to the pages of script, the work incorporates the artist's transcription of the utterances and commentary on issues raised in the writing. They are displayed in a cross formation, a shape that is taken from a section of the script, but which has since made frequent appearance in Hiller's installations. In subsequent works using automatism the writing is harder to decipher, and more akin to drawing, an activity to which it is closely related.

Coloured images in particular were generally excluded from the Conceptual model and yet Hiller's key work from the period, *Dedicated to the Unknown Artists* 1972–6 (pp.52–5), gave focus to a genre of popular colour postcards of the British seaside made by unnamed artists, which both featured and were captioned 'rough sea'. She grouped them according to category or type on framed boards and documented them with commentary, a chart and a map. The grid formation, the serial presentation and the typed labelling clearly identify the work of an artist employing the language of Conceptualism, but only retrospectively has this work been fully recognised as forming a major part of a rich moment in the history of British art and of Conceptual art internationally. The title – which identifies the work as a tribute to the overlooked and forgotten artists who painted, photographed or hand-tinted the seaside images – and Hiller's adoption of the role of curator of the collection of cards, establish distinctive themes in her work from that point onwards.

A reconciliation of the seemingly divergent approaches that emerged with her simultaneous presentation of *Transformer* and *Enquiries* can also be seen in the work *10 Months* 1977 (pp.58–61). In each of the ten sections the abstracted images of her pregnant belly are reminiscent of landscapes, while the typewritten commentaries explore her intense preoccupation with the relationship between pregnancy and other forms of creativity. Text and images are presented together, organised in a dramatic yet rational form. The interrelationship between image and text is a significant feature in much of Hiller's subsequent work. She has also continued to use the principle of sequencing in the recent series of *Homages*, which are discussed in detail for the first time by Jörg Heiser in this catalogue, and in *The J. Street Project* 2002–5 (pp.104–7), a film, a book and a series of 303 photographs made over a period of three years of research into all the streets, lanes and country roads in Germany whose names contain the word 'Jude' (Jew). In this work, as in *Dedicated to the Unknown Artists*, the rational method of presentation is in stark contrast to the emotive nature of the subject matter. Both works incorporate Hiller's enduring

interest in the theme of memory and memorials. In making such commonplace objects the subject of a dedicated and extensive presentation, the mundane is given respectful tribute and the viewer is provided with a familiar access point from which to engage with the work.

The installation *Monument* 1980–1, a work that combines a range of media in a single installation – photographic panels, a park bench and a sound tape – was prompted by Hiller's discovery of a forgotten and neglected *Memorial to Heroic Self Sacrifice* in a little-known park in the City of London. The monument, originally unveiled in 1900, consists of a loggia housing rows of glazed ceramic tablets, each describing a tale of ordinary people who died in the attempt to save others from perishing by fire, drowning or other accidents. The idea that these odd little plaques represented heroism in the abstract was what interested Hiller. The photographs she made of them form one element of the work, arranged in a grid formation in the shape of a commemorative cross. She used forty-one of them, one for each year of her life at the time, adding self-representation to the many readings of the piece. In the sound element, the artist's voice is heard delivering an open-ended series of thoughts on death and heroism, memory and representation prompted by the panels. Her words add resonance to those that appear in the photographs but are not necessarily an accompaniment to them. The viewer is required to sit on the park bench placed in front of the panels to listen to the sound through the headphones. Integrating ideas about participation from early group works, this installation represents a milestone in Hiller's quest to insert the viewer into the body of the work to activate its meaning.

From the Freud Museum 1992–7, which originated from an invitation to make a work for the museum in the house in Hampstead where Sigmund Freud spent the last years of his life, takes the form of a series of micro museums contained within archival boxes arranged on shelves in a vitrine. The boxes have embedded in them a combination of elements – objects and images from a variety of sources, accompanied by texts, notes and charts. This curious anthology of oddities, collected by the artist for their personal associations, have been meticulously arranged, annotated and indexed to provide the viewer with an array of tantalising fragments of cultural memory from which to form their own associations and meanings. Projected onto the gallery wall next to the vitrines is the film *Bright Shadow* 1994, which is also projected in miniature form in one of the boxes. Titles provide a key to the narratives suggested by each group of components contained in the individual boxes – *Fatlad, Cowgirl, simchas, Heimlich, Look Homeward, Angel, Séance/seminar.* As Kate Bush has observed: 'Hiller's collection, with its functional specimen boxes and

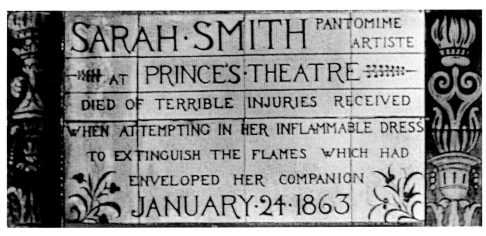

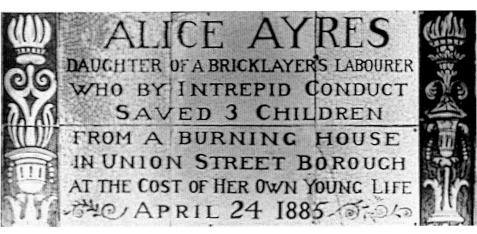

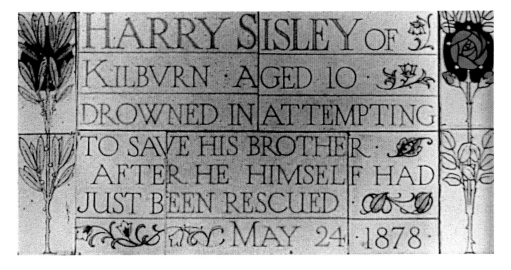

its array of shards and fragments summons a potent psychoanalytical metaphor: the plumbing of the human mind as an act of archaeology, an excavation of the unconcious where nothing is lost and everything is conceivably waiting to be disinterred.'[4] Perhaps Hiller's best-known work, it also best epitomises her interest in the potential of the gaps between the known and unknown, dream and reality.

Hiller has made extensive use in her work of the passport-size photographs taken in automatic booths. She first used them to make serial portrait works of friends, and then began working with discarded images in the ongoing series *Incognito*, begun in 1972. Since the 1980s she has continued to engage with the 'small theatre' of the photobooth, concentrating on making works in which her own presence is recorded, either with a recognisable image of her face or in the recording of some trace of her existence. The miniature scale of the original is enlarged and her own image is combined with her now signature automatic writing in works such as *Sometimes I Think I'm a Verb Instead of a Pronoun* 1982, *Photomat (Self-) Portraits* 1982 and *Midnight Series* 1982–7 (pp.74–5). Superimposed over the portraits the calligraphic marks appear as abstract patterning, and have been likened to tattoos when focused on the face. The self is incorporated at one remove in both elements making up the works. In the multi-panel work *Elan* 1981–2, sound provides an additional element, similarly mediated rather than direct in its association. The artist's own vocal improvisations are interspersed with snatches of recordings made by Latvian scientist Konstantine Raudive, who amplified the minute traces of sound made by recording in otherwise empty and silent rooms. The resultant crackles and hisses that for him suggested the language of ghosts, for Hiller represent the potential ghost of language. The work was made shortly after *Monument*, in which the sound element also evokes rather than explains some of the ideas present in the visual portion of the work.

Hiller used the Raudive material again with the slide projection work *Magic Lantern* 1987 (pp.80–1). In this visual spectacle, red, yellow and blue circles of light are projected in gradually increasing scale, singly then in overlapping combinations, creating additional colours and afterimages. The projection ends with a circle of white light when all three primary colours are projected on top of one another. Although experienced in a collective situation, the optical perception of the vivid after-images created in the retina by the projected colours occurs subjectively. In combination with the disorientating soundtrack that accompanies the compelling projection, the piece provokes both meditative reflection and enquiry. The body's instinctive response to colour is explored using a clarity of form associated with scientific methodology to subvert the boundaries between objective perception

and subjective response. The web-based work *Dream Screens* 1996 (pp.90–3) also takes colour as its primary visual component. It consists of eighty-four colour screens to be generated at will by the viewer. The sound that accompanies the screens interweaves spoken texts and memories with Morse code, a pulsar signal and a human heartbeat. The subject of dreams dominates the soundtrack, and many of the texts are recited from memory of films with the word 'dream' in the title. There is a web/wheel/map to navigate the colours, a list of the colours in terms used for traditional pigments, a transcript of the texts and writings, as well as lists of reference works. Apparently a simple, contemplative piece, it contains references to many of the subjects of Hiller's ongoing investigation.

Magic Lantern 1987
Installation at Tate Liverpool,
1996, see pp.80–1

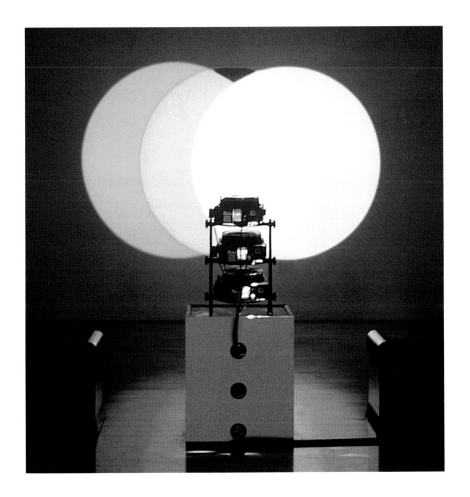

An Entertainment 1990
Installation at Matt's Gallery,
London, 1990
see pp.82–5

A recent work in which language and voice take central stage is the 2007 projection *The Last Silent Movie*, featuring a screen blank of imagery but for the transcription of spoken phrases in extinct or near extinct languages. Sound dominates the experience of the work, which is structured like a movie with subtitles. These accompany the voices, which differ greatly in their texture and rhythm, and the vocabulary and means of expression used by the speakers highlight the very varied ways in which communication is conveyed through language. Different ethnographic groups are represented in the languages, which include micro-languages spoken until recently by small groups of people in Europe, such as Manx, used in Jersey until the 1940s, and a form of Romany that lately became extinct in Wales. The recordings are taken from sound archives and often represent the last person to have spoken a language. In her conversation in this catalogue with Yves-Alain Bois and Guy Brett, Hiller discusses her desire, in collecting and choreographing the voice extracts, to reconnect them with reality, to allow the audience to reflect on the speakers themselves and on the conditions that may have prompted the loss of their language. These recordings of silenced voices, preserved into archives, have literally been given voice again in the reassembled form given by the artist.

In seeking to make the invisible visible, Hiller uses investigative structures that look beyond the rational to explore subconscious meaning in everyday activities and artefacts. In the experiments she conducted in the 1970s into the unconscious mind, she focused in particular on the experience of dreaming. The work *Dream Mapping* 1974 (pp.48–51) resulted from such a time-based investigation, which otherwise remains a shared memory for a small group for people. It is made up of the documentation, in words and maps or schematic imagery, with which the individuals sought to communicate their dreams. Rather than to interpret or explain, her project

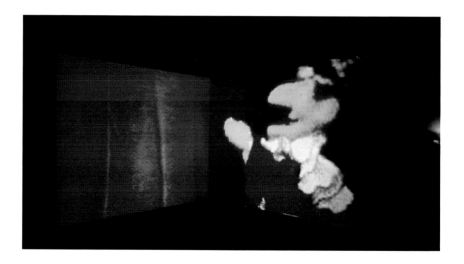

aims to heighten awareness of the way in which the subconscious, as manifested in memory, dreams, reverie, meditation or other altered states, is communicated visually. The work *Belshazzar's Feast, the Writing on Your Wall* 1983–4 (pp.78–9) was prompted by newspaper reports of hallucinations experienced on TV screens after broadcasting ended, and the hypothesising in these newspapers on the possible causes, including ghosts and UFOs. In this work Hiller seeks to establish the role of the creative imagination, rather than any of these possible external causes, in triggering such apparitions. By presenting a filmed image of a fire on a monitor, she takes the notion of the TV set as substitute for the hearth and of flames as the elemental vehicle for stimulated visualisation. She creates a situation that provides viewers with a stimulus to see images in the flames. The visual element of the work is accompanied by segmented sound in which the artist's improvised singing is interspersed with whispered phrases based on the newspaper stories and the voice of her young son describing from memory the Biblical tale that gives the work its title, as well as Rembrandt's painting of the event. Staged as various forms of installation evoking spaces for collective viewing, the work has also been shown as a TV broadcast.

A prominent feature of Hiller's work throughout her career has been the early and innovative use of alternative media, such as the inclusion of sound as an additional element in her work; the creation of large-scale multi-part synchronised video installations; and the employment of the internet as a tool for her production. Adopting and combining media in ways that are radical for their time, she absorbs them as a form of basic cultural material. The four-part wall projection in the work *An Entertainment* 1990 (pp.82–5) was devised as a formal necessity to recreate the horror of the Punch and Judy show, a popular form of children's entertainment.

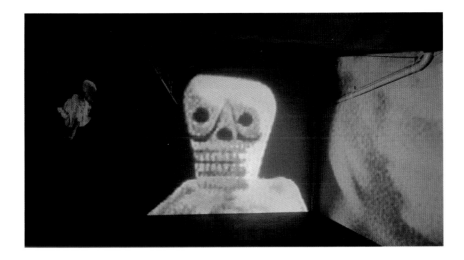

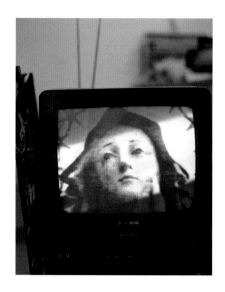

Wild Talents 1997
(right) Installation at Foksal
Gallery, Warsaw, 1997;
(above) detail
see pp.94–5

To stimulate awareness of the ghoulish nature of the tradition, which Hiller views as a ritual initiation into a culture, she situates the audience in a large yet claustrophobic theatre space, surrounded by enlarged and disorientating film images of actual Punch and Judy performances. The inevitable violence of the plot is accentuated and the forgotten mythologies embedded in the present-day incarnation of this ancient theatrical tradition are given focus. Confrontations between good and evil, between right hand and left hand, are played out by the glove puppets and mirrored by screen splits in the projection. The menacing effect is enhanced by the soundtrack, which is punctuated by the caricatured and shrill voice of Mr Punch (customarily distorted through a 'swazzle') as he enacts his violent deeds. The grainy imagery in the projections, achieved by celebrating the effects produced by low-tech equipment and further distorting them, is an example of Hiller's refusal to cleanse her work of impurity or imperfection, but instead to encompass the incidental or provisional.

The large projection format has proved a particularly apt vehicle for Hiller to explore her continued interest in unexplainable phenomena, using their depiction in popular films. The range of material available demonstrates the appeal of the subject in cinema, but within the genre exploration is mostly limited by the role it occupies as a narrative device. *Psi Girls* 1999, like the work *Wild Talents* 1997 (pp.96–9 and 94–5), is an installation featuring imagery appropriated from films

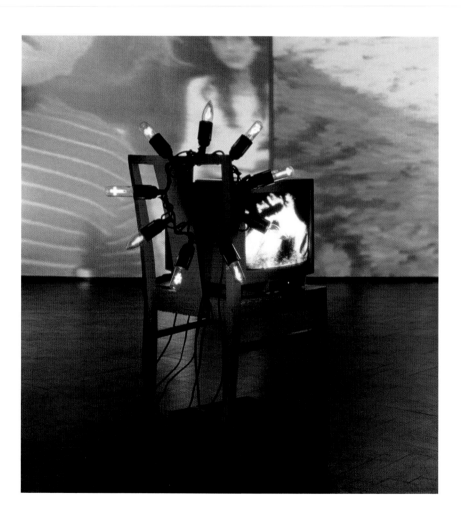

of children with telekinetic powers. The audience is immersed in the mesmerising environment at the point of high tension in each film, when the children's extraordinary power is demonstrated. The cinematic metaphor is extended with an intermittent soundtrack of drumming and the clapping of a gospel choir, followed by a period of static. This familiar manipulative device to increase tension, in combination with the synchronised images from half-remembered films, assaults the senses to an almost unbearable degree. The absolute focus of the children on performing their fantastic activities on the screens is harnessed and shifted into the work itself, to intense effect for the audience. The five large projections in this work are each overlaid with a different colour filter, immersing the audience in yellow, blue, red, green and mauve. Hiller's interest in the body's response to colour, explored both in *Magic Lantern* and *Dream Screens*, is here added to the range of sensations addressed.

The cumulative effect of collected material is experienced in a very different way in the monumental web of audio speakers that forms the installation *Witness* 2000 (pp.100–3). Language is palpable, but only as a gentle cacophony of barely audible voices. The audience is compelled to enter into the dimly lit cruciform environment of hanging wires and lift the speakers to ear level to decipher individual voices talking in a variety of languages. The hundreds of stories are testimonies from people from all over the world who have encountered UFOs or creatures from other spheres. This experience is what links the subjects, but a range of other similarities emerge in the type of language used to describe the experience, the motifs that recur in the descriptions, and the similarity in the physical effects described. The multiplicity of the accounts lends the work an authority and a fascination that would not be produced by a single witness. An unexplainable vision that might in previous centuries have been described as a religious experience, but is articulated here in the language of science fiction.

The body of Hiller's work is a matrix of powerful and visually striking vehicles for the overlapping and interrelated themes that motivate her enquiry. It is also a collection of works of art that have individual presence and integrity, taking as their subject matter areas of forgotten focus that perhaps only an artist can make accessible to a wider public. Not conceived as a retrospective view of Hiller's complete output, this exhibition brings together a selection of works that I have encountered cumulatively over many years, which allow the visitor to make a journey through a remarkable career and provide the opportunity to think, feel and reflect, which, in the end, is what Hiller's work is intended for.

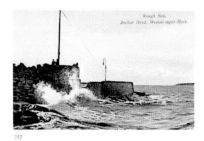
237

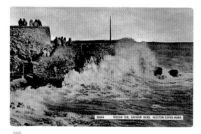
238

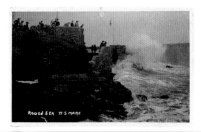
255

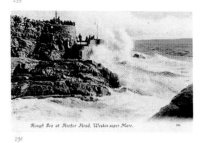
236

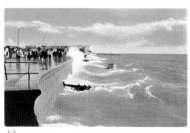
A3

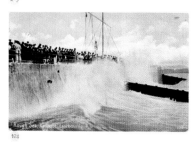
124

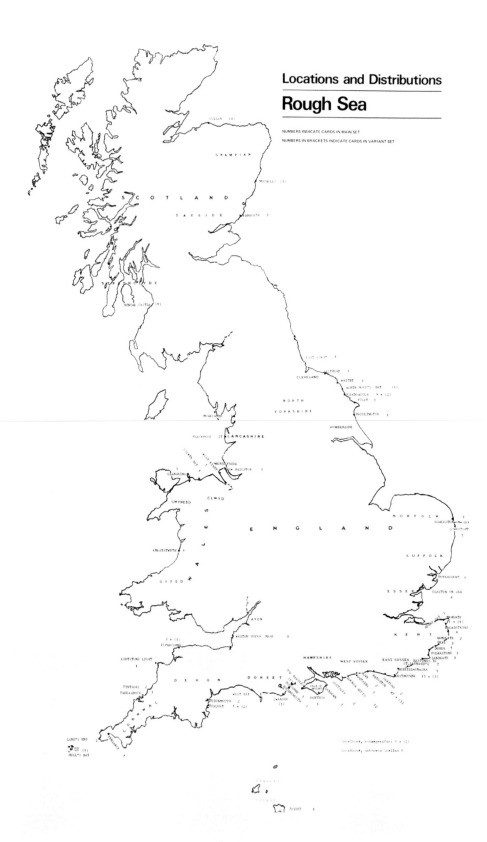

Locations and Distributions
Rough Sea

NUMBERS INDICATE CARDS IN MAIN SET

NUMBERS IN BRACKETS INDICATE CARDS IN VARIANT SET

GB We are looking at an assortment of small glass bottles covering a worktop in your studio. The bottles are old, maybe Victorian, and probably contained medicine. They are subtly varied in shape within certain limits. Why have you been collecting these?

SH These are for one of my *Homage to Joseph Beuys* works (pp.124–7). I use them as containers for water from holy wells or sacred streams that I started to casually visit in the 1960s. I like the archaeological aspect of the bottles, a kind of domestic archaeology. In the Victorian period in London there were rubbish dumps along canals or by the Thames, and of course glass doesn't decompose, so you can dig there now and find interesting ones. Aside from being rather beautiful these little old bottles are essential in this series to emphasise the idea of retrieval.

GB What connection are you making with Beuys? And why a homage?

SH I only met Joseph Beuys once, at the ICA in 1974. Everyone knows about his work or rather his attitude towards art, life, and everything else. It's a huge influence on artists for better or worse. In this series I'm referring to the way Beuys made symbolic use of matter-of-fact materials, sacramentalising everyday activities and storing up energy in ordinary objects. I always say my work starts with a cultural artefact and you could say the cultural artefact here is popular belief that these waters can produce powerful effects, cures, for believers. At the same time, my starting point is also the work of Beuys. This relationship between the popular and the unique, between so-called ordinary people and a so-called unique genius artist fascinates me and I'm always interested in finding links.

GB Energy is a subject that is interesting for both the rational/scientific and the mystical/spiritual ways of thinking. Each view of energy seems there to correct the excesses of the other.

SH You know, for a long time now I've been interested in certain legacies of modernism, in particular the tendency to make use of various occult or spiritual traditions. I made a homage to Yves Klein and one to Marcel Duchamp looking at that particular aspect of their work and influence. And along with this using and passing on of mystical ideas by artists there's an equally strong reactive tendency of dismissing or ridiculing and, well, I think it's worth looking at both sides together. It's just as with other unresolved issues, problems, themes expressed in art, I'm interested in locating the possibilities, making a new space aside from either extreme of debunking or superstitiously accepting.

GB The idea of collecting water is a nice paradox. Water is universal and ordinary, and the notion of holy water is obviously a projection of the human mind. You've studied this phenomenon of projection in many forms, for example the projection of people's fantasies onto the flames and the TV screen in *Belshazzar's Feast* (pp.78–9).

SH That piece started with newspaper reports of projection or hallucination in contemporary domestic settings, something that happened some years back and was reported in several newspapers, of people seeing ghostly images on their television screens after closedown. I whisper the newspaper articles in the piece. I called the video *Belshazzar's Feast* because I wanted to find a context, a traditional context for a modern communal hallucination, or vision if you like. Those people who watched television on that particular evening saw something weird, many people saw it. And I was interested in the idea – it's an old idea, McLuhan's idea – that television is like the fireplace or hearth, and the hearth with its moving flames is a vehicle for reverie, and reverie creates visions. I made the piece so that the video actually provokes that phenomenon of reverie in the people who watch it; they begin to see pictures in the flames. But of course if you've only been looking at my documentation you won't see what they saw. And in fact this video is sometimes so effective in that way that some people have found the piece very disturbing, because they're being empirical, avoiding psychology you see, like the journalists with their newspaper reports who said that this vision, this phenomenon, might even have been beamed from flying saucers – anything other than just saying, 'Imagination can do this', because they don't want to think about the processes of the human mind, its imaginative powers, projection and so forth. So when the piece makes viewers see things, some people get very disturbed. I remember somebody that Guy and I used to know way back – an art dealer – said to me once: 'You know, Susan, I like your work, but there's one piece I can't stand.' And I said, 'Oh, what's that?' And he said, 'It's that video, *Belshazzar's Feast*.' I said, 'Well, why?' He said, 'Those devils! Why did you put all those devils

Dedicated to the Unknown Artists 1972–6
detail, see pp. 52–5

Retrievals

Susan Hiller, Yve-Alain Bois and Guy Brett in conversation

in your video?' I said: 'I didn't put any devils there, you put them there.'

GB He must have had his personal demons.

SH Exactly. But it's very difficult to have that discussion with someone who is in denial. What devils? I didn't know what he was talking about! And other people have said to me, 'Oh, it's so clever, I saw dancing dinosaurs.' But you know, the piece is about projections, and it also provokes them. The work is a device for demonstrating how projections, visualisations, are subjectively created. But as I said, there's no way to document this effect.

GB You have often described the way you build up collections of things that have interested or intrigued you, without knowing at first what you will do with them. For example, in the 1970s you collected a certain type of seaside post-card in large numbers – the Rough Sea – at coastal towns around Britain, which later became *Dedicated to the Unknown Artists* (pp.52–5). More recently you have collected, or documented, street names in Germany which include the word 'jew' (*The J. Street Project*, pp.104–7). This latter finally took the form of a film, a photographic installation and a book. There are many other examples, in some of which you have registered very strongly the dark side of collecting.

YAB I showed the *J. Street* film in a graduate seminar. For some people, it was extraordinarily traumatic.

SH For Germans?

YAB Actually, the person who freaked out the most was Chinese. She started crying.

SH Really? How interesting, and terrible. The last time I showed it, I was verbally attacked by a young German.

GB In Germany?

SH No, here, actually, in Brighton. And that was very interesting, because usually the Germans suffer in silence when people deal with things that they still feel so uncomfortable about. But this was a young woman, and she got up in the audience at question-time afterwards, and she said vociferously, 'I don't think you should've made this work! That's long ago. It has nothing to do with us.' And then an older German woman who was in the audience argued with her about that. Obviously it triggered off an emotional reaction in both of them.

YAB Well, the film is designed to do that in many ways.

SH As you know, it's simply a progression of modern streets, a long series of con-temporary locales with no commentary and no drama, so that people can fill in the blanks with their own history, their own memory. It's very cool and relies on the audience to create a narrative. It doesn't explicitly deal with Nazism or the Holocaust.

YAB In the same session I showed the film, I also showed *Night and Fog*, Resnais's film about the Nazi concentra-tion camps, and what struck me in *Night and Fog* is that there is all this collected material, the hair or the shoes –

SH The glasses, the bicycles –

YAB So there's a lot of collection, for what, we don't know, we don't know what happened to those collected things.

SH We have some idea. I think the hair went into mattresses. I don't know what they did with the eyeglasses …

YAB Sold them? I don't know. In any case this strange collection of material is very, very disturbing, knowing where it comes from.

SH Were you doing a seminar on collecting?

YAB Yes. Collecting data, or objects. The difference between the two.

SH That's very interesting. In *From the Freud Museum* (pp.86–9) I was really inspired by Freud as a collector of objects, you know, as much as by the theory and history of psychoanalysis. In that piece I used a lot of things I'd been accumulating anyway, for instance some of the holy waters we were talking about earlier. I spent time in the Freud Museum, in the family house, and I saw the way Freud had constructed his living space as a collection of collections, which really focused ideas I had been thinking about for a long time. And even more so, to discover that in the Freud family, they documented everything, making little home movies about everything: family birthdays, escaping from Vienna, their dogs, everything. And they gave each other certificates commemorating important moments. Freud kept a complete record of all the archaeological pieces and art works he

acquired, carefully annotated. He was a really professional collector.

YAB That's a question I wanted to ask you about, actually, about the act of collecting. Because from what you describe, the kind of archaeological practice it implies, it seems that it is not so far from the collecting and documenting of data made by anthropologists. I know you say you are sick of being reminded of this aspect of your past, but I don't see how this could be avoided. In any event, this seems to me a different type of collecting from, say, the one that Bataille envisages as a fetishist.

SH Well you know Derrida's book, which is called in English *Archive Fever*. There he talks about the ultimate collection, which for him has this fetishistic quality of emptiness. I think mine is not empty of content in quite that way.

YAB There seem to be two kinds of fetishisms at stake in collecting. The one you just mentioned is about a kind of analytic process and wanting to categorise, it is about zooming in on a type, essentialising. But the reason I was asking about Bataille is that he envisioned the collector as another kind of fetishist. That is, he envisioned a direct relationship to reality, to its base matter, without what he called 'symbolic transposition', and he hoped for a while that there could be such a relationship to art, that art could be the venue of such a non-symbolic relationship (that was in part the program of his journal *Documents*) – but in the end, he lost faith in the power of art. 'I defy any collector whatever to love a painting as much as a fetishist loves a shoe', he wrote in the article he published in the

last issue of *Documents*. Which is to say: if an art collector were such a fetishist, then art could have a revolutionary potential. If collectors could be as obsessed with their art as a fetishist is, if they could be real fetishists, then art would have power to change the world, but not any more.

GB There are different forms of love, and I'm sure that an art collector can be as obsessed as a fetishist, but I don't see why obsession as such has a revolutionary potential. I'm not sure that hardened revolutionaries would welcome a bunch of fetishists!

SH I completely agree that art collecting for some people is a real obsession, perhaps a sort of fetishistic obsession based on the pleasure of ownership, of possessing objects that substitute for, and once belonged to, the real object of desire. But like you I don't see any revolutionary potential in this, and I don't think it's often compulsive or destructive. I do sometimes fantasise that my way of working has radical implications, but that may just be an artist's wishful thinking, wanting to be useful or something. For me, the process of accumulating the material ingredients for the Freud piece was rather dreamlike. I would just put my hand out and it would be there. It's like when you're in a library, and you just go to the very book you need though you haven't looked through the shelves – something happens, intuition or whatever, and it's quick. I'm very committed to that way of working. And that's why I say I can't explain and moreover don't want to explain the process of putting the work together until after it's finished. But if this process substitutes for my desire, it remains unformulated. In other

words, I never start with a proposal to illustrate although when completed the work offers a clear proposition.

GB Perhaps we need a more subtle understanding of the involuntary process of being drawn to something than is given by the conscious, active verb: 'to collect'.

SH I'm perfectly happy, now that I've been making work for such a long time, to talk about the fact that I like to collect things and to figure out how they go together or not. But at the time that I've been doing most of it, I didn't think of it as collecting. That's the comment I'd like to make. Because, you know, these water samples started thirty or forty years ago. I wasn't going to make the world's biggest collection of water, or do anything interesting with the water. The little bottles of water were like souvenirs or mementos of special moments, special places. There are a couple of them in the Freud piece, *Lethe* and *Mnemosyne*, and some others from sacred sites. But I didn't set out to make a collection. Yes, I realised I had a lot of them! Now, because I am doing the *Homage* pieces, and maybe because I've come to that time in my life when I'm perfectly happy to look backwards and see where certain things can locate themselves, that's when the waters began to form a collection.

YAB When do you decide that enough is enough?

SH With the Freud piece, I could have gone on collecting forever. It offered the opportunity not just to find things but to use up things that I'd been keeping for a long time. Everybody has a box where they put things, or a drawer, and you

don't actually know why you save certain things. I began to think about this: why, what does this mean? Why did you put that there? And then after that I could find other things – you know, for example I went to a junk market and I saw a ready-made collection. Someone had already collected little plastic animals, tiny ones, ones that are imitation glass, imitation blown-glass animals. I just thought, 'Oh, I'll buy that, it's interesting.' When I brought it home I saw that actually there was a reason for this person's collection – in this child's collection all the animals were in pairs. There was a mommy and a daddy animal, couples, just like Noah's Ark and Freudian theory. So the box of little animals could be seen as very Freudian.

YAB And when do you eventually stop?

SH Well, when the Tate acquired the installation they wouldn't let me add anything to it! And I wanted to make a contract with them, so that I could keep on adding to it, but they wouldn't let me! [laughs]

YAB They wanted to protect themselves in case you decided to add something fundamentally seditious or something.

SH Museums need things to be fixed and changeless.

GB That work gave you a kind of a structure for fitting in anything that you wanted to fit in.

SH Anything that seemed to fit itself in, I would say.

GB I'm very interested in that moment when you find the structure, you find the

mise-en-scène for what was until then merely an accumulation of things, how you find that moment of transformation, of the assumption of a poetics. This is something very different from the procedure of collecting. It takes liberties with the material, it's an artistic act, even though it's based in a profound empathy, a cherishing of the collected things. Take *Witness* for example (pp.100–3): at a certain point you realised that the tiny loudspeakers that relay the accounts of UFO sightings resembled flying saucers, or flying saucers resembled speakers.

SH I chose them for that reason.

GB Not only that, but you gave the whole work a radial structure.

SH Yes, its form is built up on that. You know I've talked before about the old idea of truth to materials. What I always do is to look hard at the originating material. In this case it was a collection of stories. And to figure out how to embody these, which are the core of the work, in the whole work, in every single aspect of the piece, in order to experience their full meaning. Listening to these people whispering in your ears is like being a priest in a confessional. The whole piece is built upon the shape of the cross and the circle. There are four pathways where you can enter the inner circle of the installation. That layering through analogous materials and forms is how to make an embodied work, a work that's faithful to the original materials in the deepest sense. The religious symbolism of the cross in the circle is crucial because the stories are examples of contemporary visionary experience. Only today people see UFOs where once

they saw angels. There's no difference in the structure of those kinds of experiences. The frustrating search for a suitable location finally ended when we found a derelict chapel, so even the setting was appropriate in its previous use and current dereliction.

YAB But I was wondering something about *Witness*. It seems to me that one of the arguments that this piece is making is that these sightings are in some ways shared phenomena. On the one hand they're quite exceptional, in the sense that, statistically, very few people have this experience; but on the other hand the sightings themselves, and the way they are narrated, are very similar (even if none is exactly the same). One could even say that they are clichés, or at the very least 'not very exceptional exceptions', to speak like Alfred Jarry. This notion was part of his *pataphysique,* a field of research he founded (tongue-in-cheek) and which he defined as a 'science of the particular'. In Jarry's pataphysical conception of the world, nothing is ever allowed to be considered at any other level than the particular, everything is an exception, and the general laws discovered in the 'traditional universe' are nothing more than a correlation of 'not very exceptional exceptions'. I think the sightings you 'collected' enter into that category. There are many people who share those bizarre experiences. In collecting this data, in bringing these facts together, you underline the generality of these particulars without undermining their goofiness. Now, the issue which I have been discussing with Guy, and which we are not able to figure out, is that you seem to be doing that without irony, or wanting to do it without irony.

SH That depends what you mean by irony. Isn't irony based on knowing two things at the same time, or feeling two things at the same time? I'm interested in collective production. All these things are collectively produced – that's what interests me about it.

GB For you, the terms 'collection' and 'collective' are intimately related.

SH Yes, always. Also the term 'collaboration' because I am collaborating with the original producers, the visionaries in *Witness,* or the people who made the postcards in *Dedicated to the Unknown Artists*. That's what interests me. The people in *Monument* who gave up their lives, that was a collective belief system. And I'm not being ironic about people's belief that they saw a UFO. That's what they think they saw, and that's their preferred description of the experience. People have experiences of all kinds, and some of them are not acceptable to people who have a rationalist framework. But as you say yourself, Yve-Alain, they're very commonplace explanations. That interests me. Is that ironic? I certainly don't think that I have an academic approach, or feel distant from them. And I've not determined, in my own mind, what level of reality they're on, because rejecting them completely depends on a world-view I'm not convinced by. I always say our definition of reality is provisional. What is imagination? William Blake said imagination was not a cloudy nothing. If it's not a cloudy nothing then what is it? With imagination you can't change anything but you can't change anything without it. So it's a potentiality that human beings have. A characteristic. And if it's a characteristic,

how far does it go? If you see angels the way Blake did – and this is a man worth respecting, because he was a brilliant poet and an artist and so forth – where do you locate that? How can you be ironic about what he believed he saw?

YAB I know you are interested in those objects as facts, as social facts. I'm quite fascinated by the bizarreness, but interested by the fact that they are common. It's a common bizarreness. Okay, coming back to irony – in your little book about Yves Klein, and people photographing themselves levitating, it's quite obvious, you state, that Klein's photo of the leap into space was a fake, which we all know. Then you say, all those people believe they levitate, and they go to extraordinary lengths to show they levitate, including manipulation, montage and whatever. When you say something like that, you're automatically taking a distance, aren't you?

SH I'm a collector of these photographs because they are fascinating and I am not ironic about that. I don't think these people think they levitated and I don't believe they produce these photographs to trick other people. They're doing it because it's a kind of aspiration. It's a desire …

GB It's a kind of longing …

YAB The dream of flight …

SH Exactly, exactly. These people are knowingly, playfully, wanting to think of human beings, of themselves, as being potentially different than they are. They are imagining an impossibility. The only time you would ever actually see yourself flying or floating would be in a dream.

So then these photographs attempt to capture and document a dream-state, a desire.

GB The posture of the body in Klein's leap is so heavenly, and perhaps a bit dandified.

SH Sometimes in the levitation pictures it's a yogic meditation pose, sometimes prayerful, sometimes floating horizontally as though dreaming.

YAB Now, one thing that I wanted to ask you about, something that you mention a lot in your essays and interviews, is your desire to create fluid taxonomies, or to declassify. And when you give some examples of 'materials that have been culturally repressed', as you say, with which you worked, it sounds like the content of Borges's Chinese Encylopedia.* So on the one hand you like to declassify, or to jolt taxonomies. But on the other hand you like charts, and tabulated records of all kinds. You have a fascination for systems of classification.

SH Yes, other people's. I don't think that way myself. You'll never see me give a talk and try to diagram it on a blackboard. My whole upbringing was about being rational. But I experienced breakthroughs of what we call creativity, or even spirituality. I found that these moments of breakthrough can be mischievous and unexpected and inappropriate. Then it occurred to me when I started making art that I could work that way with rational structures, that I could be mischievous with them, if you like. I start with cultural artefacts, things that already exist. And then I'm mischievous, and at the same time intensely serious. I want to remain true

29

* Jorge Luis Borges's 1942 essay 'El idioma analítico de John Wilkin' ('The Analytical Language of John Wilkins') contains the following description: 'These ambiguities, redundancies, and deficiencies recall those attributed by Dr Franz Kuhn to a certain Chinese encyclopedia called the *Heavenly Emporium of Benevolent Knowledge*. In its distant pages it is written that animals are divided into (a) those that belong to the emperor; (b) embalmed ones; (c) those that are trained; (d) suckling pigs; (e) mermaids; (f) fabulous ones; (g) stray dogs; (h) those that are included in this classification; (i) those that tremble as if they were mad; (j) innumerable ones; (k) those drawn with a very fine camel's-hair brush; (l) etcetera; (m) those that have just broken the flower vase; (n) those that at a distance resemble flies.' There is no evidence to suggest that this was based on an authentic list. See *Selected Non-Fictions: Jorge Luis Borges*, trans and ed. Eliot Weinberger, New York 1999, p.231.

in some way to the original materials, not to analyse them in any academic way. So the end product isn't taxonomy. It's not even about anti-taxonomy.

YAB No, but in creating collections, in creating assemblies, you automatically invent or solidify something, employing a criteria of selection. That's acting as a classifier.

SH In the Freud work I've thrown things together that would go into many different taxonomies and I've put them all in one place. There's no taxonomy there at all. I've mimicked, if you like, or utilised, the language of taxonomy, but there's no taxonomy there except complexity or indeterminacy, and the viewer's own way of organising the experience of viewing it.

GB How would that mimicry function in a work like *Dedicated to the Unknown Artists*?

SH First I have to say a bit about how this work started. It began with an accidental discovery that turned into a collection and then turned into something else, a large installation of more than 300 cards, charts, a book and some notes . . . I went to a seaside town, Weston-Super-Mare, and in an old sweetshop I found a postcard that said 'Rough Sea'. There was a picture of an extraordinary wave and there were words. The two things came together. What was the relationship between the picture and the caption? I looked at it for a long time, I was quite enchanted by it. Then I went to Brighton one weekend and found another postcard, of Brighton, a big wave, 'Rough Sea'. Well, I thought,

if there are two of them, there must be more, and I started finding them everywhere. I had discovered a genre of postcard that had all sorts of fascinating aspects. I thought of the cards as miniature artworks.

In *Dedicated to the Unknown Artists* I took on the role of curator, using a system derived from linguistics to look at aspects of the imagery. This was something I thought of as completely inappropriate and jokey, a kind of insider's joke. That was early work, maybe referring back to my academic training, and I soon got it out of my system.

The Rough Sea postcard images that derived from paintings were restricted to a genre, a stereotypical genre. But the people who were supposedly hand-tinting the photographs in a laborious, repetitive job, apparently were not controlled in that way, and they often got very creative. And that interests me. So there were a lot of things that came out of that piece. That piece is very excessive. I mean, it started off as one thing and it turned into something else, and that's because there was such a volume of material.

YAB Can I just ask that question again, for that piece – when did you decide to stop?

SH Well, I haven't. [laughter] It's still ongoing. People give them to me, and I find them. They're everywhere! You'll start to see them. You'll become infected with it!

YAB Sure, sure, I know! I think that your work can produce that effect. [laughs] I understand perfectly well the impulse people would have to send you things.

SH Well, you know that collecting is an attempt to ward off death, I mean, we all know that. I wish to live forever so I can't stop collecting the cards and making new works with them.

GB You have written about 'how important it is to find a way of talking about the work which allows it to retain its necessary ambivalence and paradox', not to make 'the work sound banal and used-up, not to make it seem as though everything is known about it'. This leads directly to your persistent critique of the art institution from an artist's point of view. You mention 'the seduction of the museum' (which I fully share), and you've used museological methods in some works of your own, yet you also blame museums for draining the vitality of artists' work, for making it appear that everything is known about it. Will there always be a conflict between artist and institution?

SH Well, it's an interesting problem, isn't it. I was recently interviewed for the British Museum magazine. And I had to think why I liked the British Museum, because I'm aware that their view of reality is very much an edited one, you know? [laughs] And I had to conclude that I like to travel in this edited way. Going to that museum provides me with a view of Africa, but it's nothing to do with Africa at all – it's the Museum's world that you enter into.

GB I was always fascinated by the Pitt-Rivers Museum in Oxford. It's an endless mania of collecting. Things are not singled out by modern display methods. There are rows of old cabinets. You open a drawer and you see hundreds of combs, different combs from all over the world.

SH Isn't it a kind of formalist analysis, through resemblance? Things that look alike must mean the same thing in different societies. Pitt-Rivers was a Diffusionist. He thought everything came from Egypt, so he put together things that looked similar. [laughter] What's wrong with that? I love it.

GB At one point they tried to modernise the Pitt-Rivers, but that failed, luckily.

SH They decided it was a museum of its time, and that was important. Another un-modernised museum is the Hunterian in London, the Royal College of Surgeons Museum. That's where my *Split Hairs* piece was exhibited. I guess, Yve-Alain, you don't know about this work, which is basically a collection of wonderful artworks that my partner David Coxhead rescued from a skip some years ago, and I researched, arranged and annotated. The works are small framed and captioned pictures made of split hairs, a fetishistic or conceptual project, by Alfred West. We produced a small catalogue with David writing a collector's essay and me writing a curator's essay, with Alfie West's images and extensive captions for his own works. I installed the collection in a vitrine in the Hunterian, where Alfie's surgical splicing skill fits in very well, and in fact his work cast the scientific purpose of the museum displays in a different light, because they were very weird and could be looked at as art rather than science.

I took the opportunity to explore the museum, and they used to have – perhaps they've changed it now – behind the main medical museum, something called the Museum of Teeth.

GB Oh God!

SH It had fantastic things, for example the dentures of Louis XIV, which were all made of human teeth, other people's teeth. And then there was a drawer of teeth that had been collected on the battlefield of Waterloo, after the battle. They were from dead people, or teeth that had been knocked out, I don't know what. [laughter] It was a fantastic place, you know! A macabre imagination, but it was all for the purposes of science, you see.

GB You are supposed to look at those things in a detached scientific spirit but you are overcome by their expressive weirdness.

SH When I wrote that article, *Sacred Circles,* years and years ago, I had discovered that the Museum of Natural History, when it had collected all its American Indian things, had acquired the items of booty that the US Cavalry took when they raided an Indian village. Not just beadwork or arrows but also scalps and noses and what were called people's privates that they had cut off. These things came into the Museum with the rest but were hidden from public sight at some point. All museums are constantly censoring out unacceptable material and unless it's still in the basement, I bet they de-accessioned it. Mostly museums house less horrible materials of course, but the process of censoring or selecting goes on all the time in different ways.

GB Suddenly we're back with the concentration camp 'collections'.

YAB I wanted to ask you a question about craft, because in many ways one could say that your work has a conceptual dimension. You've dismissed that but …

SH No, of course it does. I am a Conceptual artist really, but in a different way. I want to make works that actually *embody* ideas. I think materials carry ideas. Or another way to put this is to say that I don't want to rest with the ideas that are already in ordinary language, so I don't want to stick with language only.

I think that a major goal of Minimalism and Conceptualism was to produce art of complete transparency. The result of this would be that there was no gap between the artist's intention and the critic or viewer's interpretation of the work. I've always doubted the possibility of achieving this perfect fit and as time goes on, while I still, I think, produce works that don't disguise their methods and means or mystify my intentions, I've increasingly allowed space for the participation of viewers in the creation of meaning. I think the artwork is an instigation of a process of reflection. I don't affix a meta-interpretation by means of an appended text that 'explains' the work (although I sometimes provide clarifications or clues to what I think about it) and I don't think that my wishes or hopes for the work's effect should override the viewer's response.

YAB I am not sure that all Conceptual and Minimal art can be said to partake of such a dream of transparency. In fact, I think that within these 'movements' some of the artists very quickly perceived this frankly idealist tendency as a return to

31

the authorial claims pervasive during the heyday of Abstract Expressionism, and reacted against it. Mel Bochner's 1970 piece, *Language Is Not Transparent* is a good example of this immediate response. And within the ranks of Minimalism, I think that through the artists' interest in both phenomenology (Merleau-Ponty) and Structuralism (say, Barthes), there was a lot of suspicion with regard to the notion of 'intention' as the private domain of the author, as the site of the work's meaning. There was also a strong interest in the Nouveau Roman at the time, in which all clues concerning the psychology of characters were deliberately withdrawn, leaving the reader in charge of inventing motives for their action. Minimalism in particular, in its attention to real space, to the space of experience, shared both by the viewer and the work, insisted on the surface of things and tried to debunk the sacrosanct myth of 'interiority'. An interesting contradiction arose then, one that your work seems to have avoided completely: on the one hand, the struggle against interiority, authorial mystification, and the like, led to a militant disregard for craft as the guarantee of the artist's presence in his or her work (that's very obvious in early Conceptual art); on the other, this disregard for craft (and for the materiality of things, including language) was leading back to the traditional idea that the meaning of a work does not reside in its actual, physical being but at the level of intention. An intentionality from which the beholder would be cut off and would have to try to divine or decipher.

Your work certainly does not function like that. Even through photographs one can see that your attention to craft, or the way things are done, is very strong.

SH I suppose that my approach was to sidestep this dualism completely and to move sideways, as I've said before. It's complicated, thinking about Conceptualism, because there was on the one hand at the start the supposedly democratic, demystifying element: I can just type a list on a piece of paper and that can be art. The end product was apparently de-skilled. But then there was the other side of it too, there was a classicism in the presentation. People were using things like typography and so forth, and they were not using it in a naïve way. There was a sophistication, there was an awareness, they were visually-trained people, that's what I'm trying to say. There was always an element of craft that came through. And even the idea of stripping down to the non-aesthetic is an aesthetic programme.

GB Your kind of craftsmanship is very strong in *An Entertainment* (pp.82–5). The liberties you take distorting the images.

SH Well, I didn't work hard to create that effect, you know. I accepted it as a given condition of my film material, which in fact matched the improvised, gritty nature of the original performances. It's always been an important contribution of Conceptualism to problematise the traditional ideas of craft that still linger; good craftsmanship I think is doing whatever has to be done as well as you think it needs to be done. I don't know or care, frankly, whether I'm separating craft and ideas or bringing them together. In *An Entertainment*, the images are surprising and fresh because I used very low-budget means and made specific decisions about being true to those material factors; I was filming

puppet-shows with a little Super-8 camera, from a great distance. And so, when I transferred the films to video and enlarged them to giant proportions, they looked grainy and grotesque and abstracted. And I suppose someone else in the glossy 1980s could have said, 'I can't make a work out of this footage, this is very poor quality'. But I saw what it looked like, and I worked with it. We have such a strange idea about craftsmanship, and we think that craft has to do with a laboriously-acquired skill That's not exactly right.

YAB I think that somewhere you have described yourself as a third-generation Conceptual artist.

SH Second! [laughs]

YAB I understand your resistance towards the label 'Conceptual art', because often it's related to things that are only dealing with texts. But, you know, not always. What would your interest or lack of interest be, for example, in Sol LeWitt's book *Autobiography*, which is not verbal at all and is just made of tiny photographs arranged in a grid formation of everything from the space where he lived and worked?

SH Well, I'm a great fan of Sol LeWitt. This same kind of orderly, non-hierarchical method is the way I've always gone about working. Throwing a lot of apparently accidentally-related things together, to discover some kind of structure or narrative or shared meaning. The reason I say I am second generation is that when I started working, I was in France, painting and so forth, and I discovered Conceptual art at the same

time as Minimalism, Fluxus and other avant-garde art movements – I had been more familiar with the poetry scene than the art scene. My work became in some ways a critique or reaction against Conceptualism because I experienced it as a very puritanical, exclusive grouping. Retrospectively, you have to accept that definitions of Conceptual art were – and are – structured by collectors and museums as much as by the early practitioners, and there is a conspicuous absence of women.

If you look at the women of that generation, they found other ways to do what I call 'moving sideways from Conceptualism'; what impelled the women – and has apparently always impelled us – was a need to break through that strict patriarchal language with humour, irony, horror, personal details, whatever. To find some way to move beyond or outside those restraints. So we couldn't be called first generation. Personally I was too rebellious to accept it in total and anyway I was excluded automatically on grounds of gender.

GB But do you feel that, in this country, you were part of a broader sort of avant-garde practice, which included, for example, performance?

SH Yes, I did. Performance, video, film – contemporary art in this country was unformulated and breaking out in numerous directions. There was no definition at all really. Everything seemed possible, the music and poetry worlds overlapped with visual art, sculpture became performance art, etc., and politics became really important.

GB There was an official art world of course that was set in a Beaux-Arts mentality – painting and sculpture as the prevailing and privileged modes – and no overture, except in a few isolated cases, was made to the avant-garde. The good side of that was that people were able to develop their practice in the direction they wanted, despite doing everything on a shoe-string. Now we can see your artwork, you writing, your many talks, as constituting your 'thought'. But at the time nobody who wrote actually related one thing to another, even though we all knew one another. Also, in the mainstream institution there was a resurgence of the tedious idea of a national identity of British art, whereas the avant-garde of our generation was not concerned with that issue at all.

SH The London art world was certainly international, with people coming from all over to live here. And so many of the interesting artists were foreign. And there were no collectors to speak of who weren't caught up in the idea of 'Britishness' and 'tradition'. In any case, we were on the whole suspicious of commercialism and we worked within a semi-socialist framework of publicly-funded institutions. This had a big effect on so-called art history.

GB We've been following the idea of 'collection/selection' through your work, and it's fascinating that it's clearly still an active principle, with recent works such as *Psi Girls*, *Wild Talents* and *The Last Silent Movie*. In *Psi Girls* and *Wild Talents* you take brief sequences from Hollywood films, and in *The Last Silent Movie*, despite the allusion to film, you take material from a scientific sound archive. What

struck me very much, is that when you take a piece of film out of its narrative – out of the sort of resolution where narratives have to plod on and resolve themselves – and put into this new context it becomes very, very intense. You see it in all its plasticity. And in fact this procedure refers back again to works such as *Fragments*, whose disposition of the small scraps of Pueblo pottery laid out on the floor excited me greatly when I saw its presentation at the Oxford Museum of Modern Art in 1978.

SH One of the most enjoyable aspects of editing film or video is that that's how you see it. You see bits. You don't see the narrative, you put that together later, if you put it together. You see those moments. Yes, I'm interested in fragments of films. What I did with *Psi Girls* was pull out the punctum of each film. Because the films are terrible, but what draws people to them are these heightened moments when you see magical powers being used by one of these girls. So I took the best bit in each film, really. But I had to edit some of them together or cut out shots. What you see in *Psi Girls* is not always just one sequence in the film, or a full sequence. They're sometimes several sequences that I put together, or excerpts of a sequence.

GB I wonder if it becomes more archetypal in some way? You wrote somewhere the penetrating remark that 'we value creating archives more than sustaining people'. It seems to me you have tackled exactly this contradiction in *The Last Silent Movie* (pp.114–15). It's based on anthropological archives recording languages that are disappearing, sometimes the last

speaker of such a language. The room is a black void, the screen is black with just the name of the language being spoken and subtitles translating the speaker, who you don't see. This makes the sound, the voice, very present.

SH In this work I've paid a lot of attention to what you might call composition or choreography. Obviously if you're dealing with speech, you're dealing with people. Speech is very intimate, you see, because it touches your ear, there's a physicality in the voice, it is part of the body of the person. It doesn't represent the body, it evokes the body of the person. So I was very careful with the editing to make the subtitles go with the rhythm of the speaking. I think that's a very important aspect of this work, the way the speech rhythm controls the visual rhythm. I included quite a few examples of people speaking about their own language, and that's not easy to find. I like the fact that many of the speakers are children or older people. One section I like a lot is from Russian Siberia, an old woman telling the story about two wives, and a man listening is going 'Mm? Mm?' And then he laughs at the end and says, 'Well I've never heard that one!' You know, normally, when you listen to samples that are archived, you don't get that flavour really, a sense of people sitting around, you know, and telling jokes. In this piece I mixed in a lot of European languages, because I didn't want the piece to be 'ethnographic'. So there are languages like Livonian, which was once one of the major languages of Lithuania, but there're only about eight people who still speak it.

GB You somehow lift people out of the archive and render them as speaking subjects rather than specimens of a disappearing language. What they have to say is intensely contemporary in different ways.

SH The film starts with a man speaking a click language from Africa. This is from a wax cylinder that was found recently abandoned in a cupboard in an anthropology department. That was another point about this work – we collect, our culture collects these things. The people get killed, or die, but we collect the voices and we put them in a cupboard somewhere, and nobody ever listens to them except the person who's doing research on that language, you know? So these wax cylinders with this click language were found recently, and this man is actually talking about his language in a very eloquent way. And he addresses the audience, he calls us, 'You, the sons of the sea, you who come from across the sea.' The reason it's structured like a formal speech is because he was the last speaker of his language, and in the 1930s, he was asked to make a recording for a conference of linguists in Europe. And so he took this occasion to make a ceremonial speech to them. And he says things like, 'You've never seen me, you don't know that we're a civilised nation, we have a beautiful language.' He gives a marvellous, compassionate condemnation of colonial attitudes towards native languages and people.

GB There is something very challenging, I think, that you carry over from your anthropology days. I mean your persistent concern with efficacy. That the work must work. There is perhaps a parallel between the way in which the potency of an image or an object is preserved in many societies by ritual obligations – for example that the object (work) may not be talked about, or that it is only made visible at certain moments – and our own efforts to maintain the energy of artistic works or insights while the conditions of our 'art world' are busy commodifying, instrumentalising, explaining, over-simplifying, them. The notion of efficacy somehow returns us to the collection of medicine bottles you showed us at the beginning for your work-in-progress homage to Joseph Beuys.

SH No anthropologist would ever work like this. *The Last Silent Movie* is an impure mixture of different speech artefacts, jokes, songs, vocabulary lists from different places recorded at different times. In this work, while trespassing on their terrain, there's nothing didactic or explanatory and my audience isn't limited to specialists. I'm providing an experience that may or may not produce some insights.

YAB But you do say somewhere that people listening and seeing this video do know that the language is disappearing.

SH People already know there are extinct and endangered languages, people are always talking about how concerned they are about language loss. But that's abstract and distant, not the real voices of real people, ghosts in your ear.

Key Works, 1970–2010

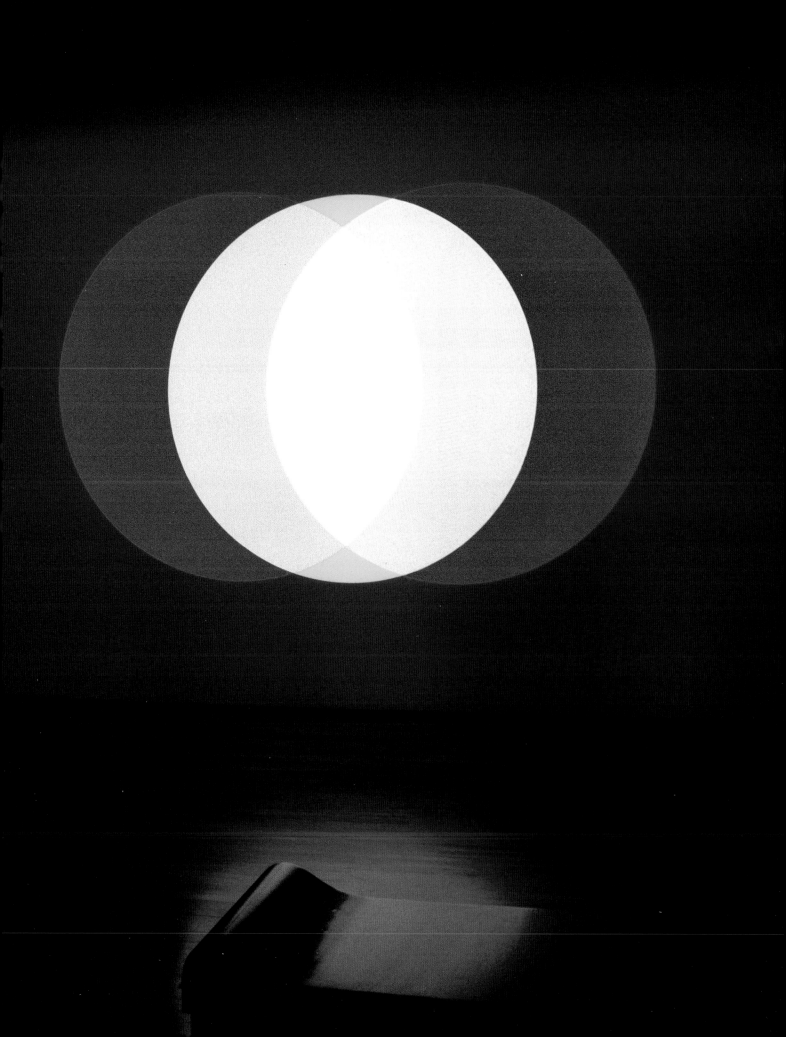

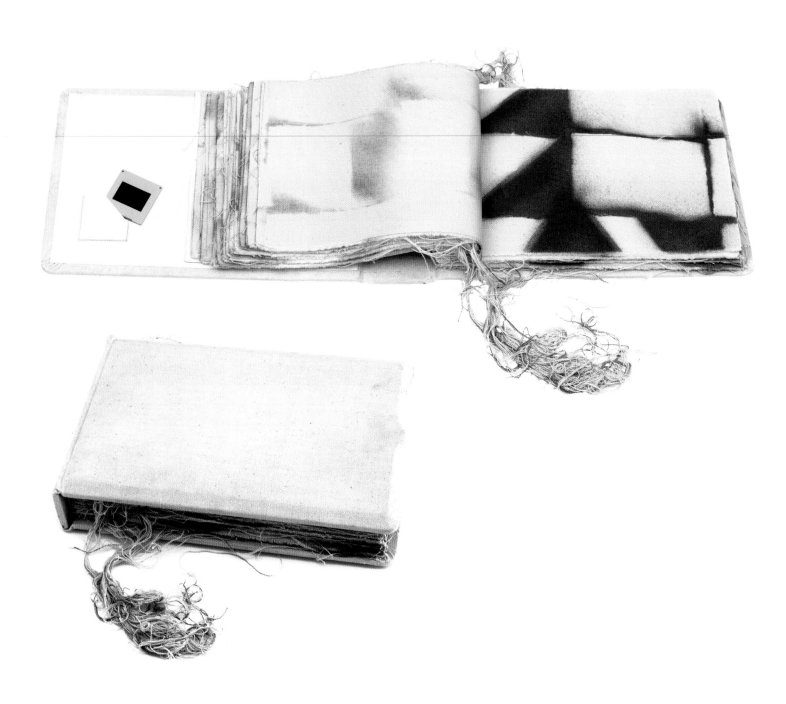

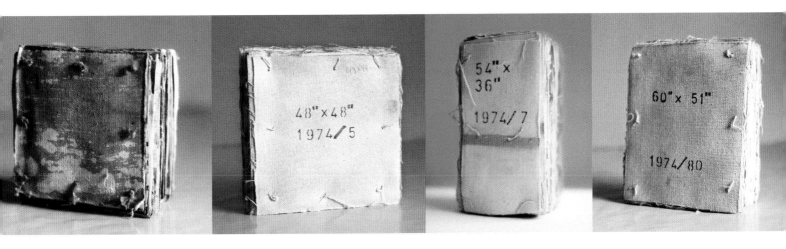

Painting Blocks
1970–84
Oil on canvas, cut
and bound with
thread into blocks

ABOVE,
FROM LEFT
Painting Block 1970
10.5 × 10.5 × 6

48" × 48" 1974/5
15.9 × 15.9 × 4.2

54" × 36" 1974/7
15.9 × 8.9 × 8.9

60" × 51" 1974/80
17.2 × 13.3 × 6.4

BELOW,
FROM LEFT
42" × 60" 1974/81
11.5 × 16.5 × 7.3

60" × 48" 1974/82
17.2 × 11.5 × 8.5

48" × 48" 1974/83
11.5 × 11.5 × 8.5

36" × 54" 1974/84
7.6 × 16.5 × 8.3

In a series of works called *Painting Blocks* begun in 1970/1 and completed in 1984, Susan Hiller cut up her own earlier paintings and remade them as ten sewn blocks. While Hiller's work is conceptual in its use of series and a Minimalist aesthetic, it has a strong material presence. It returns painting to one of its basic premises as a 'nomad art' made of portable sewn cloth or paper. Neither painting nor sculpture in any conventional sense, the rough and frayed bundles retain certain characteristics of paint on canvas, but appear to be more like three dimensional stitched 'books', with the dimensions of the original painting and dates printed on their covers. While the transformation from painting to block implies a diminution of scale, in this process, the surface becomes a mass, which retains the dimensions of the original … Hiller returns painting to something nearer its performative functions in pre-Renaissance and indigenous cultures, where it acts as a part of ritual, as a talisman or as a manual, conceived as being impermanent yet as having presence and material effects in the world.
(Rosemary Betterton, 2004)

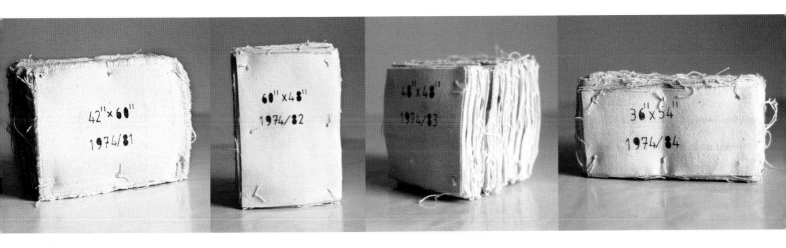

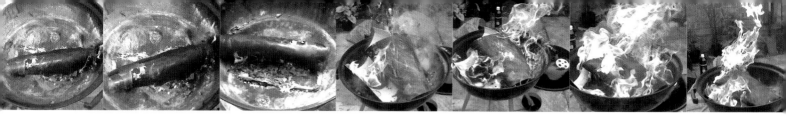

I burn a painting every year and fill a burette with its ashes. I began this project in 1972 and continue it annually as a private ritual.

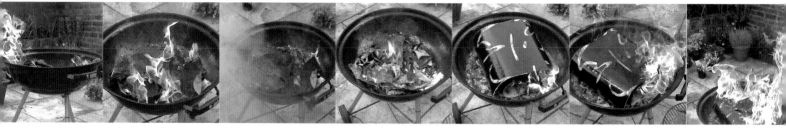

Measure by Measure (1973—1992) contains the ashes of 20 of my paintings. This idea of measuring is related to my interest in assessing the

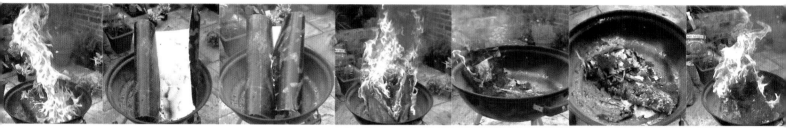

relative importance of the material and immaterial properties of things. **Measure by Measure** is one of a number of my works that originate as

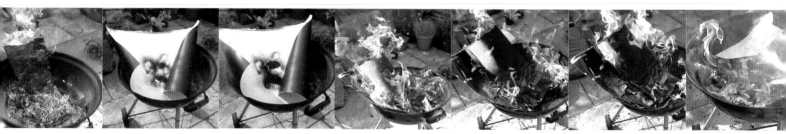

previously-exhibited paintings which I burn to ashes and reconfigure in quasi-scientific formats. Rather than announcing the death of painting

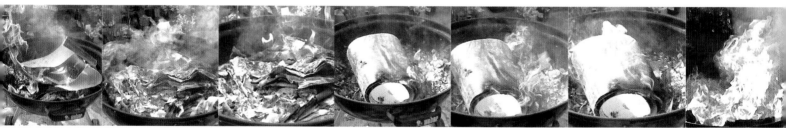

these works *'return painting to something nearer its performative functions in pre-Renaissance and indigenous cultures, where it acts as*

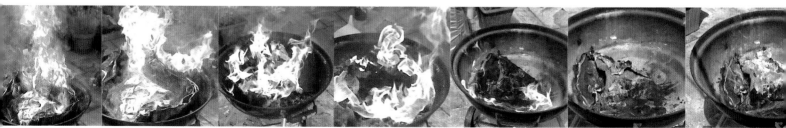

a part of ritual, as a talisman or as a manual, conceived as being impermanent yet as having presence and material effects in the world.'

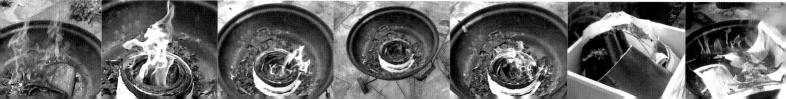

RELICS, 1972 – ongoing

By burning a number of paintings and then retaining their ashes in a slightly scientistic archive, Hiller can be said to be clearing a cultural ground. Other artists have made a big deal about destroying their work. But ... Hiller's act is one of transubstantiation through immolation. This suggests that her orientation towards conceptual art is deeply consistent with her prior critique of anthropology. In both cases we are confronted with a 'remainder' and left searching for the meaning of a cultural practice which comes to us only in an utterly fragmented material form or as a transient moment in our life-world. The customized burettes of *Measure by Measure* contain the ashes of selected paintings that span two decades. I find them mildly heroic, rather than morbid. They do not represent an end-point, but merely a continuation of a 'ritual' Hiller established with her *Hand Grenades* 1969–72 [and other works]. ' Identity is a collaboration,' Hiller has remarked; and 'the self is multiple'. These remarks are generally understood to be self-referential statements. In fact, they are more; they disclose the method Hiller uses to create *Measure by Measure*. (Michael Corris, 1994)

BELOW
Hand Grenades 1972
(from paintings made in 1969)
Ashes of paintings in
12 glass jars, rubber stoppers,
labels, pyrex bowl
11 × 18 × 18

OPPOSITE
Poster made for Centre Pompidou, Paris, showing the burning of Hiller's paintings, including a statement by the artist quoting Rosemary Betterton.

41

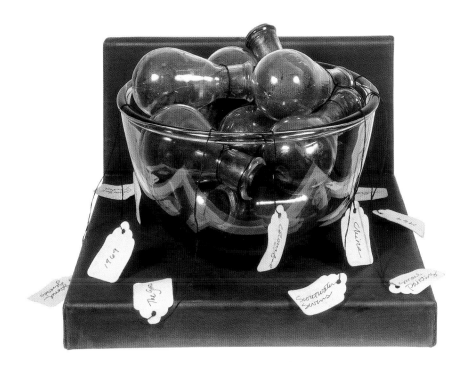

LEFT
Collected Works 1972
(from paintings made 1968–72)
Ashes of paintings in glass test
tube, rubber stopper, label
height 14.5, diameter 3

BELOW AND RIGHT
Measure by Measure
(part I) 1973–92
Paintings burnt annually
from 1973
Ashes of paintings in
burettes, rubber stoppers,
lead tags, glass jars,
two steel shelves
71 × 258 × 24

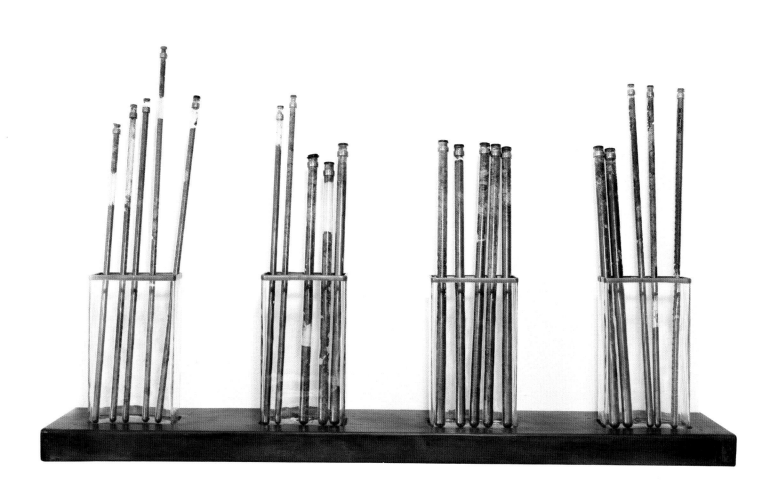

TRANSFORMER/TRANSFORMATION, 1973/4

OPPOSITE AND LEFT
Transformer 1973
approx. 335 × 670
Nylon filament grid,
hand-printed papers
Installation at Gallery House,
London, 1973

Hiller bound segments of her paper installation
Transformer, first shown at Gallery House in 1973,
into the second issue of *Wallpaper* magazine.
Published in December of the following year,
each of the 260 copies included a section titled
Transformation, consisting of a photograph of the
original installation of *Transformer*, a segment of
the actual piece and a hand-drawn map to locate
the segment within the photograph.
(Rebecca Dimling Cochran, 1996)

Pages from *Transformation*
in *Wallpaper*, no. 2, 1974

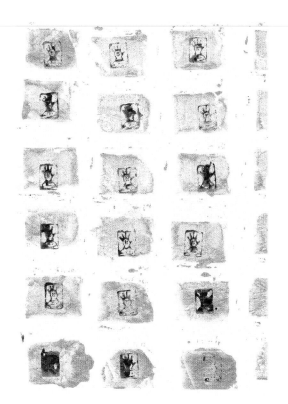

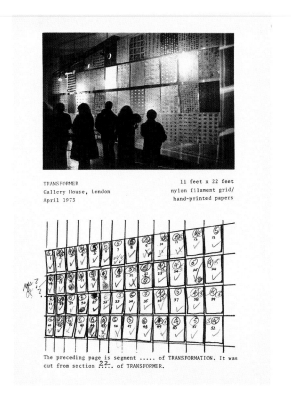

TRANSFORMER
Gallery House, London
April 1973

11 feet x 22 feet
nylon filament grid/
hand-printed papers

The preceding page is segment of TRANSFORMATION. It was
cut from section 22. of TRANSFORMER.

'TRANSFORMATION' is a distribution and relocation of the material elements used
in 'TRANSFORMER'. It consists of 260 A4 tissuepaper segments, five cut from each
of the 52 sections of 'TRANSFORMER'. Bits of nylon filament line are bonded to the
paper in many instances. The 260 segments are bound into the 260 copies of the
second issue of 'Wallpaper'. 'TRANSFORMATION' should be understood to be located
in from one to 260 sites simultaneously. (Susan Hiller, 1974)

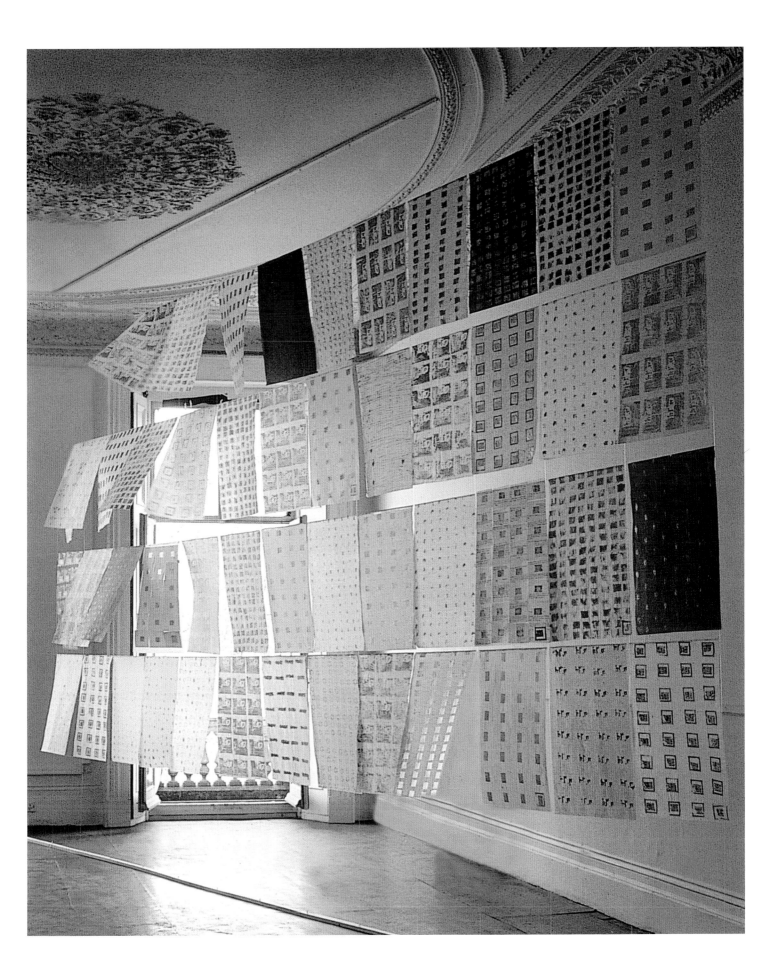

ENQUIRIES/INQUIRIES, 1973–5

Enquiries/Inquiries 1973–5
2 carousels, each with 80 slides
(2 illustrated opposite),
neon sign
Dimensions variable

As information the world can be pictured communally, but only its surface … *Enquiries/Inquiries* scatters details covering everything from a petrified pebble to the names of important persons, arranging, it seems, a place for everything on this earth. But Hiller negates such categorisation by showing simultaneously pairs of [British and American] definitions that make nonsense of each other … Between the work's surface representing the factual world and that surface made visible lies the essential pun. In *Enquiries/Inquiries*, we gain 'insight' into the world by our participation in its re-ordering of sight. The work scrutinises the meaning of the 'presentable' world of facts through the slide projector's mechanical eye. Through the translucent surface of the slides our eyes begin the process of seeing other possible worlds of meaning. We move towards enlightenment, from the mechanical to the preternatural powers of light. (Caryn Faure Walker, 1977)

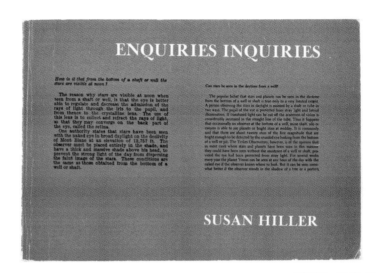

Front cover of
Enquiries/Inquiries, 1979

46

First showing of *Enquiries* at
Gallery House, London, 1973

Can stars be seen in the daytime from a well?

The popular belief that stars and planets can be seen in the daytime from the bottom of a well or shaft is true only to a very limited extent. A person observing the stars in daylight is assisted by a shaft or tube in two ways. The pupil of the eye is protected from stray light and lateral illumination. If transfused light can be cut off the acuteness of vision is considerably increased in the straight line of the tube. Thus it happens that occasionally an observer at the bottom of a well, mine shaft, silo or canyon is able to see planets or bright stars at midday. It is commonly said that there are about twenty stars of the first magnitude that are bright enough to be detected by the unaided eye looking from the bottom of a well or pit. The Yerkes Observatory, however, is of the opinion that in most cases where stars and planets have been seen in this manner they could have been seen without the assistance of a well or shaft, provided the eye had been protected from stray light. For several weeks every year the planet Venus can be seen at any hour of the day with the naked eye if the observer knows where to look. But it can be seen somewhat better if the observer stands in the shadow of a tree or a portico in order to reduce the diffuse light.

How is it that from the bottom of a shaft or well the stars are visible at noon?

The reason why stars are visible at noon when seen from a shaft or well, is that the eye is better able to regulate and decrease the admission of the rays of light through the iris to the pupil, and from thence to the crystalline lens. The use of this lens is to collect and refract the rays of light, so that they may converge on the back part of the eye, called the retina.

One authority states that stars have been seen with the naked eye in broad daylight on the declivity of Mont Blanc at an elevation of 12,757 ft. The observer must be placed entirely in the shade, and have a thick and massive shade above his head, to prevent the strong light of the day from dispersing the faint image of the stars. These conditions are the same as those obtained from the bottom of a well or shaft.

DREAM MAPPING, 1974

Dream Mapping 1974
3-night event, 7 dream notebooks,
3 group dream maps,
additional documentation
Dimensions variable

Dream Mapping 1974 was an extended process incorporating discussion. It culminated in three nights when the seven participants slept out together at a Hampshire farm in a field rich in 'fairy rings', formed by mushrooms. In the ancient tradition of conscious 'incubation' of dreams, Hiller had prepared the ground in selecting this site. Rather than being carried away to fairyland, as legend has it, the dreamers within the fairy rings were carried away into each other's dreams. The dream maps they produced after each night were finally superimposed into a composite that pictured the shared consciousness of an 'organic community'. Like virtually all of Hiller's works, *Dream Mapping* incorporated both intimacy and cosmic scope. By 'dreaming creatively and in an aware sense', the participants functioned 'as artists in a way we can hardly come to terms with'. (Lucy Lippard, 1986)

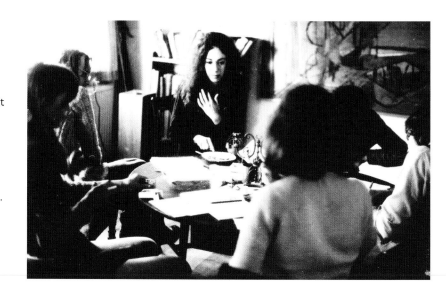

No role is allocated to an 'audience'. The participants are passive and active in both the viewing and participating sense, and what occurs among the group is an enactment or, more appropriately, an enacting of the work ... Susan Hiller's original approach combines various roles, as artist, in giving form to an amalgamation of ideas, as producer, in organising people and finance, as a participant, in the actual work, and documenting the outcome ... [The dream maps] are art(ifacts) showing the process of art through dreaming. They "belong" to the artist only insofar as they provide a record of the group adventure. (John Sharkey, 1976)

ABOVE
Susan Hiller with participants
of *Dream Mapping*

OPPOSITE
Notebooks of participants
in *Dream Mapping* 1974
Pencil, ink, watercolour
23 × 36 (open)

48

Participants sleeping in a field at
Purdies Farm, Hampshire, 1974

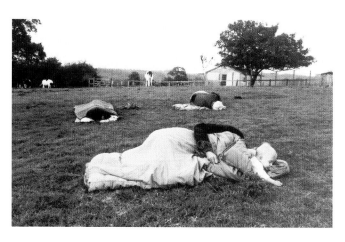

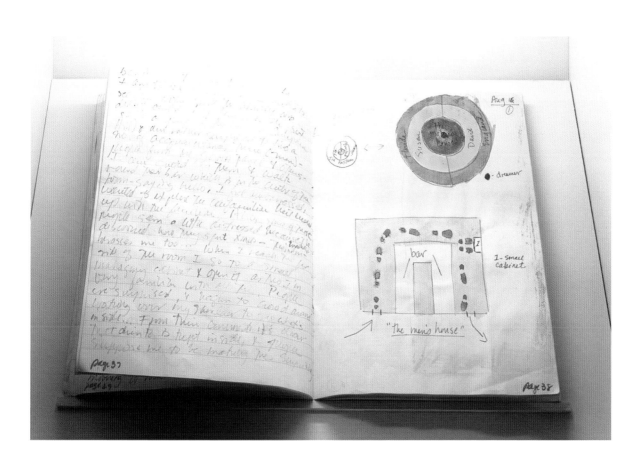

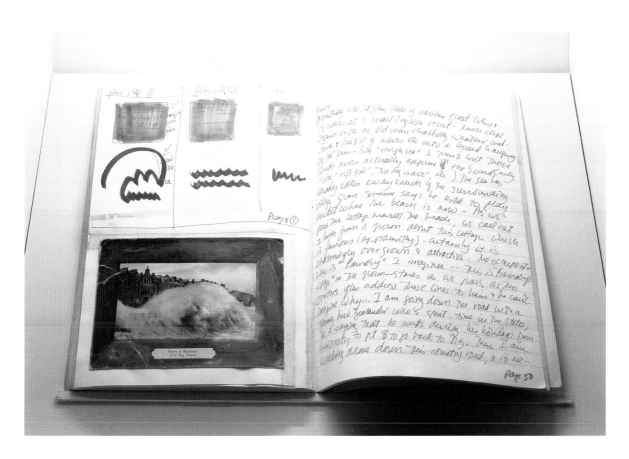

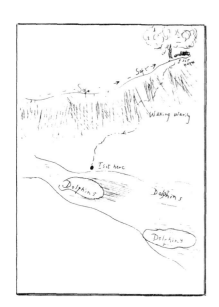

Dreamer 1

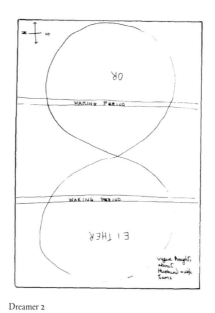

Dreamer 2

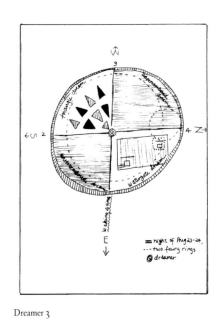

Dreamer 3

Dreamer 4

Dreamer 5

Dreamer 6

Dreamer 7

Individual dream maps (1–7)
and composite group map
(opposite) for the night of 23/24
August 1974

DEDICATED TO
THE UNKNOWN ARTISTS, 1972–6

*Dedicated to the
Unknown Artists* 1972–6
305 postcards, charts and maps
mounted on 14 panels;
book, dossier
Each panel 66 × 104.8

Hiller's sustained situation between emotion and idea has frequently involved the appropriation of artefacts of popular culture, things imbued with frankly sentimental significance, and their insertion into abstract frameworks of interpretation or classification. *Dedicated to the Unknown Artists* 1972–6, for instance, collects over 300 postcards depicting waves crashing onto shores around Britain, each one bearing the legend 'Rough Sea'. The artist subjected them, as she wrote in 1976, to a 'methodical–methodological approach', tabulating such details as location, caption, legend and vertical or horizontal format. For all its obvious corralling of a touching domestic sublime – chaotic white plumes of water erupting across tidy rows of hotels and guest houses, the imagined holidaymaker's sunny frisson at the image of her littoral playground overcome by natural forces – and its rigorous ticking of such visual attributes as colour, border and architectural content, *Dedicated to the Unknown Artists* is in essence a work about invisibility. The set of

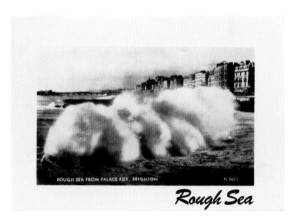

Front cover of *Rough Sea*, 1976

'Rough Sea' postcards only came into existence in the artist's collection: the visual correspondences it points out were previously unseen. That Hiller effected a study of the invisible precisely by exhibiting objects of such ravishing (and also kitsch) visual texture is surely exactly what made the work, at the time, such a scandal for adherents of an austerely linguistic Conceptualism.
(Brian Dillon, 2007)

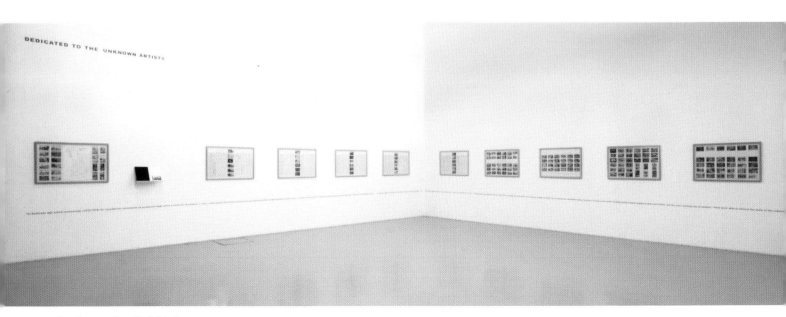

Installation at Castello di Rivoli,
Turin, 2006

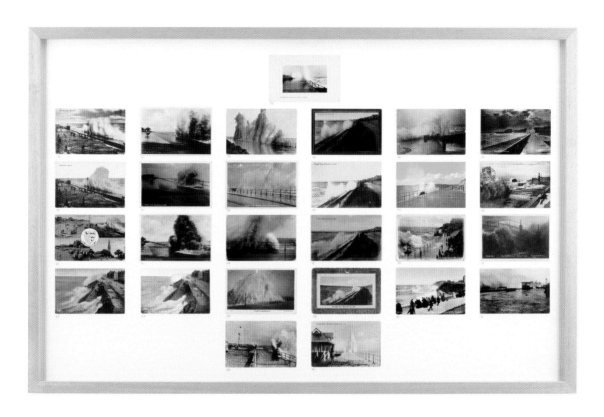

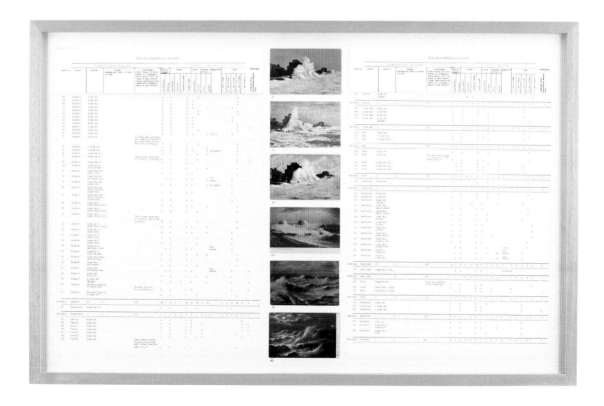

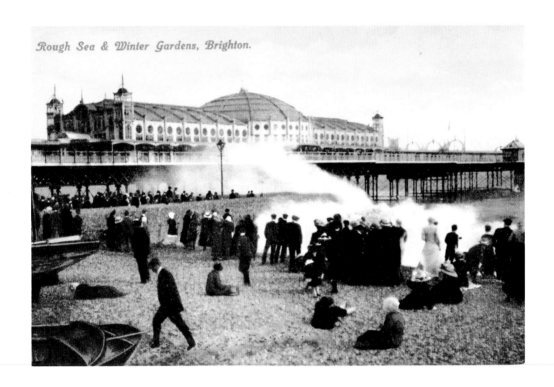

Rough Sea & Winter Gardens, Brighton.

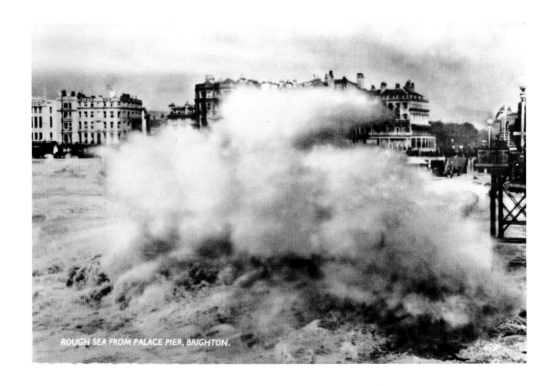

ROUGH SEA FROM PALACE PIER, BRIGHTON.

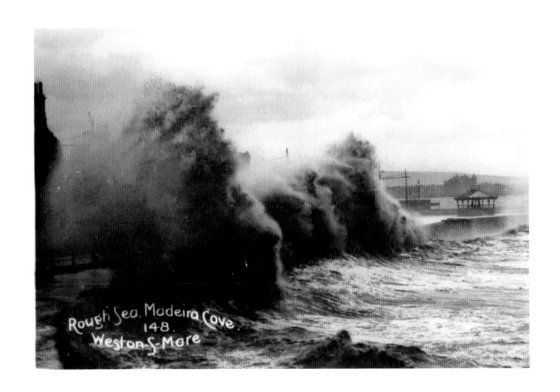

Rough Sea, Madeira Cove.
148.
Weston-S-Mare

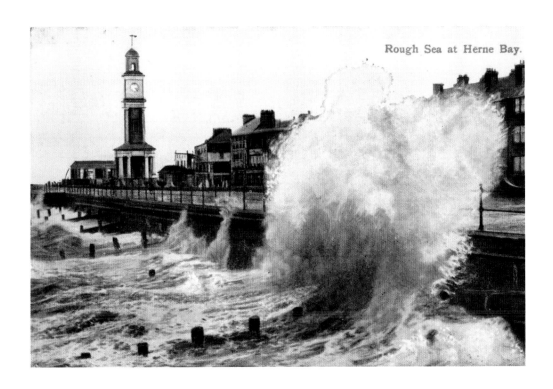

Rough Sea at Herne Bay.

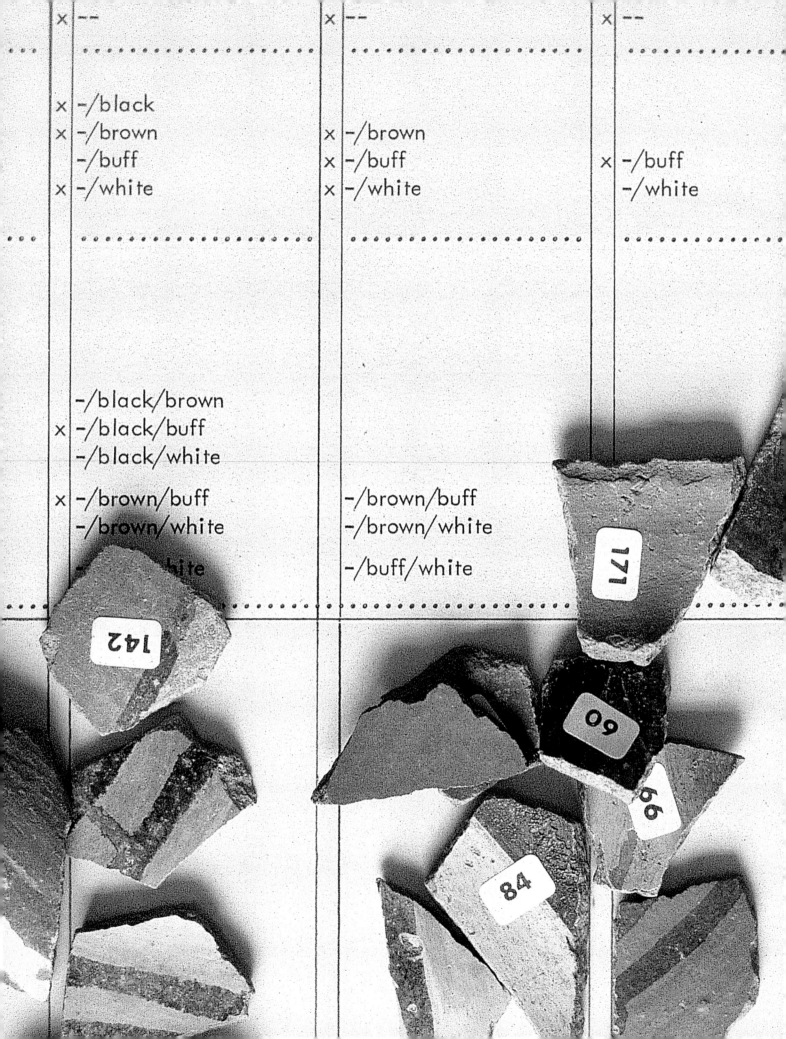

x --
x -/black
x -/brown
-/buff
x -/white

-/black/brown
x -/black/buff
-/black/white

x -/brown/buff
-/brown/white

x --
x -/brown
x -/buff
x -/white

-/brown/buff
-/brown/white
-/buff/white

x --
x -/buff
-/white

FRAGMENTS, 1976–7

Fragments 1976–7
178 gouache drawings, A4;
8 composite gouache drawings,
A3; 210 potsherds; 5 monochrome
charts and diagrams, A4 and A3
(see below); 12 handwritten or
typed texts in polythene bags,
15.2 × 10.1; two monochrome
photographs 15.2 × 20.3

Fragments is closest in spirit to, although considerably more complex than, *Enquiries/ Inquiries*. The fragments of the title refer to broken pieces of painted Pueblo pottery which comprise its primary data. Unlike the 'facts' in *Enquiries/Inquiries* the components of this piece are three-dimensional rather than linguistic; the conventions of time and presentation in which it is framed are archaeological.

An introduction section, called (Art) Tradition and (Dream) Inspiration outlines the parameters within which the Pueblo women work in making and painting designs on their pots, and by implication suggests that the contemporary artist is bound within the same restrictions – those of the inherited tradition of art and the personal 'inspiration' which leads to the making of art. 'So many dreams of fragments, "remnants", broken or old or incomplete pieces … to be reconstructed': the artist's note indicated the weight of history and the fragmented knowledge of the world which we still have. In previous work the primary data had all been machine-made. The irregularity and asymmetry of these hand-made and decorated fragments within the organised structure of the piece on one level suggests a framework for alternative value-systems and perceptions.
(David Elliott, 1978)

Detail of the installation at
Hayward Gallery, London, 1978

10 MONTHS, 1977–9

10 Months 1977–9
Ten black and white composite
photographs and ten captions
Installed size 203 × 518
Installation at Moderna Museet,
Stockholm, 2009

10 Months consists of photographs taken by the artist of her body during pregnancy, arranged in ten 'lunar' months of 28 days, and accompanying texts from her journal entries for the same period. The sentimentality associated with images of pregnancy is set tartly on edge by the scrutiny of the woman/artist who is acted upon, but who also acts; who enjoys a precarious status as both the subject and the object of her work. ('She is the content of a mania she can observe'). The belly swells and rises like a harvest moon – but the echoes of landscape, the allusions to ripeness and fulfilment, are refused by the anxieties of the text, and by the methodical process of representation. The conflict between a need to speak, and the difficulty of speaking, is exacerbated at this moment when the self is 'engrossed' and identity peculiarly uncertain. ('She now understands that it is perfectly possible to forget who one has been and what one has accomplished.')
(Lisa Tickner, 1980)

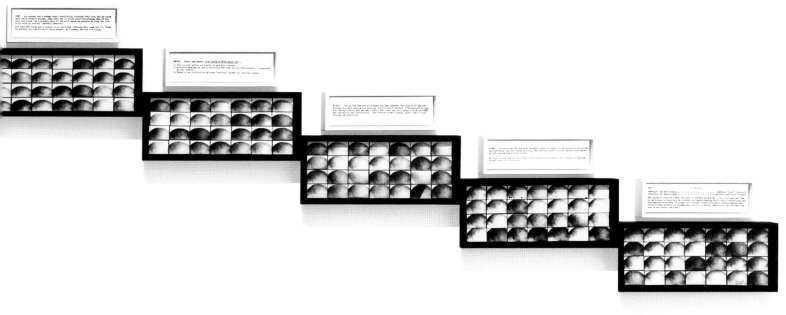

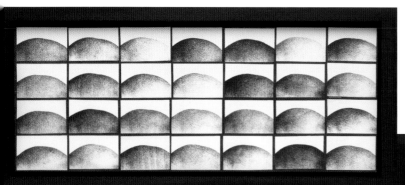

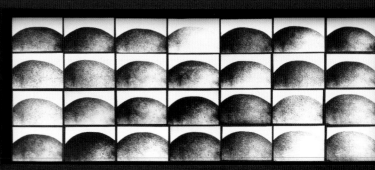

FIVE/ She now understands that it is perfectly possible to forget who one has been and what one has accomplished.
Continuing the piece requires great effort. It is her voice, her body. It is painful being inside and outside simultaneously.

SIX/ She speaks (as a woman) about everything, although they wish her to speak only about women's things. They like her to speak about everything only if she does not speak "as a woman", only if she will agree in advance to play the artist's role as neutral (neuter) observer.
She does not speak (as a woman) about anything, although they want her to. There is nothing she can speak of "as a woman". As a woman, she can not speak.

Installation at Hayward Gallery,
London, 1980

SEVEN/ Knots and knows, <u>Some NOT's & NO's about art</u>- -

1. The subject matter of a work is not its content.
2. A work's meaning is not necessarily the same as the 'intention' or 'purpose' of the artist.
3. There is no distinction between 'reading' images and reading texts.

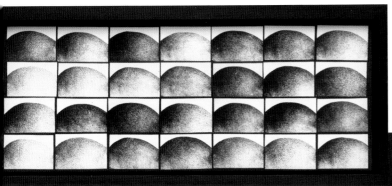

EIGHT/ She is the content of a mania she can observe. The object of the exercise, she must remain its subject, chaotic and tormented. ("Tormented" is <u>not</u> too strong a word, she decides later.) She knows she will never finish in time. And meanwhile, the photographs, like someone else's glance, gain significance through perseverance.

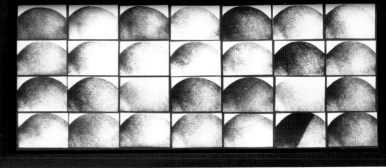

AUTOMATIC WRITING, 1979–81

Sisters of Menon 1972/9
4 L-shaped panels (1972):
blue pencil on A4 paper with
typed labels, each 91.2 × 64.2
(detail right)
4 panels (1979): typescript
and gouache on paper,
each 31.8 × 23 (details overleaf)

In 1972 Susan Hiller's attempts at automatic writing resulted in texts apparently dictated by some external force. Plural, female, and rhapsodic, the 'writers' called themselves 'Sisters of Menon'. In a script that was not her own, they beseeched Hiller to join their company. Their voices, which Hiller described as insistent, repetitive, personal and punning, set up a paradoxical relationship between asserted existence and apparent insubstantiality ('I live my sister') ... [and] constantly switched from 'I' to 'we' to 'everyone'. As an artist, Hiller's chosen task has often been to examine images or writing as evidence ... In time the Menon texts have been treated in a similar way, providing Hiller with a focus for the investigation not only of such recurring themes as art and death, but also of the nature of signs and the limits of individuality. (Stuart Morgan, 1984)

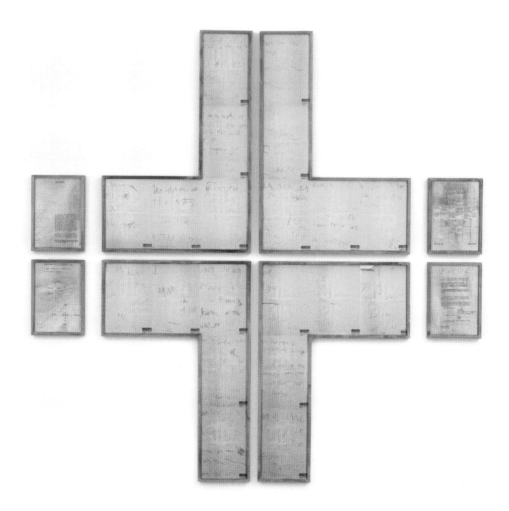

I AM THE SISTERS OF

MENON

automatic writing
5.5.72

The text of this piece was produced
by the technique of automatic writing at
Loupien, near Sete, France, in May 1972.
At that time I was working on a project
called DRAW TOGETHER, a group exploration
into 'the origin of images & ideas'. One
evening after completing my part of the
work, I picked up a pencil and began to
make random marks on a blank sheet of draw-
ing paper. At first the marks formed what
looked like childish drawings I could not
decipher. Then, coherent words began to a-
ppear. The pencil seemed to have a mind of
its own and wrote page after page of text
in an unfamiliar style. For a while it seem-
ed an engrossing and somewhat eerie exper-
ience to step aside so completely.

I was aware at that time that some
mediums used automatic 'writing', and that
the technique had produced material used by
Jung, Swedenborg, Yeats, and the Surrealists,
but I had never experimented with it myself.

. .

MESSAGES SUPPRESSED BY THE SELF DO NOT CEASE
TO EXIST. MESSAGES SUPPRESSED BY THE CULTURE
DO NOT CEASE TO EXIST.

who is this
one/I am this
one/Menon is

(1)

Menon is
this one/you
are this one/

(2)

I am the sis-
ter of Menon/I
am your sister/the
sister of — of ev-
eryone's sister/I
am Menon's sister

(3)

— I live in
the water/I
live on the
air/

(4)

I am — the
sister/love
e my sister/

(5)

the woman is
the sister/a
man is the
mother of
the sister/

(6)

eye eye eye
eye I live my
sister/

(7)

— — — — — —
— — — — — —
VLant-NO zero
is the silly
morse/is the
sister of
sister of

(8)

Menon/ we
three sisters
are your sis-
ter/this is
the nothing
that we are/

(9)

the riddle
is the sister
of the zero/
we are the
mother

(10)

of men/we are
the sister of
men/o the
sisters

(11)

I want the
water/I

(12)

want the air/
I want the
sister of Men-
on to become
as the water/

(13)

will you be-
come my sis-
ter/

(14)

I am the
sister of
everyone/I
am your sis-
ter/we 3
sisters are

(15)

1 sister/
you are
the sis-
ter/last
night we

(16)

were 3 sisters
now we are 4 sisters/
you are the sister
of Menon/we are 3
sisters/we live on
the air in the water/

(17)

we are the
sisters of
everyone is
sister/I am
sister/love
the sisters/

(18)

Menon/
the
the
oh

love love love
to the sisters
of everyone/
who is the sis-
ter/come to
the come to the
e

(19)

— — — — —
we are your
sisters
from Thebes
Thebes/

(20)

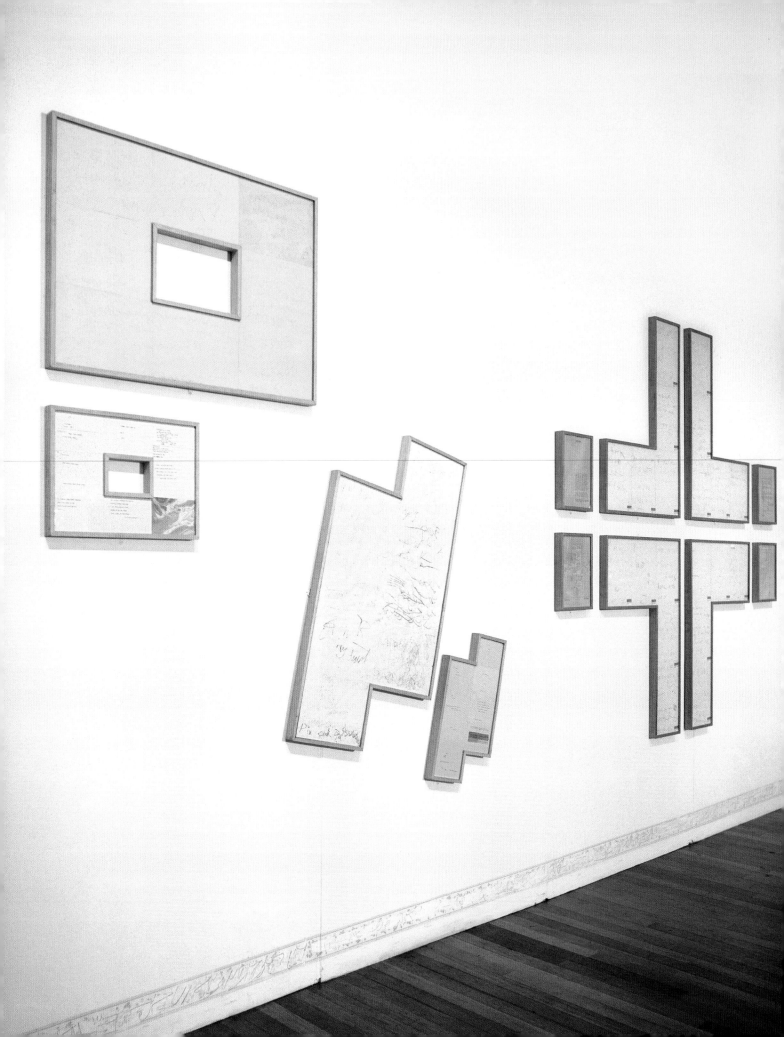

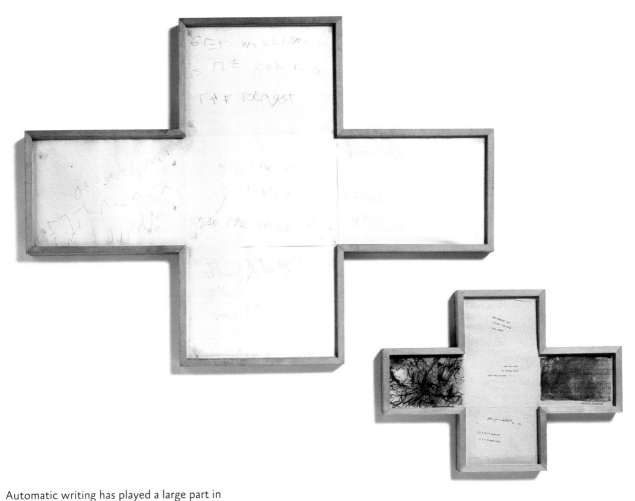

Automatic writing has played a large part in Hiller's work … Its status is as a symbolic absent presence … For Hiller the Surrealists' defence of the irrational as significant becomes subject to feminist appropriation … It is not so much that automatic writing might free us all from the tyranny of our rational waking life, but that its unintelligibility and as such its marginality in our culture, is a potent symbol of female speech. Hiller is not inviting us to read her scripts as intelligible. They are not decipherable. On the contrary they are paradoxes. Their marginality is the mark of their metaphoric power.

To see the world as writing, as script, as the Surrealists did, is therefore to see it projectively. Hiller's use of the fragmented image engages in similar disruptive strategies. Thus just as the Surrealists believed that this projective content lay in dreams, Hiller uses unconscious material in her art as a mean of dissolving the unity of the self into the social. (John Roberts, 1984)

OPPOSITE
Installation of automatic writing works, including *Mary Essene* 1975/81, *My Dearest* 1975/81 and *Sisters of Menon* 1972/9 All pencil on paper with coloured perspex; typewriter, photocopy and gouache (for dimensions see p.182) Institute of Contemporary Arts, London 1986

ABOVE
Get William 1975/81, First panel: pencil on paper under pink perspex 65.3 × 91.2 (1975) Second panel: photocopy and watercolour on pink paper 34.4 × 47 (1975)

WORK IN PROGRESS, 1980

Work in Progress 1980 is a narrative about the nature of creative utterances. The work in question took place over a two-week period. During the first week, the artist was continuously present in Matt's Gallery evolving the project and discussing its progress with visitors. One aim was to use the existing dual function of the space as studio and gallery – a place of play and invention as well as a place of display … The artist had begun by moving into the space her work table and several paintings that had been exhibited earlier. She then proceeded to unravel the weave of one canvas, thread by thread. At the end of each day, the pulled strands were hung in skeins on the wall. At the end of the first week, each skein was hand-worked, by knotting, looping or braiding, into individual three-dimensional 'thread drawings' or 'doodles', while the remaining canvases were cut into small rectangles, baled into little bundles and given a date stamp. The 'doodles' were pinned to the walls and the bundles displayed on small shelves and exhibited during the second week. These vivacious figures were therefore not predetermined; they arose from the artist's 'feeling for the materials' and her response to the energy of the space, and represented 'the internal processes which [were] invisible during the monotonous craft-like pulling of the thread'. (Jean Fisher, 1990)

ABOVE
Work in Progress, Tuesday 1980
Thread from
deconstructed painting
Dimensions variable

RIGHT
Susan Hiller at Matt's Gallery,
London, 1980

Monument 1980–1
41 photographs, each approx.
50 × 100, overall 457.2 × 685.8;
park bench with audio
component, 14 min 23 sec

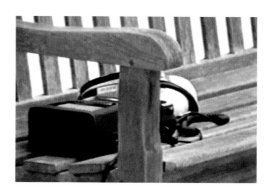

A darkened gallery. At the far end a few dimmed lights play across a diamond shape formation of colour photographs 15 foot by 22. Each of the photographs is of a late Victorian memorial plaque: a name, a date of death, an act of heroism. ELIZABETH BOXALL aged 17 of Bethnal Green who Died of injuries received in trying to save A CHILD from a runaway horse. June 20, 1888. G GARNISH A young clergyman who lost his life in endeavouring to rescue a stranger from drowning at Putney. January 7, 1885. DAVID SELVES aged 12 of WOOLWICH supported his drowning playfellow and sank with him clasped in his arms. September 12, 1885. A memorial is an annotation of remembering, a monument is a device to generalise out those acts of remembering, to bring back into the smoothening operations of ideology a highly particularised emotion. It is this paradox of memorial and monument that, in part, Susan Hiller's installation dwells on: upon the inter-changeability of subjective and objective modes of speech. In front of the photographs is a park bench, its back to the photos, upon it a cassette recorder with headphones attached. It is a dare to put on the headphones, to sit upon the bench, to – in effect – become part of the installation, to, in self-consciousness, become part of the monument, to be looked upon as such by the passers-by. It is a strange rambling, poetic mono-logue that one hears, troubling over the nature of death, over the nature of representation, over death as representation. (Tony Godfrey, 1981)

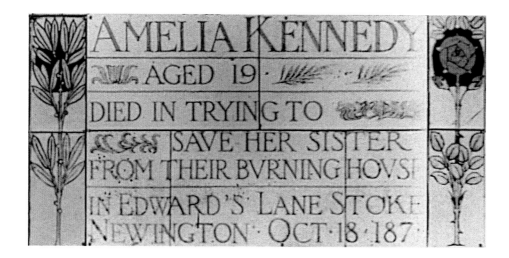

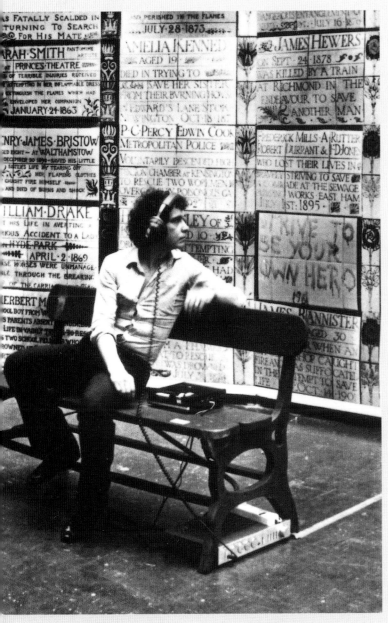

Installation at Ikon Gallery,
Birmingham, 1981

You are sitting as I've imagined you with your back to the Monument. The Monument is behind you. The Monument is in your past. Do the dead speak through us? This is my voice, unrolling in your present, my past. I'm speaking to you from my here-after, the hear-after. I'm an audible raudive voice. We could exist forever, inscribed, portrayed as inscriptions, portraits, representations. I'm representing myself to myself . . . and for you to you. This is my voice. Now it will speak to you about the ideology of memory, the history of time, the fixing of representation: fixed, like a photograph, taped, registered, or inscribed . . . You can think of life after death as a second life which you enter into as a portrait or inscription and in which you remain longer than you do in your actual living life . . . Her voice is unwinding past your ear; a line, a text, an inscription, like those on the wall behind you. An inscription, a registration, a trace . . . 'Monument' represents absences. These are representations of those who have gone, 'passed away'. Absence is a metaphor of desire. Representation is a distancing in time and space. It's a 'regeneration' of image and ideas. Time can't exist without memory. Memory can't exist without representation.

"a boy's life / & died of burns & shock / drowned in attempting to save / in spite of terrible injuries received / clasped in his arms / returning to search / the result of a recent accident / self-sacrificed by giving up her / died of injuries received attempting / to save a neighbour's children . . ."

From the soundtrack of *Monument* 1980–1

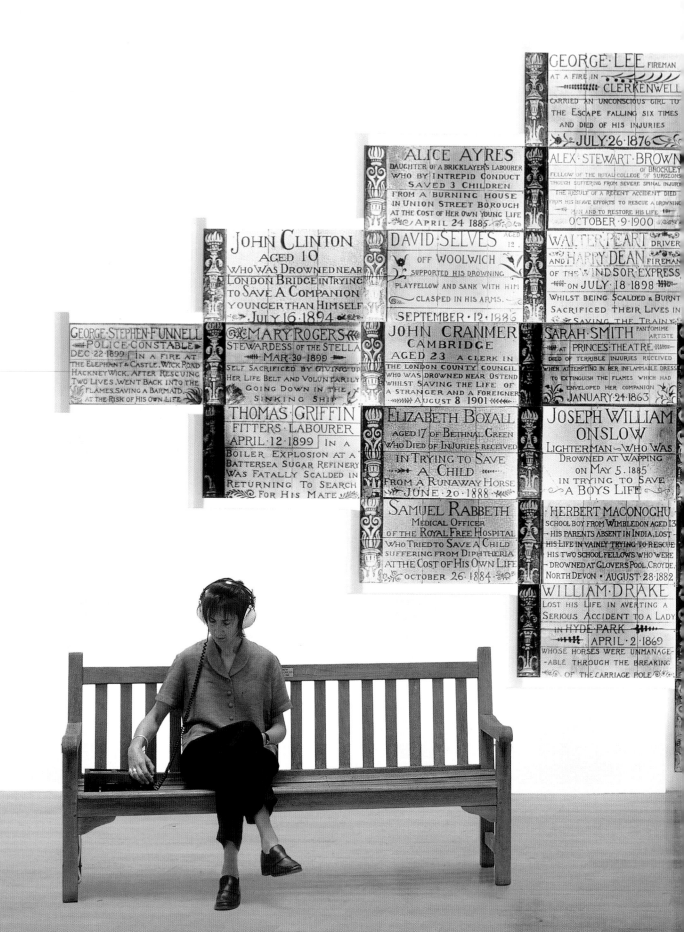

Monument 1980–1
Installation at Tate Britain,
London, 1997

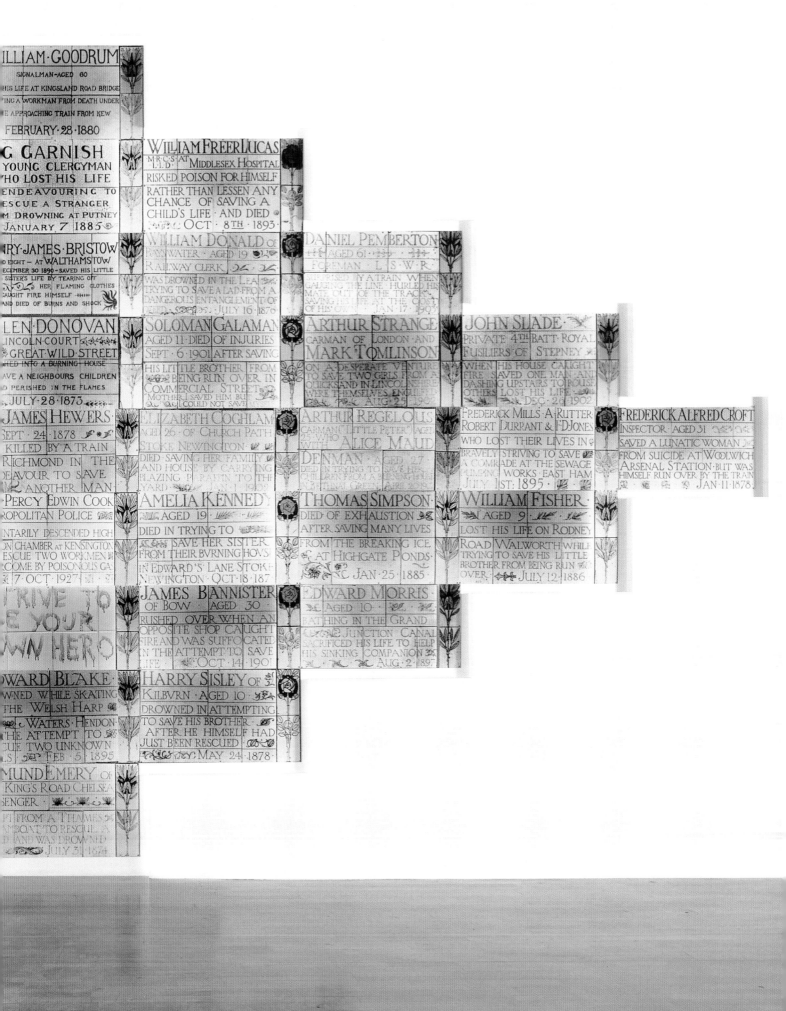

WILLIAM·GOODRUM
SIGNALMAN·AGED 60
HIS LIFE AT KINGSLAND ROAD BRIDGE
SAVING A WORKMAN FROM DEATH UNDER
THE APPROACHING TRAIN FROM KEW
FEBRUARY·28·1880

G GARNISH
A YOUNG CLERGYMAN
WHO LOST HIS LIFE
ENDEAVOURING TO
RESCUE A STRANGER
FROM DROWNING AT PUTNEY
JANUARY 7 1885

HENRY·JAMES·BRISTOW
AGED EIGHT · AT WALTHAMSTOW
DECEMBER 30 1890 · SAVED HIS LITTLE
SISTER'S LIFE BY TEARING OFF
HER FLAMING CLOTHES
BUT CAUGHT FIRE HIMSELF
AND DIED OF BURNS AND SHOCK

HELEN·DONOVAN
LINCOLN COURT
GREAT WILD STREET
RUSHED INTO A BURNING HOUSE
TO SAVE A NEIGHBOURS CHILDREN
AND PERISHED IN THE FLAMES
JULY·28·1873

JAMES·HEWERS
SEPT·24·1878
KILLED BY A TRAIN
AT RICHMOND IN THE
ENDEAVOUR TO SAVE
ANOTHER MAN

PERCY EDWIN COOK
METROPOLITAN POLICE
VOLUNTARILY DESCENDED HIGH
TENSION CHAMBER AT KENSINGTON
TO RESCUE TWO WORKMEN
OVERCOME BY POISONOUS GAS
7 OCT·1927

STRIVE TO
BE YOUR
OWN HERO

EDWARD BLAKE
DROWNED WHILE SKATING
ON THE WELSH HARP
WATERS·HENDON
IN THE ATTEMPT TO
RESCUE TWO UNKNOWN
BOYS·FEB 5·1895

EDMUND EMERY OF
KING'S ROAD CHELSEA
PASSENGER
LEPT FROM A THAMES
STEAMBOAT TO RESCUE A
CHILD AND WAS DROWNED
JULY 31·1874

WILLIAM FREER LUCAS
M·R·C·S AT MIDDLESEX HOSPITAL
L·L·D
RISKED POISON FOR HIMSELF
RATHER THAN LESSEN ANY
CHANCE OF SAVING A
CHILD'S LIFE · AND DIED
OCT·8TH·1893

WILLIAM DONALD OF
BAYSWATER · AGED 19
RAILWAY CLERK
WAS DROWNED IN THE LEA
TRYING TO SAVE A LAD FROM A
DANGEROUS ENTANGLEMENT OF
WEED JULY 16·1876

SOLOMAN·GALAMAN
AGED 11·DIED OF INJURIES
SEPT·6·1901 AFTER SAVING
HIS LITTLE BROTHER FROM
BEING RUN OVER IN
COMMERCIAL STREET
MOTHER I SAVED HIM BUT
I COULD NOT SAVE MYSELF

ELIZABETH COGHLAM
AGED 26·OF CHURCH PATH
STOKE NEWINGTON
DIED SAVING HER FAMILY
AND HOUSE BY CARRYING
BLAZING PARAFFIN TO THE
YARD

AMELIA KENNEDY
AGED 19
DIED IN TRYING TO
SAVE HER SISTER
FROM THEIR BURNING HOUSE
IN EDWARD'S LANE STOKE
NEWINGTON·OCT 18·187

JAMES BANNISTER
OF BOW·AGED 30
CRUSHED OVER WHEN AN
OPPOSITE SHOP CAUGHT
FIRE AND WAS SUFFOCATED
IN THE ATTEMPT TO SAVE
LIFE·OCT·14·1901

HARRY SISLEY OF
KILBURN·AGED 10
DROWNED IN ATTEMPTING
TO SAVE HIS BROTHER
AFTER HE HIMSELF HAD
JUST BEEN RESCUED
MAY 24·1878

DANIEL PEMBERTON
AGED 61
FOREMAN L·S·W·R
SURPRISED BY A TRAIN WHEN
GAUGING THE LINE · HURLED HIS
MATE OUT OF THE TRACK
SAVING HIS LIFE AT THE COST
OF HIS OWN · JAN 17·1903

ARTHUR STRANGE
CARMAN OF LONDON AND
MARK TOMLINSON
ON A DESPERATE VENTURE
TO SAVE TWO GIRLS FROM A
QUICKSAND IN LINCOLNSHIRE
WERE THEMSELVES ENGULFED
AUG 25·1902

ARTHUR REGELOUS
CARMAN ("LITTLE PETER") AGED
25 WHO WITH ALICE MAUD
DENMAN · AGED 27
DIED IN TRYING TO SAVE HER
CHILDREN FROM A BURNING HOUSE

THOMAS SIMPSON
DIED OF EXHAUSTION
AFTER SAVING MANY LIVES
FROM THE BREAKING ICE
AT HIGHGATE PONDS
JAN·25·1885

EDWARD MORRIS
AGED 10
BATHING IN THE GRAND
JUNCTION CANAL
SACRIFICED HIS LIFE TO HELP
HIS SINKING COMPANION
AUG·2·1897

JOHN·SLADE
PRIVATE 4TH BATT·ROYAL
FUSILIERS OF STEPNEY
WHEN HIS HOUSE CAUGHT
FIRE SAVED ONE MAN AND
DASHING UPSTAIRS TO ROUSE
OTHERS LOST HIS LIFE
DEC·26·1902

FREDERICK MILLS A·RUTTER
ROBERT DURRANT & F·D·JONES
WHO LOST THEIR LIVES IN
BRAVELY STRIVING TO SAVE
A COMRADE AT THE SEWAGE
PUMPING WORKS EAST HAM
JULY 1ST·1895

WILLIAM FISHER
AGED 9
LOST HIS LIFE ON RODNEY
ROAD WALWORTH WHILE
TRYING TO SAVE HIS LITTLE
BROTHER FROM BEING RUN
OVER·JULY 12·1886

FREDERICK ALFRED CROFT
INSPECTOR·AGED 31
SAVED A LUNATIC WOMAN
FROM SUICIDE AT WOOLWICH
ARSENAL STATION·BUT WAS
HIMSELF RUN OVER BY THE TRAIN
JAN 11·1878

Susan Hiller tackles the question of how to give substance to a feminine subject, without assuming the centrality and identity of a subject, simply designated female instead of male ... The artist has developed a self-image as process and activity: which becomes *Sometimes I Think I'm a Verb Instead of a Pronoun*. Her work in the Photomat series demonstrates the expressive peculiarities of machines and disrupts conventions of representation, even to the recreation of photomats on a 'human scale'... In the Photomat Portraits from 1982, Susan Hiller resists [personification] by closing her eyes, by defacing her identity and finally in *Sometimes I Think I'm a Verb Instead of a Pronoun* by painting out and writing in the identity of the artist. (Annette van den Bosch, 1984)

In its format ... *Midnight Baker Street* recalls the portrait of Cardinal Richelieu which Van Dyck painted to enable Bernini to sculpt a bust in the absence of the sitter. Yet unlike the Baroque portrait, which sought to provide all the essential information, Hiller's work (three pictures taken in photo booths, hand-painted and enlarged) refuses to render up the sitter. She is distanced psychologically by the fact that her eyes are shut, but more importantly, by the imposition of the script which covers her face, suggesting the way in which verbal discourse structures all experience, and especially the manner in which it intervenes to condition perception. But since it is not legible this wild calligraphy might in fact be a form of grafitti, a cancelling out of the image, a presenting of the self in terms of an act rather than an image (her appearance). Equally, it is reminiscent of tattooing, and thus becomes a type of embellishment ... Contradictions, alternatives and ambiguities cannot be regarded as negative aspects of experience but as inevitable, even enriching ones. Just as the self is not a simple unitary construct, but a collective, collaborative, multiple entity, Hiller's work incorporates what are sometimes referred to as 'alternative' forms of representation and communication, without itself becoming marginalised. (Lynne Cooke, 1985)

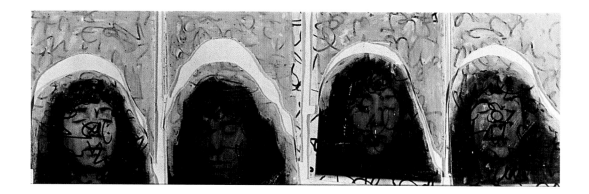

Midnight, Tottenham Court Road
1982
C-type prints
enlarged from handworked
photobooth images
overall 24.5 × 76.2

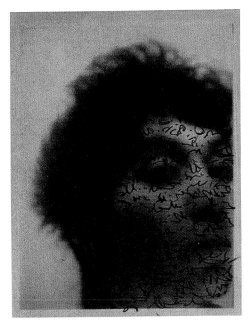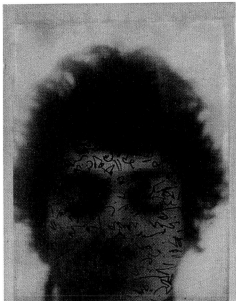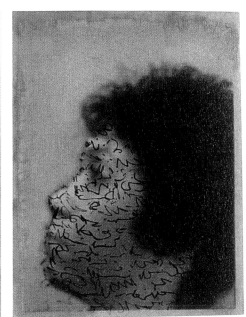

Midnight, Baker Street 1983
C-type prints
enlarged from handworked
photobooth images
each 71 × 51

Midnight, Notting Hill 1986
C-type prints
enlarged from handworked
photobooth images
overall 76.2 × 100

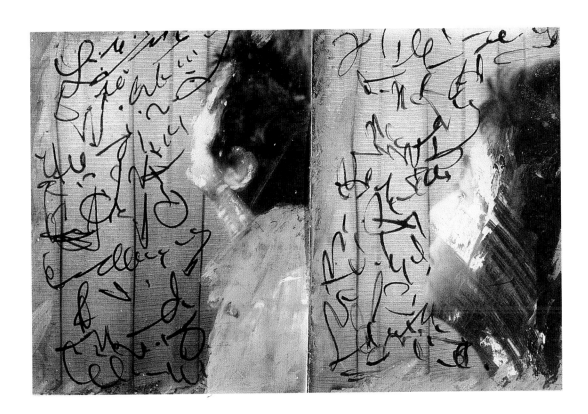

*Sometimes I Think I'm a Verb
Instead of a Pronoun* 1982
C-type prints
enlarged from handworked
photobooth images
8 panels from a series of 12
Each panel 72.4 × 110.5

Sometimes I Think I'm a Verb
Instead of a Pronoun 1982
detail

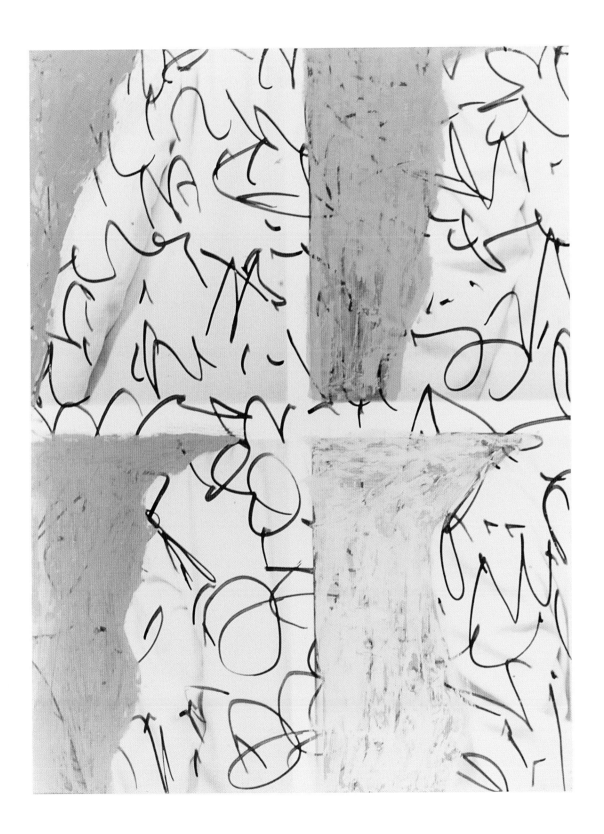

BELSHAZZAR'S FEAST, 1983–4

Belshazzar's Feast, the Writing on Your Wall 1983–4
12 collages, each approx. 51 × 41;
video with sound, 21 min 52 sec;
interior furnishings

The rehabilitation of the communal imagination, its reawakening from the restless, potentially lethal sleep imposed by corporate culture, is a major aspect of Hiller's enterprise. In *Belshazzar's Feast*, she uses the TV set as a metaphor for the communal hearth, but on the screen, flames leap and flow with subliminal energy, like uncontrollable nature threatening to burst its cultural bonds … but also, at times, like the mesmerising monotony of the airwaves. Domesticity is evoked by wallpaper in the installation; it too has its dark side, its own agenda, in the ideological message its pattern carries. On the tape, a 'preconscious' singing alternates with recollections of the Rembrandt painting and Bible story of Belshazzar's feast enunciated by Hiller's son Gabriel, and with news stories about the appearance of alien faces on local TV screens announcing some doomful fate for the planet … As the video's sounds evoke emotions, and the dancing ideograms of the flames evoke images, viewers are still forced to make their own pictures, create their own fantasies, or content, since the subject matter remains 'out of sight'. (Lucy Lippard, 1986)

Installation at SMAK
(Stedelijk Museum voor Actuele
Kunst), Ghent, 2004

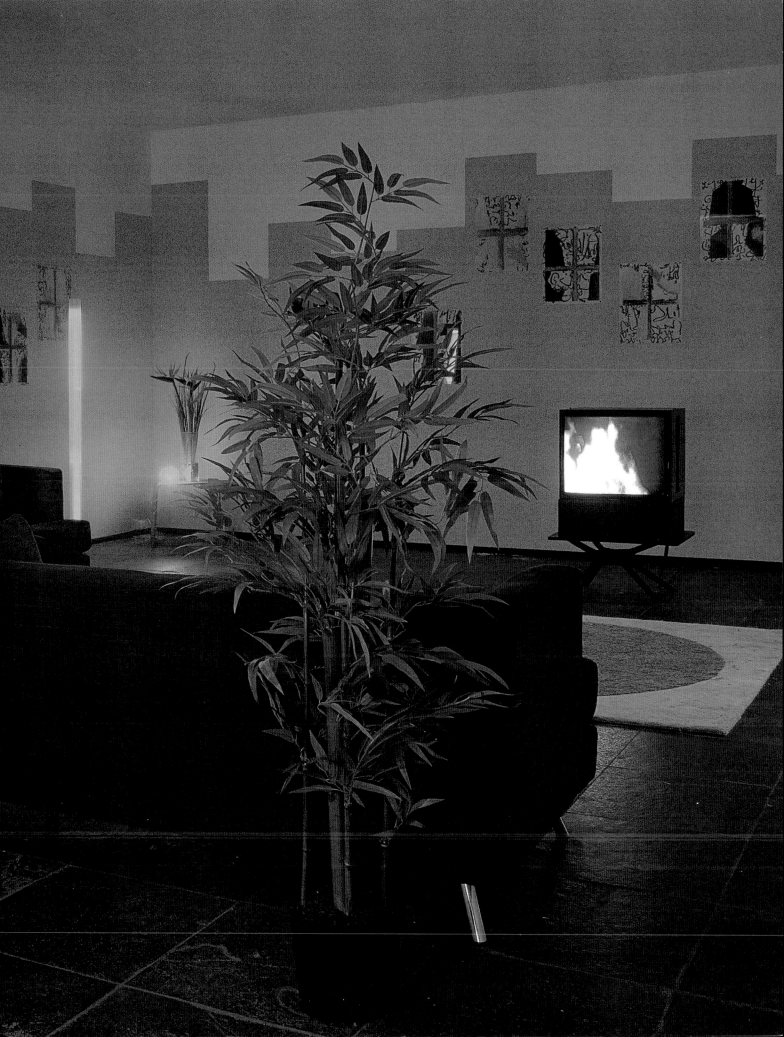

MAGIC LANTERN, 1987

Magic Lantern 1987
Commissioned by
Whitechapel Gallery, London
3 channel 35mm slide projection
with sound, sychronised,
12 min

The basic form of the visual presentation is clear and simple. Three overlapping circles of coloured light are projected on a screen in a darkened room, changing hue at regular intervals. Played against this arena of pure form and colour is a collage of chanting and fragments of curious voice experiments staged by the Latvian scientist Raudive, who claimed to have identified recognisable words and names in the noises he recorded in empty rooms.

It is by way of the visual spectacle, and its echoing of the formalities of scientific method paraded in the voice experiments, that the conventional separation between the 'rigours' of scientific method and anarchic phantasy are most vividly subverted and blurred … The ambiguities of attending closely to a repeated sensory stimulus are reinforced by the visual spectacle in such a way that distinctions between objective perception and subjective response become ever more unstable … Here a clarity and simplicity of form normally associated with the logical certainties of science have become the occasion for dissolving 'rational' definitions of meaning in a deft and seductive display of words and coloured lights … *Magic Lantern* effects a carefully orchestrated and at the same time subversively anarchic interplay of language, sound and spectacle in which you both think you know clearly where you are and forever lose your bearings.
(Alex Potts, 1988)

80

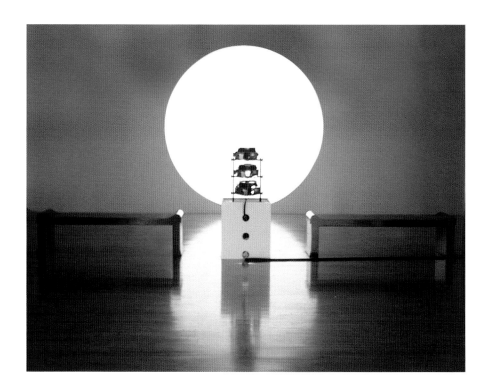

Installation at
Tate Liverpool, 1996

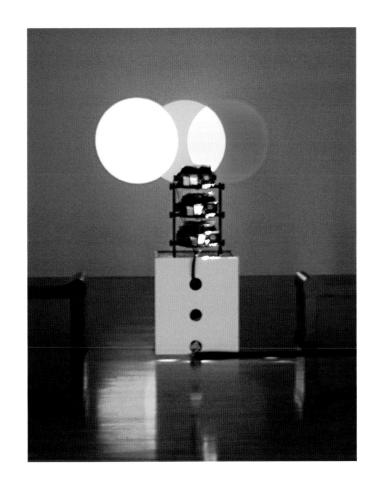

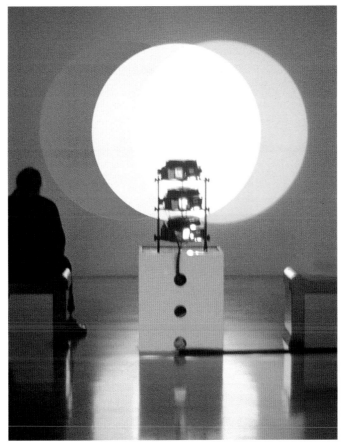

AN ENTERTAINMENT, 1990

An Entertainment 1990
Commissioned by
Matt's Gallery, London
4 channel video installation
with sound, 25 min 59 sec
Each projected image
approx. 260 × 480

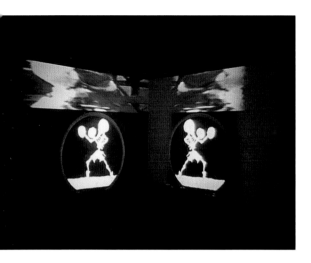

The piece is conceived to a scale that has an
effect on adults as frightening as Punch and Judy
can be for small children, and reawakens through
this the ways in which early encounters with
violence normalised in this way involve the
learning of a disavowal. The puppets are taken
out of the booth and its tiny proscenium and
the viewer is immersed in unexpected sound,
movement and action ... The experience of
Hiller's piece itself does not, finally, rest with
the ambiguous attractiveness and fearfulness of
Punch. It is the experience of entering a darkened
room and of not knowing what is going to happen
next, or where. You are compelled to identify
with the action as it unfolds, with whatever is
happening around you, out of your control,
rather than with specific characters. The four-wall
set-up is too big. It is simply beyond your powers
of projection or control as a viewer; you cannot
identify with the mechanism of projection as
you have learnt to do in a cinema in order to
comprehend what you see. Here the movements
enter you. (Ian Hunt, 2003)

82

Installation at Matt's Gallery,
London, 1991

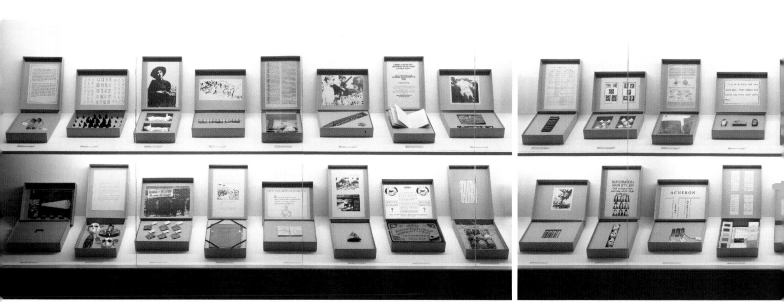

FROM THE FREUD MUSEUM, 1991–6

From the Freud Museum
1991–6
Commissioned by Book Works
and Freud Museum, London
Vitrine 220 × 1000 × 60,
containing 50 boxes,
each 25 × 32.5, and video, 15 min

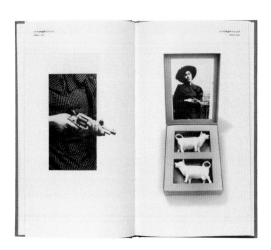

'I deal with fragments of everyday life, and I'm suggesting that a fragmentary view is all we've got.' For Hiller, art is an investigative practice, but because of its extreme subjectivity it resists the totalising, colonising pretentions of a second order discourse of explanation and contextualisation ... *From the Freud Museum* deliberately and self-consciously attacks the project of making the 'visible legible' in museological and historiographic contexts. She uses traditional archaeological collection boxes which have been deliberately fashioned to emphasise the vulnerability of the artefact contained within. According to Denise Robinson, it is 'paradoxically ... the process of framing that completes the tearing of the objects from their contexts.' These artefacts include: 'an emblem in the form of a sweet for the Royal Wedding of Diana and Charles; a ouija board; 4 bars of soap marked "Made in England"';

a pamphlet on the suffering of the Jewish minority in Romania; earth samples from the six counties of Northern Ireland ... Hiller creates a hyper-consciousness of their new status – a living breach.' Her decision to work outside the bounds of ethnography rejects ... the paradoxical primacy of an explanatory second-order discourse. (Stephen Kelly, 2010)

Front cover and spread from
After the Freud Museum, 1995

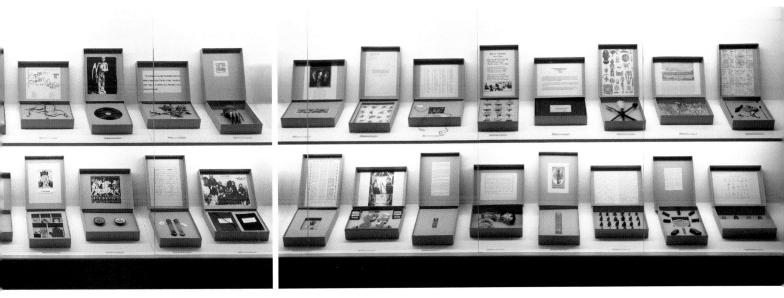

Installation at Hayward Gallery,
London 1997

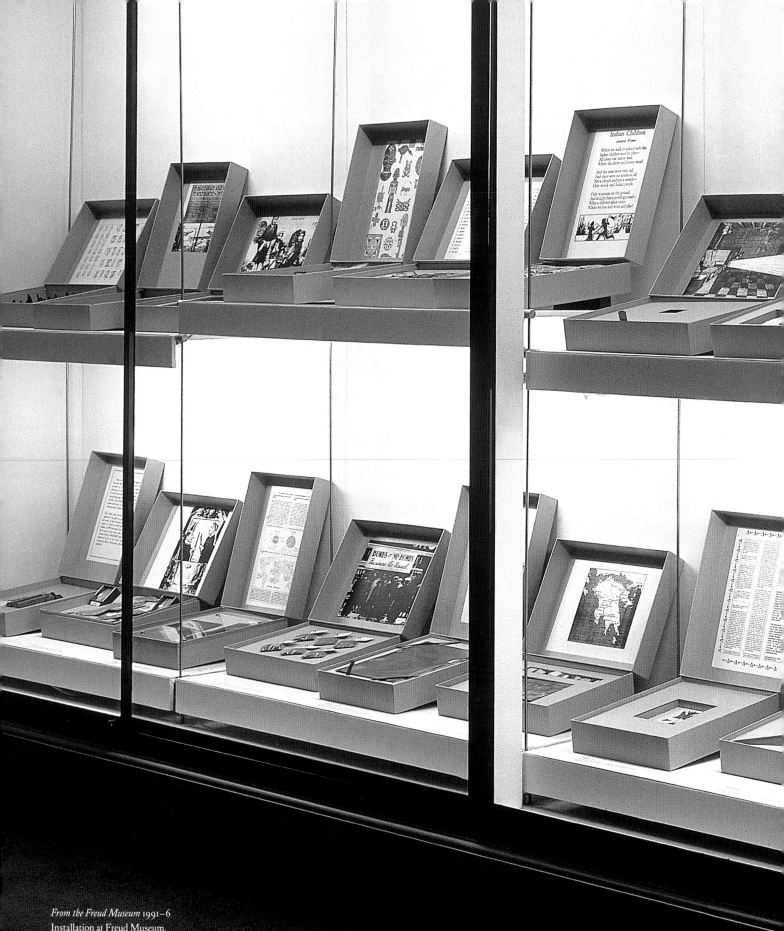

From the Freud Museum 1991–6
Installation at Freud Museum,
London, 1994

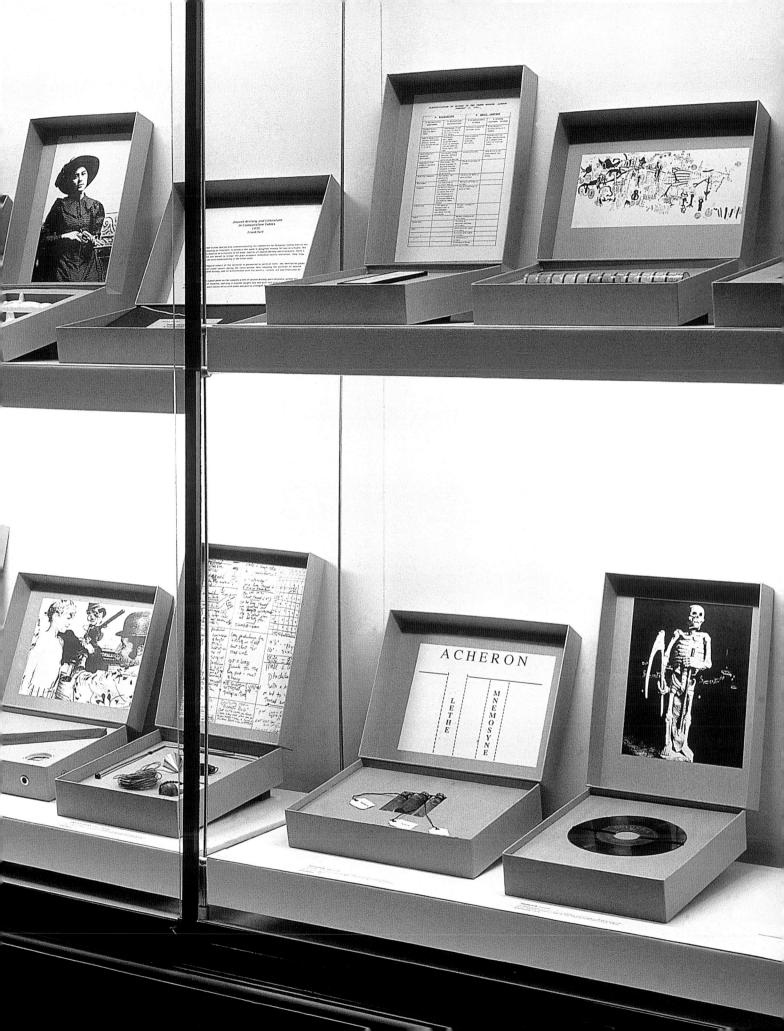

DREAM SCREENS, 1996

Dream Screens 1996
Commissioned by DIA Center
for the Arts, New York
Interactive audio-visual work
for the internet

Dream Screens 1996 [is] a work designed specifically to trap the wandering imagination of late night Web surfers. This is a complex work, which draws on a number of discourses, including those of painting, psychoanalysis and popular cinema. The user enters through a web-shaped colour palette where she can then choose to click into one of a large range of colour fields. At the same time, she can choose from a selection of languages and listen to short narrations, like recollected dreams, interspersed with pulsar signals and heartbeats – the juxtaposition of near and far. The model is the labyrinthine game of infinite couplings and flows, the shift from structure (the finite) to the event (the indefinite), which is the nature of cyberspace itself.

(Jean Fisher, 2000)

90

http://awp.diaart.org/hiller

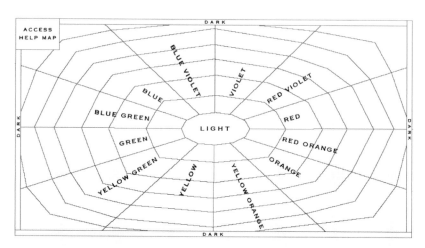

Names of Colors for *Dream Screens*

Mauve	Cadmium light	Celadon
Mineral lake	Antimony chrome	Sap green
Cashew lake	Chrome orange	Bladder green
Ostrum	Chinese red	Moss green
Manganese violet	Red ochre	Zinnober
Tyrian purple	Terra ombre	Smaragd
Caput mortum	Tuscan lake	Green earth
Madder lake light	Bole	Verdigris
Garance	Gallioline	Frit
Magenta	Indian yellow	Egyptian green
Dragons blood	Orpiment	Turquois
Folium	Sandaraca	Bremen blue
Kermes	Roman ochre	Manganese blue
Havana lake	Euchrome	Copper arsenate blue
Potter's pink	Aurora	Bleu céleste
Antwerp red	Yellow lake	Azurite
Armenian red	Gamboge	Blue lake
Brazil wood lake	Saffron	Assuro oltremarino
Derby red	Hansa yellow	Astorian blue
Terra rose	Chrysocolla	Lapis lazuli
Venetian red	Cyprus yellow	Woad
Brown pink	Citron	Lavender
Realgar	Uranium yellow	Lilac
Cinnabar	Jacaranth	Cobalt violet
Saturnine red	Bohemian earth	Solferino
Terra cotta	Hooker's green	Mineral violet
Iron oxide	Bistre	Byzantium purple
Indian red	Burnt green earth	Plumbago

Dream Screens 1996
Installation at Baltic,
Gateshead, 2004
(see also overleaf)

‹FADE IN› morse code

I'm watching a man who has an amazing psychic power to somehow generate dreams that everyone can see. Works by several famous modern artists turn into dream sequences in his mind — I remember bits that look like they're 'by' Max Ernst, Léger, Man Ray, and Duchamp. Famous dead musicians (including John Cage) apparently have written scores to accompany these artists' dreams. This music, which I can hear, makes the dreams seem like film noir-style movies. For some reason, none of this is very interesting, although I'm aware it's clever stuff, like a conceptual exhibition of artists' dreams.

. . .

Programs for Re-programming: One

Dreams are an evolutionary mechanism. In dreams, genetic programs are recombined with images from a reservoir of personal and collective memories shaped by the culture each dreamer inhabits.

. . .

‹FADE OUT› morse code

The signal you have just heard is in morse code and comes from someone who is, in fact, fast asleep. The message is 'I am dreaming, I am dreaming'.

‹FADE IN› pulsar

We're artists invited to join a commune; the commune owns land somewhere hot and tropical. This doesn't turn out very well for us. We become extremely paranoid about the other people in the commune whom we suspect want to trick us, even kill us. The atmosphere is terrible. At one point we are virtual prisoners of these people who have become completely insane. We can't escape because we're locked up and anyway we're in the middle of the jungle. People are being tortured, it's more and more horrible. They spy on us, watch everything we do. We have to pretend to be on their side. We have to take part in their ceremonies and be enthusiastic. All the time we are trying to keep our heads about who we are, and remember that our goal is to escape from these dangerous lunatics, but it's very hard not to merge into them.

From the transcript of *Dream Screens* 1996

about *Dream Screens*

Introduction to *Dream Screens*

Map of *Dream Screens* and List of Colors

Dream Screens transcript

Dream Screens sources

Books and websites on dream

reenter *Dream Screens*

a *Dream Screens* book, please print the five documents located in the folder

WILD TALENTS, 1997

Wild Talents 1997
Commmissioned by
Foksal Gallery, Warsaw
3 channel video installation;
chair, lights
2 programmes: colour with
sound, 6 min 26 sec
1 programme: black and white,
silent, 6 min 30 sec

OPPOSITE
Installation at Foksal Gallery,
Warsaw, 1997

Wild Talents shows us fragments from American and European films from the past 30 years, stylistically diverse in their fictional depiction of children with special powers, and the remnants of a documentary film, proof of a miracle – a pilgrimage to see children in the ecstasy of religious experience, children who see visions. The subject of *Wild Talents* may be children who have special powers, yet this is deferred through another encounter: in part an encounter with an auditory, visual field, a phantasmagoria of projected and illuminated moving images oscillating between the sacred and the ritualistic buried within mass media, and the profane delights at the heart of religious ritual. Hiller's work has always been structured through her absorption of Minimalism's tactics of repetition. Just as her automatic writing experiments invoke Surrealism's idealisation of such 'writing' while disturbing direct transmission through the effect of repetition, in this instance she uses the documentary material as a source to unfold the anxiety of such representation, through editing, re-formatting and duplication to erase the pretence of the unique and ensure the effect of repetition.

All of this takes on a form which dissembles the force that drives the fantasy of mastery – a fantasy always working to contain that which is other to it. (Denise Robinson, 1998)

Installation at Australian
Experimental Art Foundation,
Adelaide, 1998

94

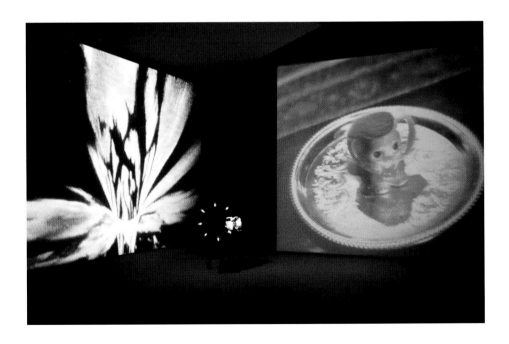

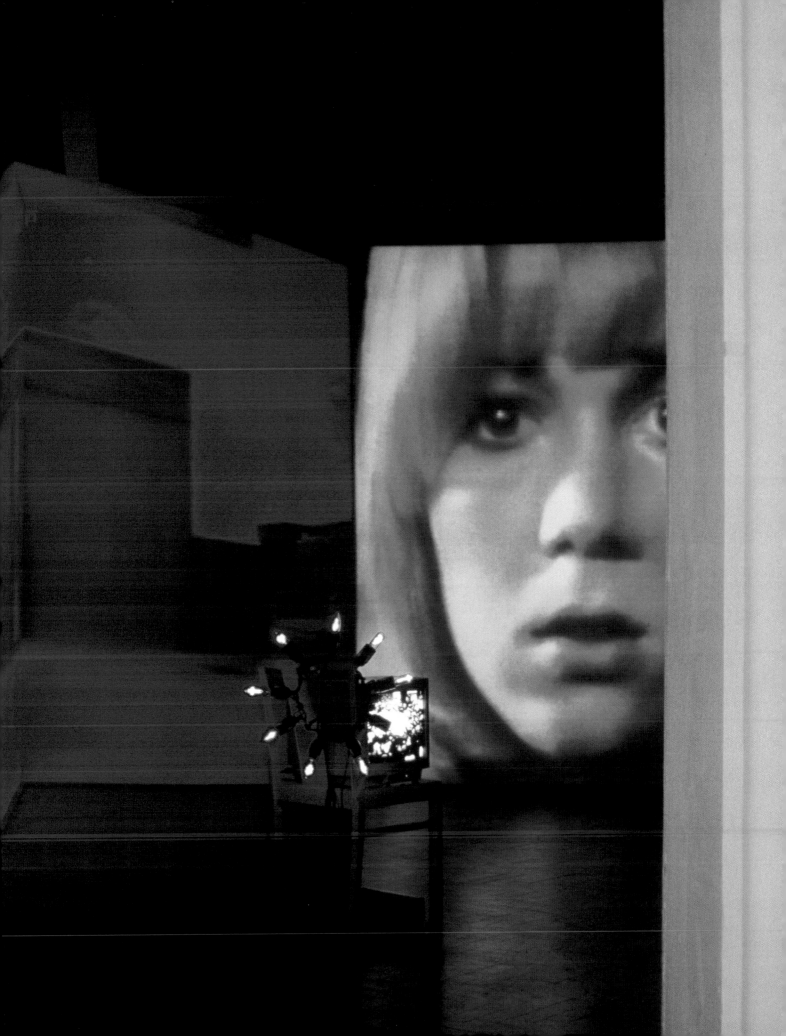

PSI GIRLS, 1999

Psi Girls 1999
Commissioned by
Delfina/Millwall Productions,
London
5 channel video projection
with sound, synchronised,
15 min,
Each projected image
approx. 266 × 355

In *Psi Girls* we see five clips from movies which show adolescent girls performing telekinetic feats. On five large screens we see the girls exercising their fierce and concentrated gaze. They move objects by thought alone. Each screen is tinted a different colour, and is joined halfway through, by the pulsating rhythm of a seductive soundtrack. The effect is unsettling; we are drawn into a dream-like daze, a suspension of disbelief, only to be suddenly awakened with the loud and unkind 'white noise' of a blank TV screen. But the sequence repeats itself, each scene now in a different corner of the room and a different colour.

Susan Hiller describes these clips as 'moments of pleasure'. She strips away the rest of the film to leave only the uncanny remainder. The film-makers sentimentalise and idealise the visionary qualities of childhood, presenting us with an exhilarating world of imaginative plenitude that is lost to adults. But Hiller assembles them alongside each other and the footage takes on a new meaning, signifying the threat of unchecked female desire and the subversive violence of adolescent sexuality. Each scene is a moment of cinematic ecstasy and conveys something of the magic of a lucid or waking dream. *Psi Girls* collects together scenes from popular culture in which gratifying wishes and needs are connected with infantile fantasies of omnipotence. The girls depicted here are unrestrained by the reality principle, nothing poses itself as an obstacle to their desire. They assert the primacy of the imagination, and the erotics of pleasure, over all constraint. (Christopher Turner, 2000)

OPPOSITE
Installation at Delfina,
London, 1999

OVERLEAF
Installation at Gagosian,
New York, 2001

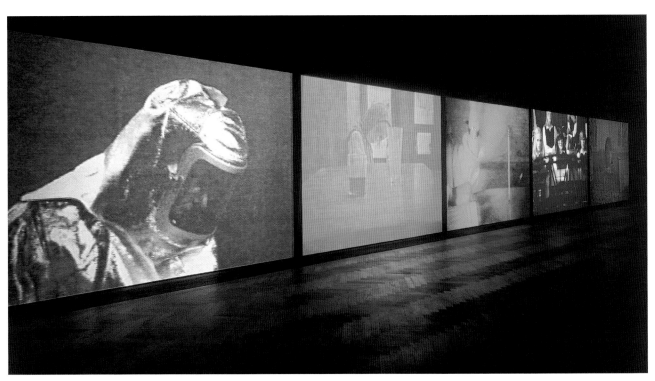

Installation at Kunsthalle Basel,
2005

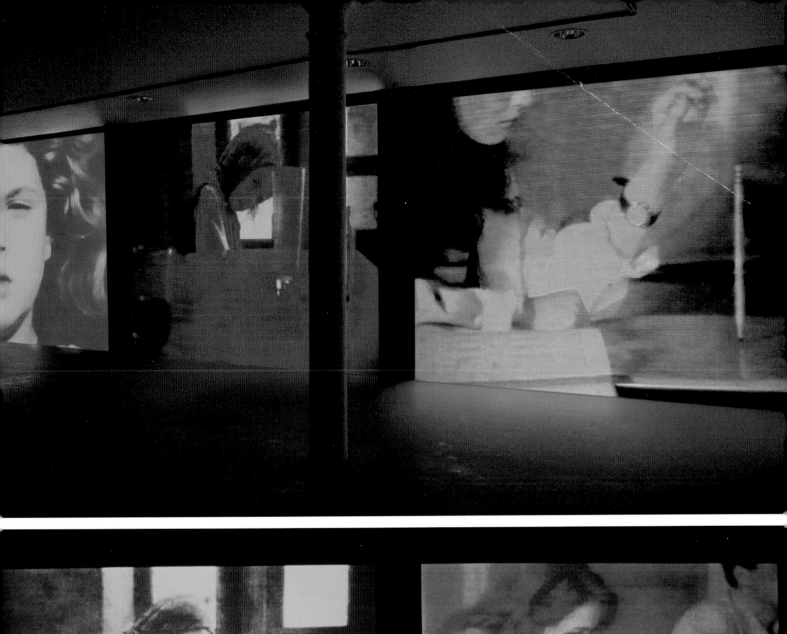
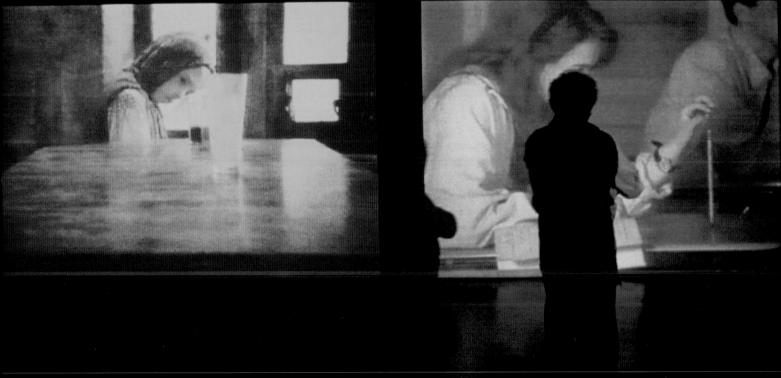

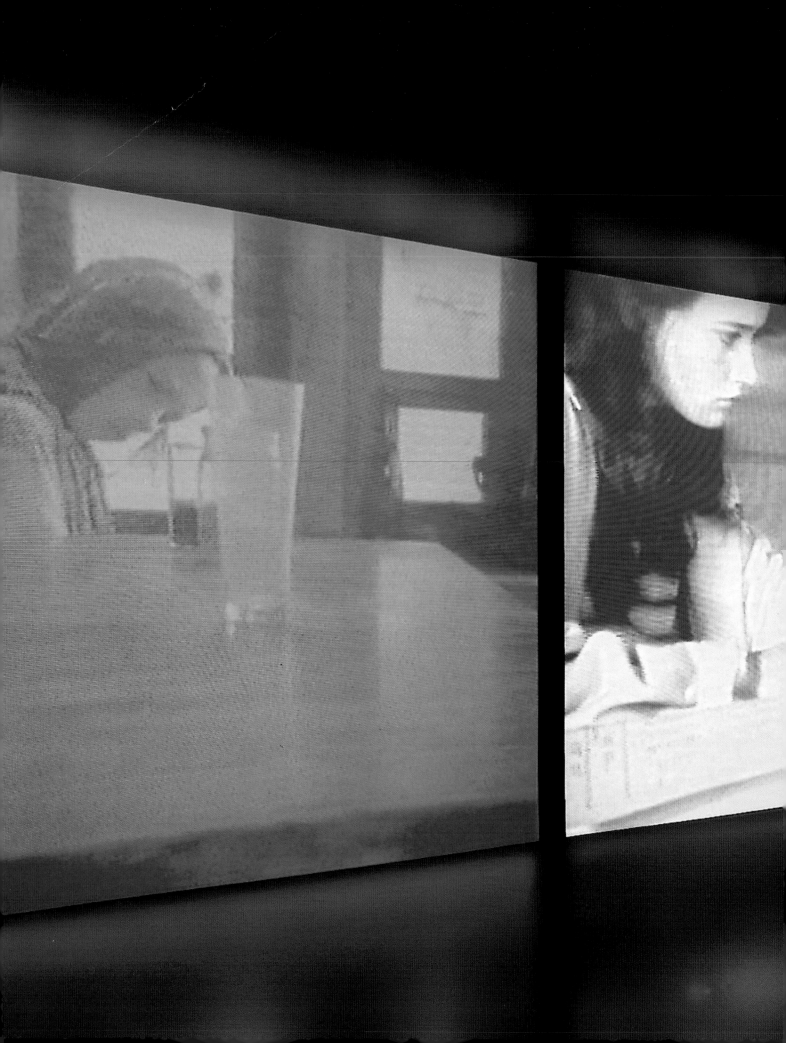

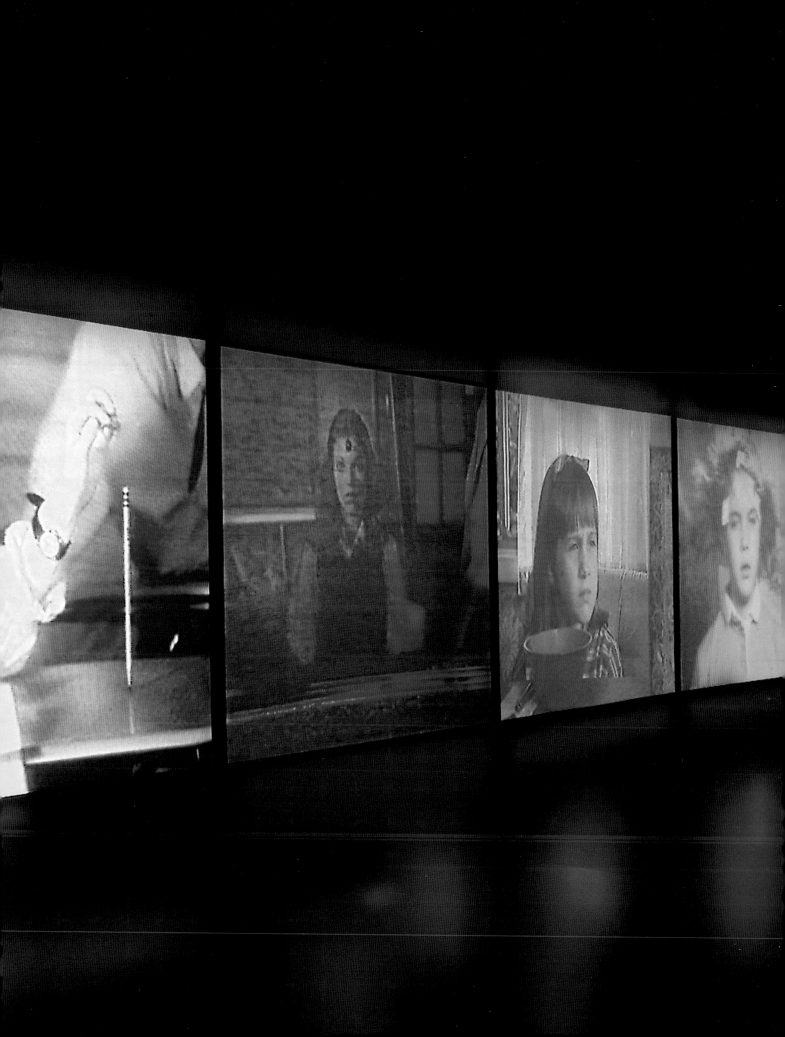

WITNESS, 2000

Witness 2000
Commissioned by Artangel
Approx. 400 speakers,
10 audio tracks, each of 50
to 60 recordings; wires, lights
Installed size approx.
1800 × 900

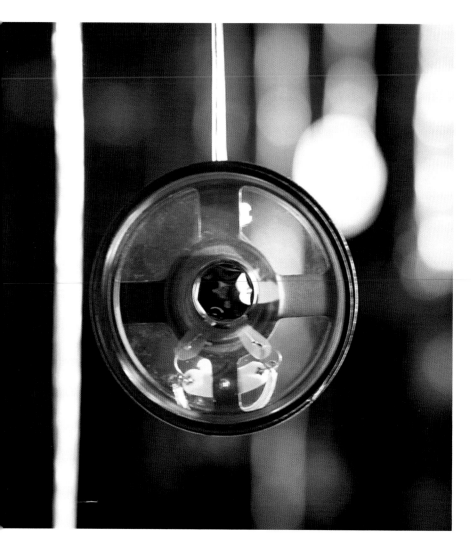

The installation is first seen through the frame of its entrance: an open forest of silvery wires and dangling ovoids, filling the top half of a room. A dim, faintly perceptible susurration emanates from the space ... A few steps in, the environment clarifies further: the 'forest' is made of flat round speakers, like microphones or radios, each hanging at the end of its speaker wire ... These irregular endpoints delineate the variable band of human ear-height (from walking children to the very tall). The interface between the lower void of the room and its upper striations thus takes the shape of a formalised wavy sea – an impression reinforced by the whispering ambient sound. We are inside a kind of mappa mundi; a map or image of the world ... Every speaker transmits a voice telling a story, the voices speak in a great range of languages; eventually, one realises that they are all relating stories of close encounters with UFOs ... Consider the range of positions available to the listener with which to categorise this late 20th century phenomenon ... They may be fictional, illusory or hallucinatory (a somewhat different category); or physically real. If the latter, they may be interpreted as man-made, natural, extra-terrestrial or supernatural.
(Louise Milne, 2004)

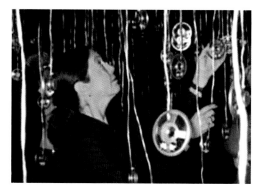

Installation at The Chapel,
Golbourne Road, London,
2000

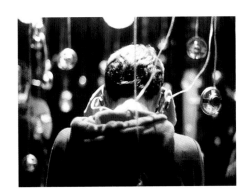

Mandarin

Belarusian

Arabic

German

Bengali

Hebrew

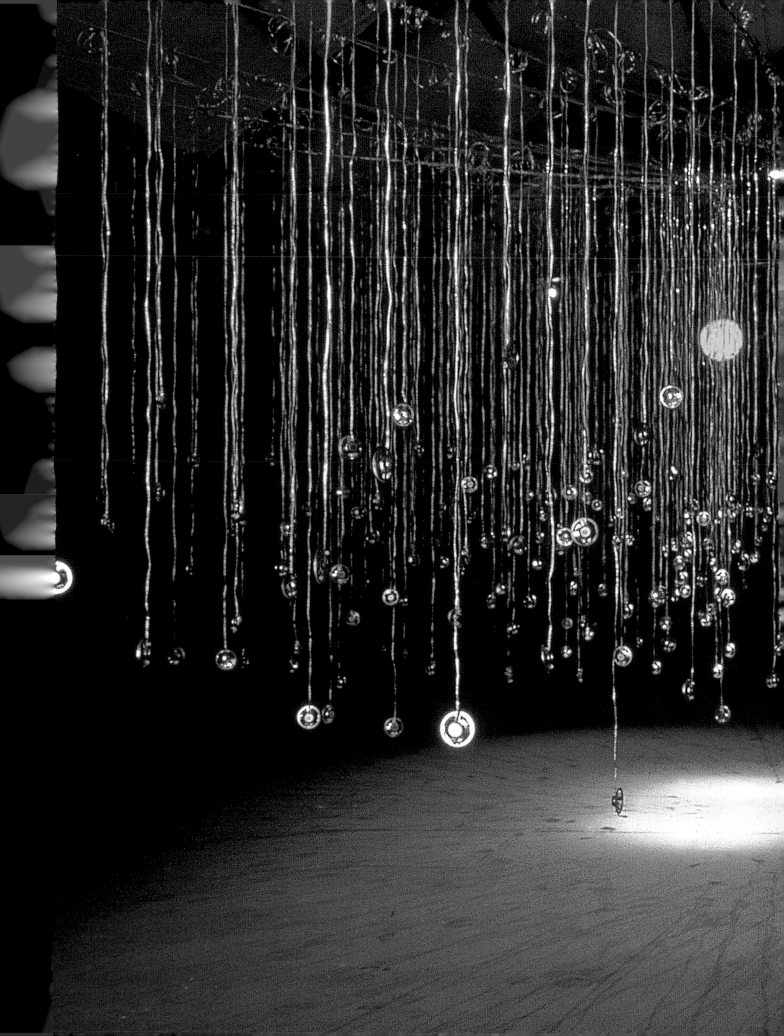

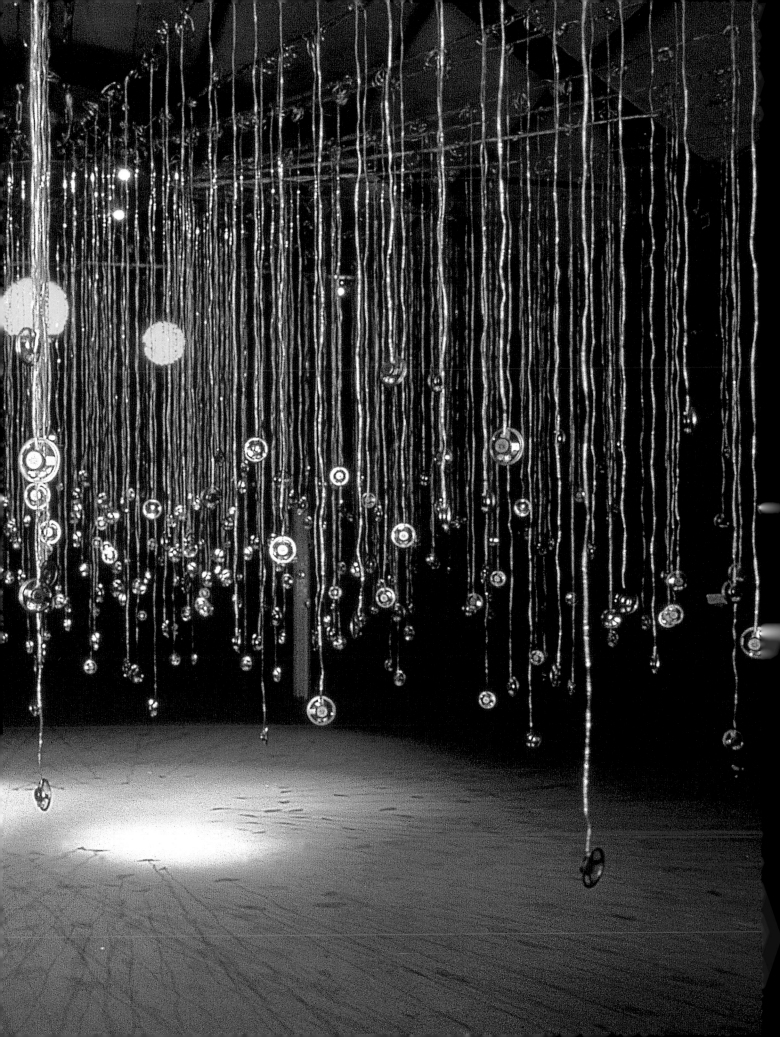

THE J. STREET PROJECT, 2002–5

The J. Street Project 2002–5
303 photographs
each 28.7 × 20;
map, list of sites;
film: colour, 67 min;
book, published in 2007
(see below)

Screening of the film by
Artprojx at Prince Charles
Cinema, London, 2005

In *The J. Street Project*, Hiller's assiduous charting of every street sign in Germany bearing the prefix Juden (Jew) expands the referent of each of these markers from a local geography to the more encompassing territory of history. The 303 signs, dispersed throughout Germany on city streets, pathways, lanes and country roads, bespeak, to uncanny effect, the very absence of what they announce. The work sharply focuses the dissonance between these everyday unremarked signs and the emotion and memories embedded within the genocidal history they at once reiterate and occlude.

The J. Street Project originated in Berlin in 2002 with the artist's startled encounter with one of these street signs. The subject this opened led the artist into three years of research and travel in Germany. *The J. Street Project* comprises an index of 303 photographs of the signs, presented in a monumental grid; a large scale outline map of Germany pinpointing each of these sites, shown with a listing of the resonant location names (the Juden – alleys, walkways, avenues, roads, groves, ways); a 67-minute film situating each sign amid the movement of daily life in settings from urban and suburban to countryside and village; and a 644-page full-colour book presenting and identifying each of the 303 street signs.
(Renee Baert, 2006)

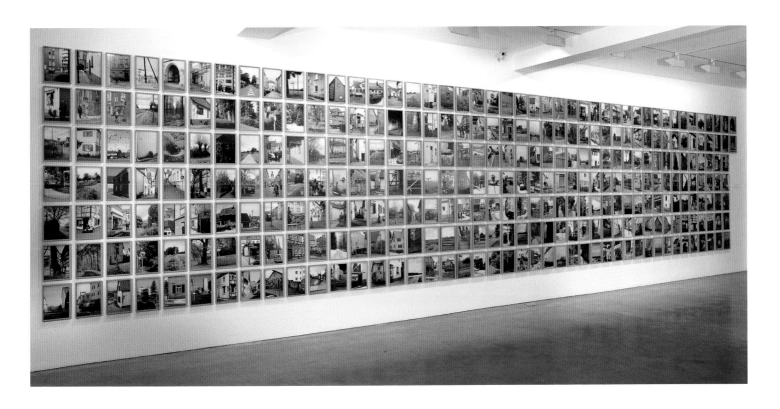

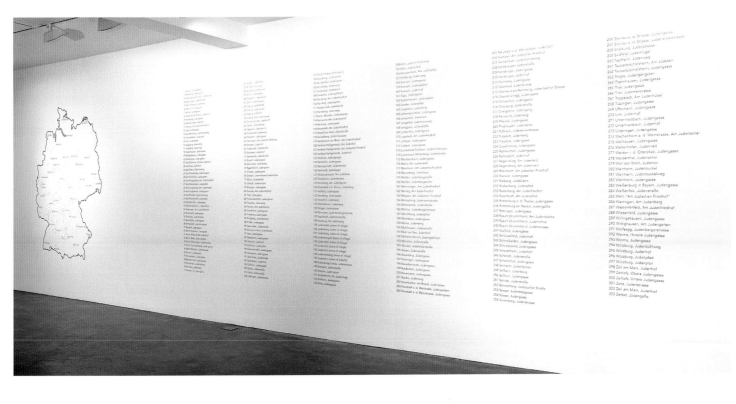

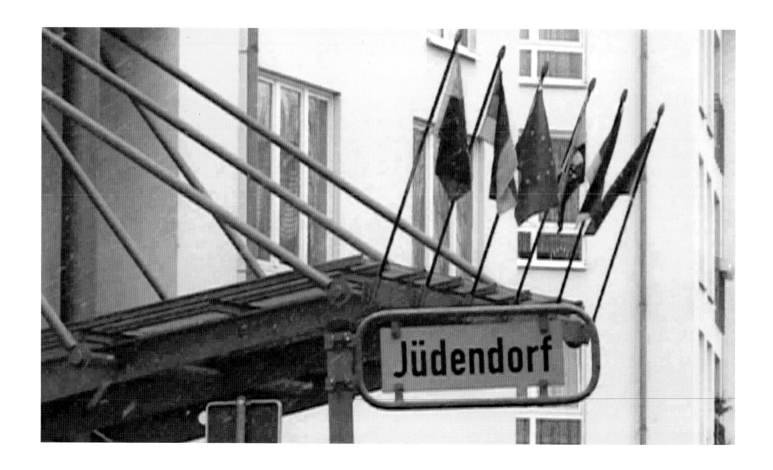

The J. Street Project 2002–5
2 film stills, and below the
installation at Timothy Taylor
Gallery, London, 2005

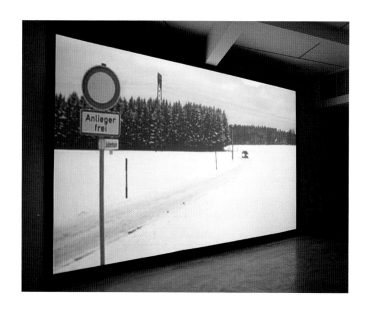

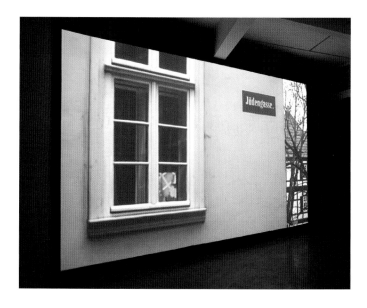

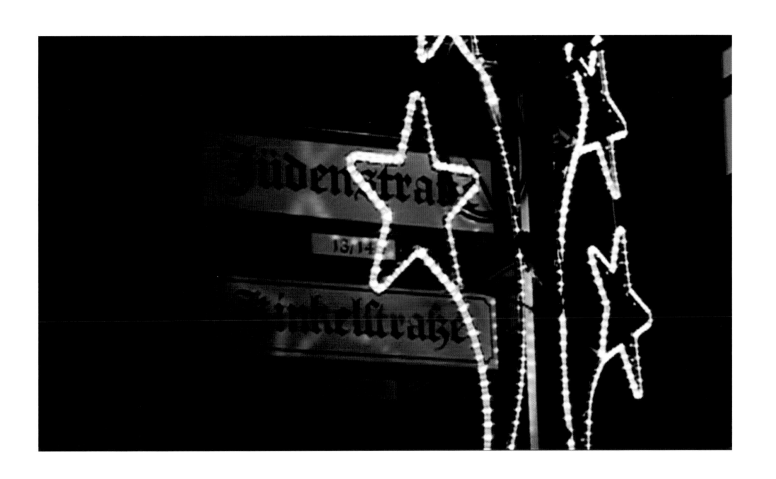

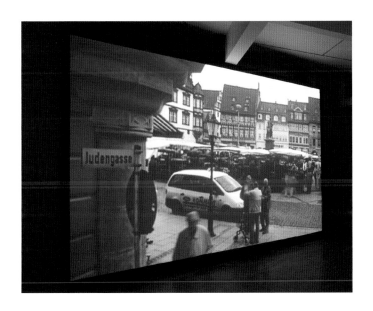

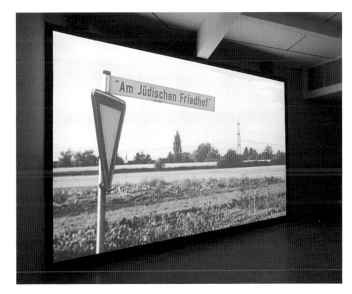

Susan Hiller's works made from domestic ceramics, recycled metallic letters from gravestones, and palette or kidney-shaped tables date from her time living in Berlin in the early 2000s. Rather than reflecting tensions between objects, abstraction and taxonomy, these configurations pose specific questions about the relationships between artifacts, their conditions of production, and the limits of interpretation.

The ceramics, sourced in flea markets, were made in Germany between 1949 and 1989, when the country was divided between the Capitalist West and the Communist East. These popular domestic ornaments – crafty, lumpy, richly glazed – share a rough optimistic modernity. So far, so formal. However, the base of each vase is stamped either with the letters GDR or G–, indicating that it was manufactured in the German Democratic Republic, or with the inscription 'Made in West Germany'.

The struggle between Capitalism and Communism, played out across the world, opposed two models of the relationship between workers, their labour, the means of production and what was produced. Each model posited an entirely different – and transformative – relationship to the other. No type of production – industrial, aesthetic, intellectual, or cultural – was exempt from the model: all productions that embodied these forces and relationships and the societies that resulted were essentially and profoundly different from each other.

Und Jetzt? 2003
GDR and West German
ceramics, recycled bronze
letters, table
128 × 53 × 36

Archaeologists infer societies and their economies from their artifacts; different shaped pots define the 'Beaker People' or the 'Corded Ware culture'. Yet with these works Hiller presents us with the artifacts of two radically opposed ideologies and societies and, already, we find ourselves unable to tell the productions of one from the other. We are presented with a conundrum of interpretation as we seek to uncover relationships between formal resemblances and what were recently held to be essential differences.
(Richard Grayson, 2010)

A Longing to be Modern 2003
GDR and West German
ceramics, recycled bronze
letters, table
152 × 106 × 77

WHAT EVERY GARDENER KNOWS, 2003

What Every Gardener Knows
Susan Hiller

Arranged by J. Maizlish

Starting with a deep bass, the notes build up to a highly synthesized and penetrating force before slowly fading away again … *What Every Gardener Knows* is a sound installation developed by Susan Hiller in relation to Gregor Mendel's (1822–84) theory of genetic inheritance. Based upon Mendel's Laws, which should be familiar to all gardeners, an electronically programmed carillon rings out: a long version on every hour and a shorter one on the quarter hour. Hiller used the binary system of Mendelian genetics to develop this composition of two repeated notes – a 'crossbreed' of familiar and alien elements … The Enlightenment defined man primarily as a seeing subject, whereas hearing was regarded as an unreflected, manipulative sensory mechanism whereby information was transmitted directly from the outer ear to the brain. Hiller uses this sensory experience to question the rationalisation of the subject and examine Mendel's discovery of genetic patterns, which was later abused by the so-called science of eugenics to justify killing

What Every Gardener Knows
Commissioned for an exhibition in Stadpark Lahr 2003
Audio installation
Musical loop, playing once on the quarter hour, twice on the half hour and three times on the hour (documentation below)

RIGHT
Mendel theme and variation (v.1- 19.04.03) scored for stereo sine waves / 130 bpm

people with 'undesirable' hereditary traits, just as gardeners try to eliminate weeds … In contrast to the idea of breeding perfectly uniform populations, Hiller's interpretation of Mendel's Laws celebrates the diversity of life forms – a variety that can only be produced by combining alien characteristics with familiar ones and vice versa. (Christine Nippe, 2008)

Installation at Skulpturenpark
Berlin_Zentrum for the fifth Berlin
Biennial for Contemporary Art, 2008

Unlike all my other works using sound, 'What Every Gardener Knows' is invisible. The piece is designed for an outdoor or garden setting, using waterproof audio equipment appropriate for this purpose. Ideally the two loudspeakers are concealed on each side of a path or hidden amongst shrubs, rocks, etc. When nicely installed in a garden environment, the hardware is completely hidden and the sound of my carillon resonates over a wide area like the music of church bells or the call to prayer from mosques.

CLINIC, 2004

The gallery is empty except for supporting pillars.
But the emptiness is articulated by sound. Astral
voices float far above you, a murmuring buzz,
occasionally broken by a rapid fire of fragmentary
argument that shoots back and forth ... And as
you pass through it, triggering off sensors, the
voices descend to speak to you personally, to
report their out-of-body experiences that Hiller
has tape-recorded from people of all creeds and
cultures. As you listen, the whole atmosphere
seems transformed. You stand transfixed amid the
spaces, staring through distant skylights, searching
as if for something unexplained that lies beyond
language. No answers are offered. Hiller may work
with sound but her pieces, like all great art, open
on to silence. (Rachel Campbell-Johnston, 2004)

Clinic 2004
Commissioned by
Baltic, Gateshead
Audio-sculpture: 20 speakers,
amplifiers, CD sources, sensors,
real-time audio processing,
light modulation system

Installation at (above)
Kunsthalle Basel, 2005
(below and left)
Baltic, Gateshead, 2004

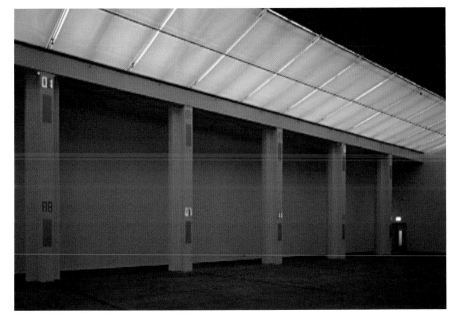

KLALLAM
(nearly extinct)

...When the flood water receded,

THE LAST SILENT MOVIE, 2007

The Last Silent Movie 2007
Single channel projection with
sound, 20 min; 24 etchings on
paper based upon oscilloscope
traces of the voices heard on
the soundtrack, each 37 × 42.5.
Produced with James Hill at
St Barnabas Press, Cambridge

This is not exactly a typical movie nor is it
a 'silent movie'; from start to finish the screening
room is filled with voices, mainly of dead people
speaking dead languages ... It is immediately
striking that this is a black projection without
images ... However the blackness of *The Last
Silent Movie* is not only a matter of resistance to
image making, nor is it quite accurate to say this
is a projection without images. We could instead
put it the other way around: the lack of images
encourages projection, the audience's projection
onto the screen of imagined images that they
conjure whilst experiencing the work ... As we
think about the speakers and singers, we realise
that we are in what Hiller has elsewhere called
'intimate contact' with these subjects, despite our
complete separation from them, since the sounds
of their voices literally reverberate in our ears,
an experience which can prove quite uncanny ...
We realise that the extinction of the languages
we hear in *The Last Silent Movie* is the extinction
of other realities, of other ways of living and
understanding the world. (Mark Godfrey, 2008)

Plate 7 KLALLAM *They're lying to us.*

Plate 1 K'ORA *The people in this country speak a beautiful language.*

Plate 15 POTOWATOMI *Bad behaviour.*

Plate 3 XOLENG *Now then, come help me paint my creation.*

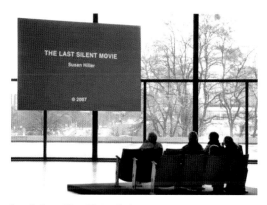

Installation at Neue Nationalgalerie,
Berlin, for the fifth Berlin Biennial for
Contemporary Art, 2008

OPPOSITE
Installation at Göteborgs Konsthall,
Gothenburg International Biennial for
Contemporary Art, 2009

HOMAGES, 2008 – ongoing

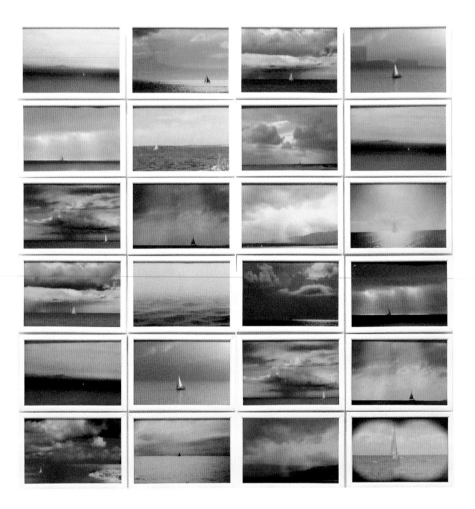

Hiller met the Belgian conceptual artist Marcel Broodthaers at an opening in London in 1972 and discussed with him her postcard project, which would become *Dedicated to the Unknown Artists*. By way of acknowledging this conversation, Hiller recently made two pieces that refer both to her own 'rough sea' works (1972 onwards) and to Broodthaers's film *A Voyage on the North Sea* 1974. Hiller's *Voyage: Homage to Marcel Broodthaers* 2009 and *Voyage on a Rough Sea: Homage to*

Marcel Broodthaers 2009 honour Broodthaers's use of unexpected repetitions to undermine an apparently orderly sequence of images. Like him, she has employed unnatural colour, upsetting the idea of a realistic depiction. Where Broodthaers's 16mm film approximates a slide show, animating as it does a series of static images, Hiller's are static wall-based works, made from still images that resemble frames from a filmic sequence.
(Andreas Leventis, 2010)

Voyage: Homage to Marcel Broodthaers
2009
24 digital prints, each 10 × 15
Overall 66.5 × 64

Voyage on a Rough Sea:
Homage to Marcel Broodthaers
2009
20 digital prints,
each 30 × 40
Overall 157 × 164

Levitations: Homage to
Yves Klein 2008
150 black and white
digital photographs in 25 framed
composites, each 10.2 × 15.2
Overall 170 × 170

In November 1960 the artist Yves Klein proposed a performance in which he would 'present himself on-stage, stretched out in space a few metres above the ground, for five or ten minutes'. The proposal noted that he had previously 'practiced levitation' and Klein provided evidence for this claim in the form of the iconic photograph *Leap into the Void*. Despite being faked, Klein's photograph remains a mesmerising image.

In *Homage to Yves Klein* 2008, Hiller presents a large grid of photographs collected from the internet, showing people supposedly in the act of levitating. This work, like Klein's prototype, explores the implications of the long-established tendency in modern art to make use of certain mystical or spiritual belief systems. Unlike Klein's version, however, here the focus is not on the hoax of a singular artistic genius, but on the fabrications of a great many ordinary people. Hiller's piece examines the connection between knowing that levitation is just a fantasy and yet still apparently believing in it or at least wishing to present oneself to others as possessing this supernatural ability to overcome gravity. Hiller considers these pictures not as attempts to deceive but as indicators of a genuine collective desire to reconsider the limits and potentialities of human beings, expressed by picturing 'a self seen only in dreams.' (Andreas Leventis, 2010)

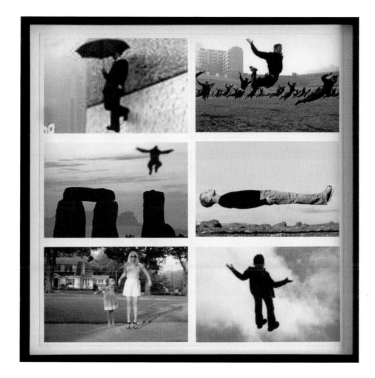

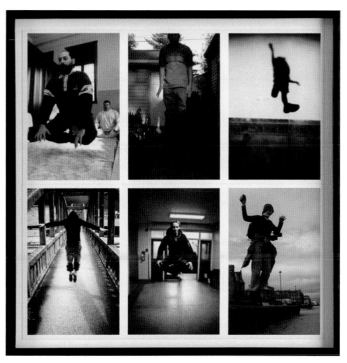

*Auras: Homage to
Marcel Duchamp* 2008
50 digital prints,
each 30.4 × 30.4
Overall 190 × 380
(Below and right: details;
full work overleaf)

Susan Hiller selected a little-known painting by Marcel Duchamp – *Portrait of Dr R. Dumouchel* 1910 – as the starting point for this work. Unearthly colours follow the contours of the sitter's body and a luminous white band radiates from his hands. Duchamp was illustrating the ancient belief in auras, supposedly radiance from energy fields emanating from and surrounding each living thing, detectable only by clairvoyance.

In *Homage to Marcel Duchamp*, by presenting a large number of photographic portraits sourced from the internet, illustrating a range of individuals surrounded by amorphous, shifting clouds of coloured light, Hiller draws our attention to the persistence of occult beliefs in popular culture; by evoking Duchamp's painting she suggests a relationship between contemporary belief in auras and important tendencies in modernist painting. While we might typically expect to see auras in historical representations of saints, Hiller's subjects are ordinary mortals of different ages from a cross-section of cultures, whose apparent auras are produced and recorded by computerised photographic equipment.

In introducing this work, Hiller mentions Walter Benjamin's prediction that mechanical reproduction techniques would shatter the power of art's link to magic, which he called its 'aura'; this prediction is ironically scrutinised in this installation of portraits which Hiller calls 'metaphors of the self in a digital age'. (Andreas Leventis, 2010)

120

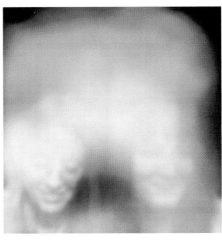
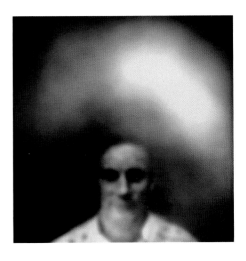

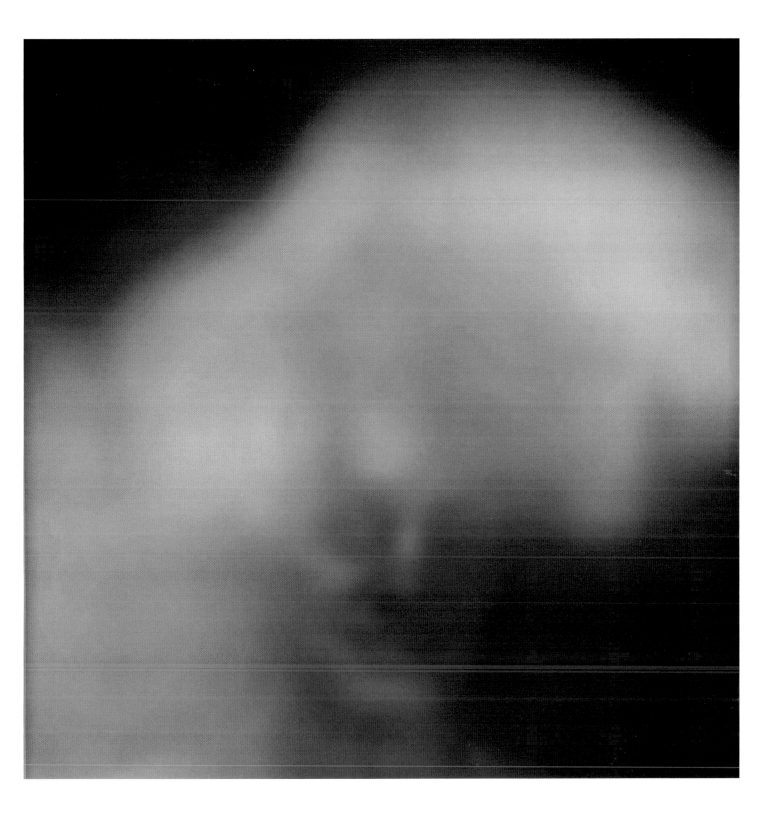

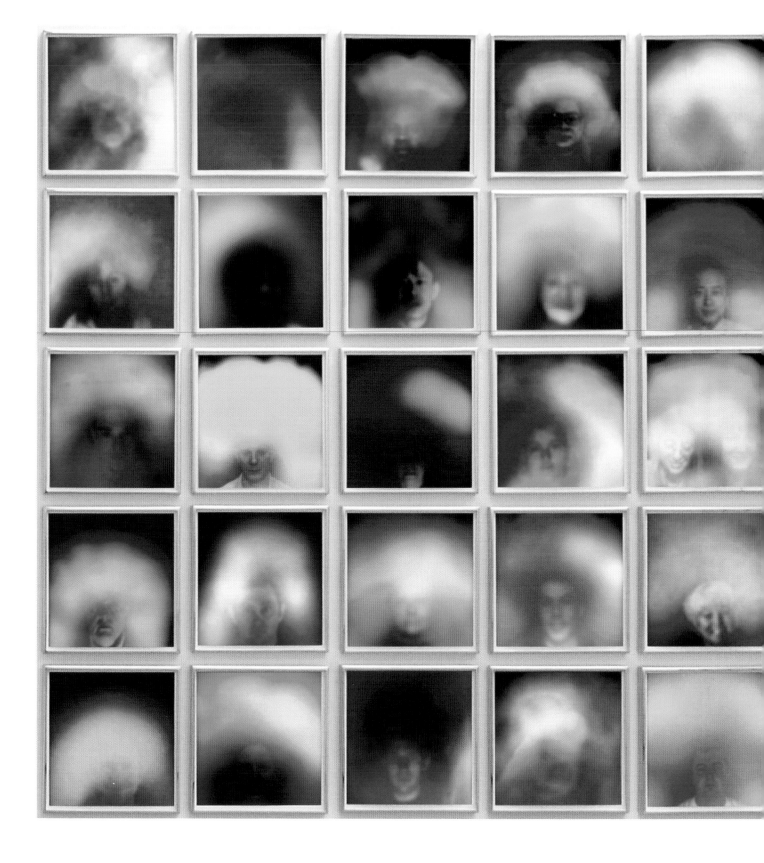

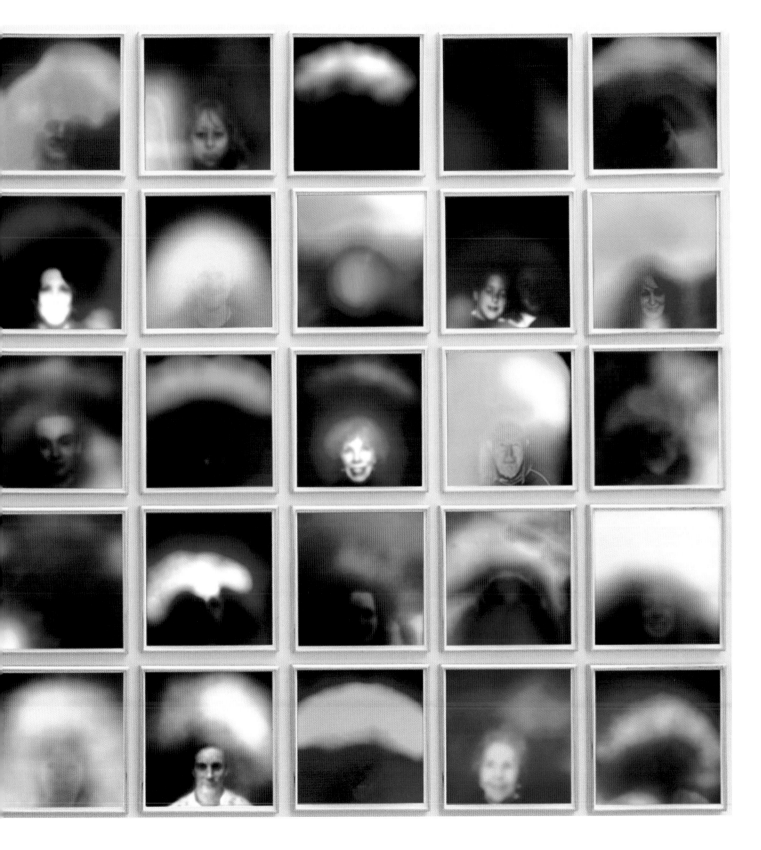

*The Tao of Water: Homage
to Joseph Beuys* 1969–2010
Felt-lined wooden cabinet,
felt squares, bottles of water
collected from holy wells
Cabinet 56 × 84 × 28.5

In 1974, Hiller was introduced to Joseph Beuys
at the ICA, London. Referring back to that
encounter, she has made a series of cabinet
works whose titles both allude to and question
traditional and contemporary 'alternative' beliefs
and cures, and the very nature of faith itself.
Having collected water from holy wells and sacred
springs around the world since 1969, Hiller decants
her samples into small glass medicine bottles
excavated from London middens and arranges
them within recycled wooden cabinets. Her use
of the display cabinet or vitrine, together with
the black felt with which they are lined, makes
overt reference to Beuys's signature materials
and presentation techniques. These works
simultaneously honour and scrutinise the
ways in which he attributed symbolic use
to matter-of-fact materials, sacramentalised
everyday activities and claimed to store up
energy in ordinary objects.
(Andreas Leventis, 2010)

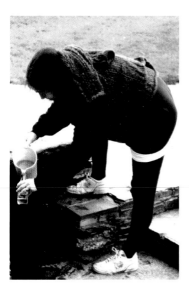

Hiller collecting water from
(left) Lethe, Greece, in 1990
and (right) Doon Well, Ireland,
in 1991.

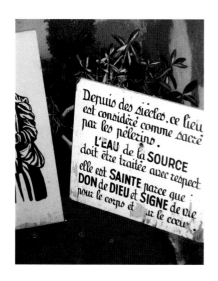

Holy wells at Marsat, France,
and Caversham, England

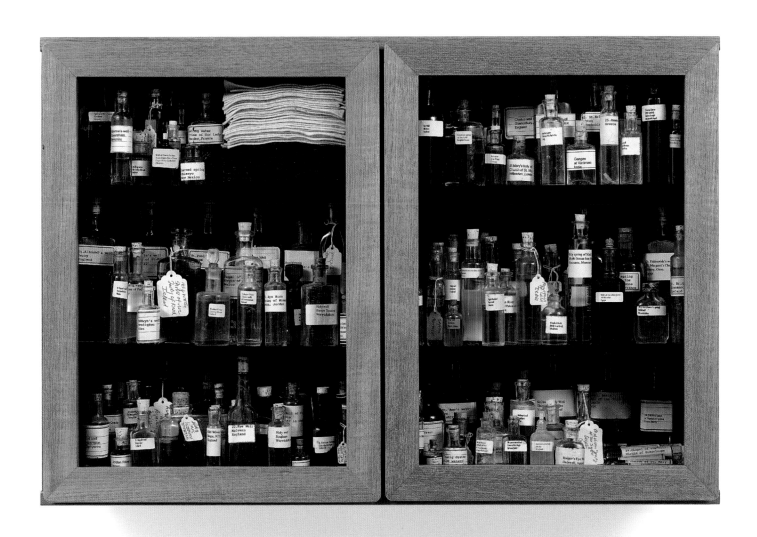

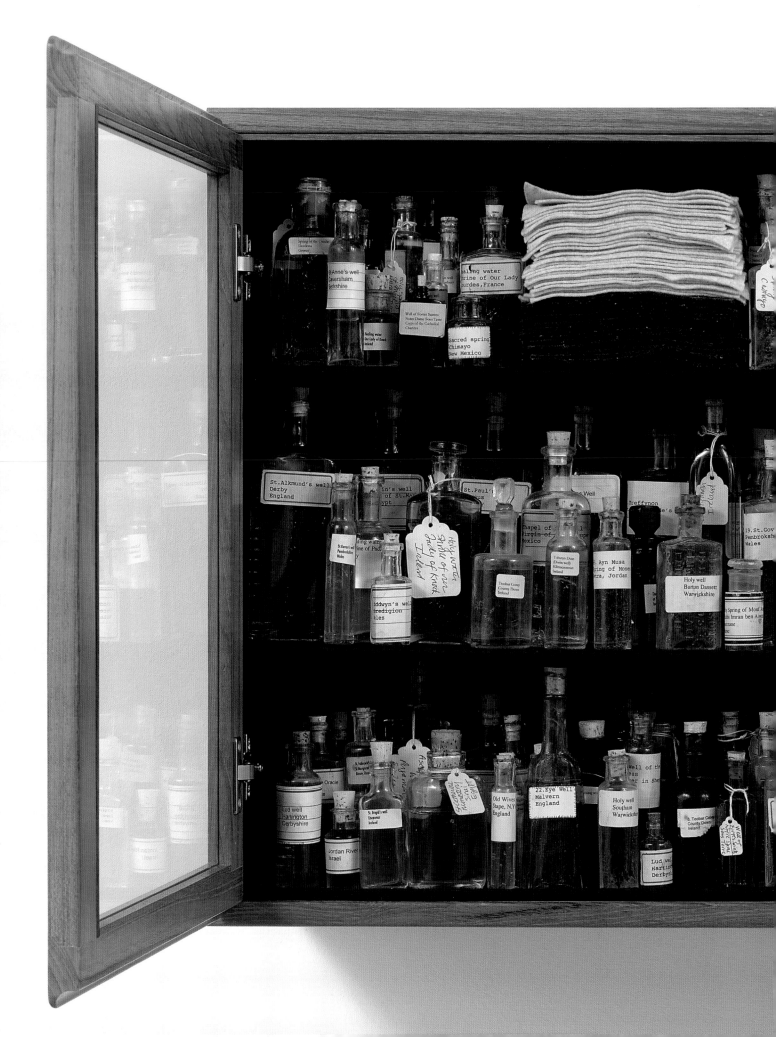

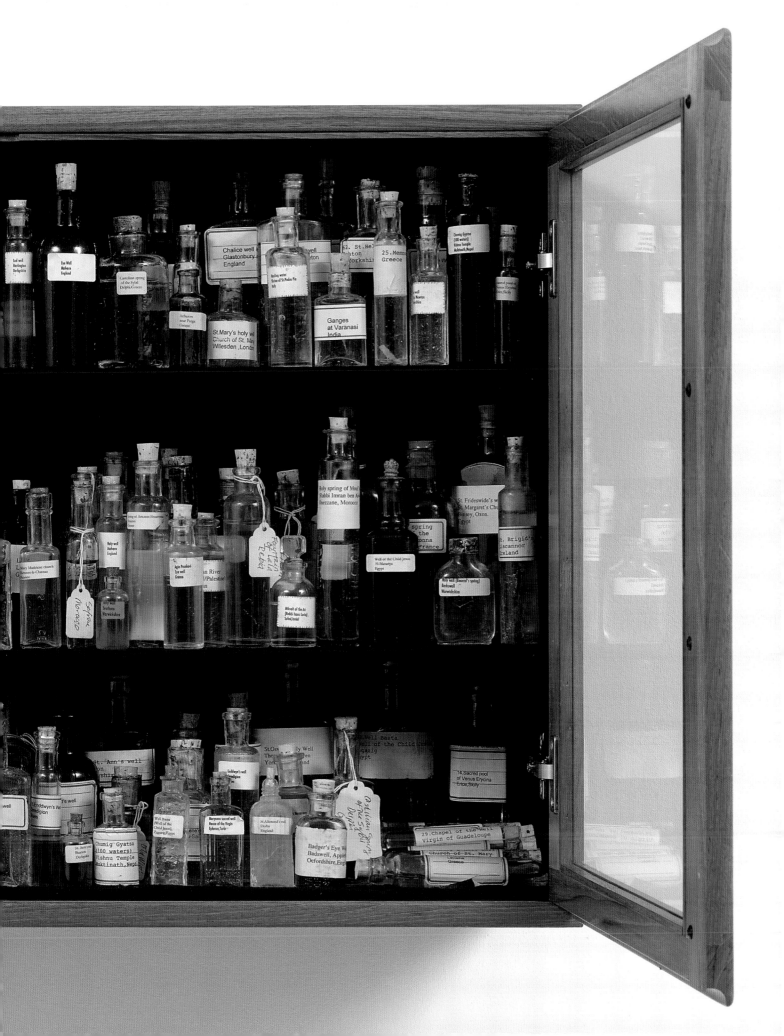

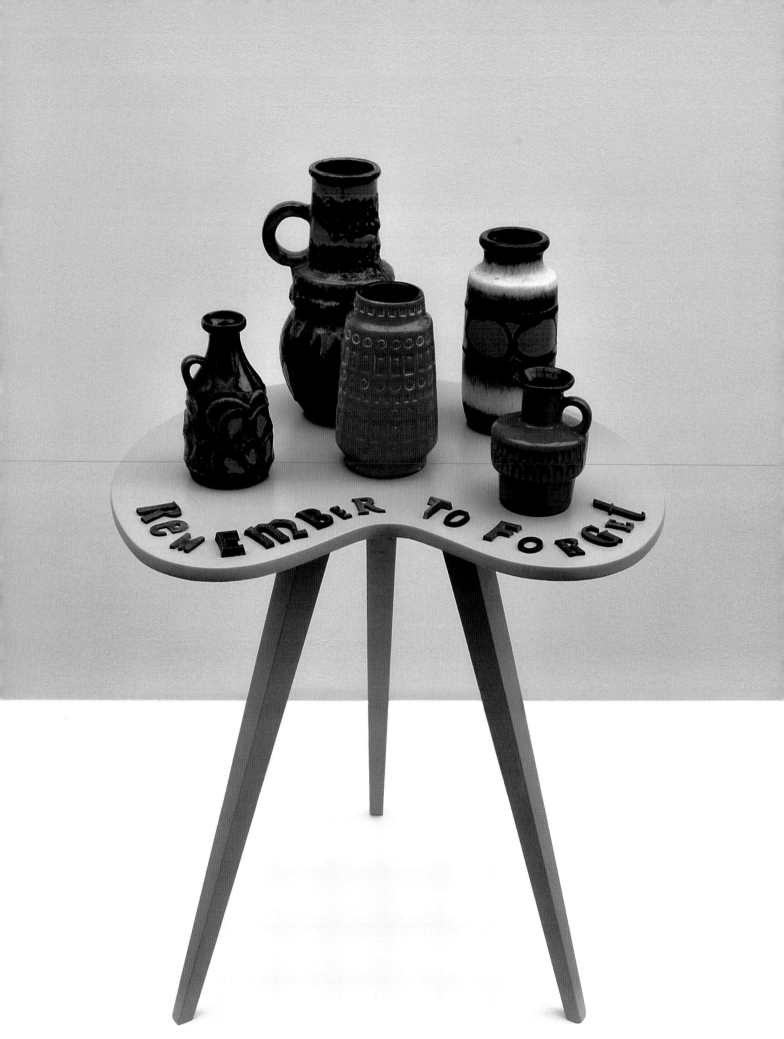

Five 1950s-style ceramic vases are placed on a three-legged table. The tabletop is kidney- or palette-shaped, as was popular in mid-twentieth-century Germany, and undulating along its edge are bronze letters that spell out the imperative: 'Remember to forget'. What is it that we are being reminded to forget? Are we being reminded to forget about the generic, petit-bourgeois kitsch style ironically used in post-modernist interiors? The proposition is puzzling: how are we supposed to remember the act of forgetting while not remembering that which is to be forgotten?

What did Freud say about forgetting and remembering? He termed the active production of the unconscious, the labour of remembering to forget, 'Repression work'. His understanding of the fetish involves a related mechanism: the split occurring in the 'instinctual representative' (a conglomerate of imagined things invested with libido).[1] The fetish arises in the split between what has been actively 'forgotten' or repressed, and what is 'remembered' and idealised as an object of desire. The idealisation (whether of a shoe, or a table) is impossible without the 'deep connection' to that which was repressed.[2]

But Hiller's table and its imperative – remember to forget – is probably less about the individual's psychic repression than about a trans-individual, structural mechanism inherent to the object, and/or the proposition; it is not so much about something that the mind remembers to forget, than about something that has already been rendered invisible by the time the individual's mind focuses on it. The vintage vases on the table are either labelled 'Made in GDR' or 'Made in West Germany', and thus demarcate an ideological split as well as a surprising similarity in style, while the bronze letters are recycled from Berlin tombstones, reminding us of the forgotten dead. One thinks therefore of the division of Germany into two parts, which has been consigned as something to remember to forget about while the country moves on, or the way in which the Eastern bloc and the Soviet Union and Communism and the Cold War are only remembered in order to be forgotten about. Hiller's strange table leads us from the great analyst of libidinal economy to the great analyst of economy proper, from Freud to Marx, and to the passage in *Capital* (1887) about commodity fetishism. That passage involves a similarly strange table, and may not only tell us something about the nature of furniture and commodity fetishism, but also about the work of Susan Hiller and its relation to Conceptualism. Marx writes:

> A commodity appears, at first sight, a very trivial thing, and easily understood. Its analysis shows that it is, in reality, a very queer thing, abounding in metaphysical subtleties and theological niceties. So far as it is a value in use,

Remember to Forget 2003
GDR and West German
ceramics, recycled bronze
letters, wooden base, plinth
106 × 58.5 × 50

Messages Suppressed by Culture Do Not Cease to Exist

Jörg Heiser

there is nothing mysterious about it, whether we consider it from the point of view that by its properties it is capable of satisfying human wants, or from the point that those properties are the product of human labour. It is as clear as noon-day, that man, by his industry, changes the forms of the materials furnished by Nature, in such a way as to make them useful to him. The form of wood, for instance, is altered, by making a table out of it. Yet, for all that, the table continues to be that common, everyday thing, wood. But, so soon as it steps forth as a commodity, it is changed into something transcendent. It not only stands with its feet on the ground, but, in relation to all other commodities, it stands on its head, and evolves out of its wooden brain grotesque ideas, far more wonderful than 'table-turning' ever was.

… A commodity is therefore a mysterious thing, simply because in it the social character of men's labour appears to them as an objective character stamped upon the product of that labour; because the relation of the producers to the sum total of their own labour is presented to them as a social relation, existing not between themselves, but between the products of their labour.[3]

There are three crucial points here. First, by turning the 'social character' of labour into something abstract and dependent on exchange value that very 'social character' becomes invisible in the thing, vanishing behind a veil of mystery. Second, it is this mystery that leads Marx to use the allegory of fetishism – the term during his time was almost exclusively employed in relation to 'primitive' religious practices in the colonies, so that in effect he was talking about an 'irrational' structure at the heart of the rationalist utilitarianism of capitalist society. Third, it is more than just incidental that Marx, when talking about the strange character of the commodity fetish, also uses the comparison to a séance session – the summoning of spirits with the help of a table, especially popular at the time of Marx's writing, the mid-nineteenth century.

What does this have to do with Hiller? The usual reading of Conceptualist art practice would be that two of its major objectives, in a Marxist vein, were to eliminate the fetishised art object and to lift the veil from the artistic production mystified by the Romantic notion of the solitary artist genius, thus exposing its actual social character. As an American living in Britain, Hiller realised her first major works in the early 1970s, in the context of an art scene that included first-generation Conceptualists such as Art & Language and the members of the Film-Makers' Co-op, who, in a similar way, followed the idea that art was a rational proposition, self-reflective of its own production. Hiller at least partly complied

with the by-then well-established parameters of Anglo-American Conceptual art: she de-emphasised the importance of the object in favour of the social process of production, and employed Conceptual methods of establishing rules of categorisation and analysis, using texts and charts.

But there is also a fundamental difference. Rather than eliminating the fetish, the séance and the mystery, in many of her works Hiller put these factors, denounced as irrational, centre stage. 'The pencil seemed to have a mind of its own', reads her description of the development of *Sisters of Menon* 1972 (pp.62–5) – a description that eventually became part of the piece. The artist sat down and practised automatic writing in a kind of partial trance ('It seemed an engrossing and somewhat eerie experience to step aside so completely'),[4] in the tradition of Pierre Janet and Carl Jung, as well as the Dadaists and Surrealists. Automatic writing is meant to bypass the super ego and tap straight into the unconscious, or even (in the Jungian sense), the collective unconscious. The resulting letters are crude, large and jagged, but there are decipherable words and short sentences, such as: 'Who is this one/ I am this one/ Menon is … I am the sister of Menon/ I am your sister/ the sister of – of everyone's sister … We are the sisters of Menon/ Everyone is the sister.' The sheets of paper are arranged into four L-shaped frames, which in turn form a cross; the cross is extended horizontally by four singular A4 frames, which include the above-quoted description and a typewritten transcription of the words that Hiller had scrawled.

In other words, the irrationally automatic is recuperated through the rationally controlled. This ironic turn becomes even more ironic if we take the mention of 'Menon' literally (even at the risk of speculation, since obviously the outpouring of automatic writing cannot really be taken for a conscious ironic reference). One might think of the 3,400-year-old Colossi of Memnon in Egypt, but there are also surprising resonances with Plato's Socratic dialogue *Meno*, named after Menon III of Pharsalos, a young Greek general. Socrates discusses with him the possibility of defining virtue. Menon spouts the sophistry that one cannot look for what one doesn't already know. Socrates answers by picking an uneducated slave from Menon's entourage, helping him to discover how, through geometry, one can determine twice the area of a square – a demonstration of what Socrates considers a spontaneous recovering of knowledge, whether from the world-spirit, or from a past life. There is no mention of sisters in Plato's text, nor of Plato in Hiller's, but the 'Sisters of Menon' precisely manifest that lack of female involvement. They take the positions of both Socrates and the slave, and tap into suppressed regions of knowledge as a means to crack open the question of the connection between virtue

and power (female collectivity and emancipation) as well as that of form (the geometry of the L-shapes and the cross, the scribbles and the typewriter, capturing the ambivalence between freeform expression and minimalist-conceptual formalization). But given the precondition that the mention of these 'Sisters of Menon' is not consciously controlled in the first place, all of this amounts to a conceptual proposition that is uttered in the spirit of undermining the very fetishisation of the proposition.

The description included in the piece ends with two sentences in capital letters: 'MESSAGES SUPPRESSED BY THE SELF DO NOT CEASE TO EXIST. MESSAGES SUPPRESSED BY CULTURE DO NOT CEASE TO EXIST.' This is a basic lesson of both psychoanalysis and anthropology (and, with Marx's fetish commodity in mind, of economy). Questions such as 'Do you believe in ghosts?' or 'Do you believe telekinesis exists?' are somewhat beside the point for someone versed in these fields: collecting stories of the mysterious is not primarily about ascertaining the existence of supernatural phenomena, but about exploring them as manifestations of the individual or collective imagination (not excluding, crucially, the imagination of the person who is doing the inquiring).

Collective fantasies and anxieties are virulent in an even more concrete and pressing way in a cycle of works that is otherwise more serene, factual, indexical: *The J. Street Project* 2002–5 (pp.104–7). Here, Hiller completed the self-assigned task of visiting all 303 places scattered across today's Germany where the names of streets, alleys or paths refer to a Jewish presence. She recorded their present-day existence in the form of static camera shots edited to a feature-length film, as well as photographs, wall displays and a book. Choosing a Conceptual, technological-serial approach over a conventional narrative style, in the film she nevertheless alludes to the pervasiveness of collective anxieties, for example with the use of background music. Several street scenes feature musical-box melodies or church bells; these act as motifs of childhood or village cosiness, which is of course a device we know from horror films, signalling repressed trauma and lurking violence. As the accumulation of street signs such as 'Judengasse' or 'Jüdenstraße' become loaded with significance, these streets and corners are held in suspense between attesting to the historical wealth of Jewish life in Germany and its destruction, between stigmatising naming and the naming of this naming. Here, as with the process of fetishisation, there is a split between that which has been actively 'forgotten' or repressed and that which is 'remembered' or idealised – a process that is better described, depending on where it is situated on an upward scale of self-reflection, either as denial or the work of mourning.

Photographs from
The J. Street Project 2002–5
see pp.104–7

'Messages suppressed by culture do not cease to exist': Hiller approaches and actually proves this insight in yet another filmic way with *The Last Silent Movie* of 2008 (pp.114–15). The single-channel cinematic projection presents us with a collection of original sound recordings of endangered, fully or terminally extinct languages, subtitled in either English, German, French or Spanish. The result is a twenty-minute mixture of obscure, moving and haunting recordings: of an old man speaking South African K'Ora, who challenges, with prophetic poise, those 'sons of the sea' from Europe to *listen* for once to his beautiful language; or a soft-voiced man, accompanied by guitar and bursts of laughter, telling the Dadaistic little story of a cricket befriending a ball of mud, in Waima'a, a language from East Timor. These recordings of verbal language mark the (imminent) absence of that very language – and yet are thick with physicality, and given their status of extreme rarity, thus become a kind of aural fetish. The term 'fetish' was coined in the eighteenth century in response to religious practices encountered by the colonisers in the indigenous cultures they had subjugated that entailed the belief that a man-made object has power over others. It is tragically ironic that the labour that went into the production of the critical abstract language revolving around the term 'fetish' took place in the same era, the nineteenth and twentieth centuries, that saw the silencing of the very languages from the regions where that concept had first been encountered.

So how can Hiller's film be a last, and silent, movie? With its onscreen inter-titles announcing the respective language source, it conjures the era and genre of the silent movie; it replaces the aural silence with visual silence, i.e. the absence of contrasts, figures and visual space (the screen remains black save for the titles and credits). Though recorded mostly in the post-silent-movie era, the crackles and hisses of the aural material alone, like abrasion marks on old film stock, provoke the sense of the summoning of ghosts from a bygone age, and, most crucially, the silence of the languages themselves in the moment of, and after, their death. The vast majority of these recordings cannot be sourced on the internet, but are housed in academic archives – 'collected' as though separate from their human speakers – where they die a second silent death. Since they are not normally available to non-specialists, hardly anyone accesses them. The work uncovers this silence, implicitly raising the question of why, as Hiller has put it, 'we value creating archives more than sustaining people'.[5] *The Last Silent Movie* itself is what ensures that 'messages suppressed by culture do not cease to exist'.

The J. Street Project and *The Last Silent Movie*, in different ways, use the stripped-down aesthetics of 1960s Conceptualism and Minimalism against the grain. In her

1980s and 1990s works such as *Belshazzar's Feast* 1983–4 (pp.78–9) – a mixed-media installation about sightings of unusual phenomena on TV monitors in 1980s Britain – and *Psi Girls* 1999 (pp.96–9) – a five-screen video projection composed of short sections taken from five Hollywood films depicting adolescent girls capable of telekinesis – Hiller had already, although less obviously, invested Conceptual methodologies with the 'mysterious' (and vice versa, subjected the mysterious to Conceptual scrutiny). She did not do so just for the sake of a pursuit of the counter-intuitive. This was about more than that. Many of her works implicitly tackle a central conundrum of Conceptual art practice: if it rid itself so neatly of the unconscious, private, spiritual, mystical (as in, not yet understood) parts of the process of artistic labour manifested in the fetishised art object, didn't that mean that there was still a vanishing trick at work? Didn't this mean lifting the veil from the 'social character' of artistic labour, and, in the same go, drawing it over those 'irrational', supposedly private psychological factors? Thinking this through, the consequence is indeed ironic: while eliminating the fetishised object, the rationalistic Conceptual proposition runs the risk of becoming just as fetishised, since it follows a similar logic of rendering invisible the – psychological, but also social – labour that went into producing it. The problem is not the Conceptual method, as such, but the fact that it often involves an attempt to make the idea or proposition appear as if it had occurred out of the blue, like an apparition – just like the commodity fetish.

This becomes even more ironic and pressing at a time when knowledge and ideas have become commodities of advanced capitalism, wares to be exchanged and speculated with. The Conceptual artwork behaves like the séance table, 'standing on its head' to produce 'grotesque' ideas, as Marx said. That can of course be fascinating, just as commodities are often fascinating. But it also begs the question whether Conceptual artworks are truly – as they often implicitly claim to be – self-reflective of their own production. First, the immediate social preconditions of artistic production must be taken into account – whether it is dad's monthly allowance, the unpaid transcription work of a lover, the hidden camera operator or editor, or the (awkward) presence of one's own body in production and presentation. Second, the intellectual, 'mental' preconditions of producing forms and ideas must be acknowledged – i.e. the ambition and anxiety, and among the latter most notoriously, in the famous words of Harold Bloom, the 'anxiety of influence' – the artist's stifling awareness of work he admires, or to which he owes a debt.

Many of Hiller's works, it seems, are precisely about making these mental and social preconditions the actual *material* of the work – yet not in an exposing, accusatory way. The dilemma for Conceptualism is that in order not just to trade

in fetishised objects for fetishised artistic propositions, the work would have to expose the social character of the production of that proposition. Yet that very exposure is extremely problematic: if it succeeds, it might do so at the expense of those who are subject to social scrutiny (or patronage); if it fails, purposefully or not, it results in a fetishisation of the *gesture* of exposure, at the expense of that gesture's supposed effects.

Hiller's work is a complex answer to this dilemma. In shorthand: rather than denying the social character of production or claiming to be able to subject it to total transparency, she artistically concedes that there is something inevitably ambivalent and concealed about that production. Rather than giving away a secret, she confirms that it exists – while still keeping it. And rather than claiming the immaculate conception of an artistic idea, her work makes clear that certain other factors were involved, not reporting on them in detail however, but leaving the rest to the imagination. It is as if, rather than saying: this is the case, she is saying: this is what I state to be the case, but I won't prove it, so you have the option to make that leap of faith with me or not.

Since 2008, Hiller has made (or completed) a number of works in homage to other artists, namely to Joseph Beuys, Yves Klein, Marcel Duchamp and Marcel Broodthears (she is also considering works based on Man Ray and Gertrude Stein).[6] These pieces exemplify the enlightening strategy of exposing, rather than explaining away, ambivalence and concealment. The material of *Homage To Beuys* 1969–2010, almost literally and physically, is the viewer's willingness to invest belief. Hiller has collected water from holy wells and sacred springs around the world, and decanted each sample into small Victorian medicine vials of varying shape and colour, which she places in felt-lined wooden cabinets. 'These little bottles of waters are more than just souvenirs', she has said, 'they are containers of an idea about the potentials hidden in ordinary things and experiences'.[7]

Believers want to trust that the souvenir vials they buy at pilgrimage sites are not just filled with ordinary tap water; Hiller, in turn, makes us want to trust that

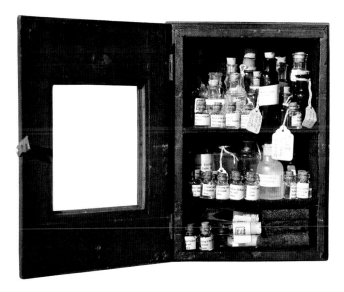
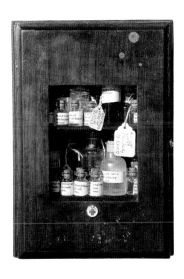

she actually made all these far-flung trips, rather than just opening a London tap. But as much as I am convinced that Hiller did make them – turning banal tourism into a pilgrimage whose ultimate destination was the completion of her own artwork – I still question what actually distinguishes ordinary water from sacred water. After all, water is part of an endless circulation, so whatever made water from a specific place sacred would in any case be dispersed elsewhere. (Or is sacredness a question of percentage?) In this sense (as Hiller herself has said),[8] a priest filling vials with tap water in a place of pilgrimage is, strictly speaking, not a trickster but simply someone who works on the premise that God is in all things.

It is the psychological labour involved in the willingness not to ask where the water actually comes from that makes the social labour of producing vials of holy water disappear. That is the parallel between the fetish and the relic: both build on the split that allows for idealisation, impossible without the deep connection to that which is repressed, whether the fear of disempowerment, or more fundamentally, the fear of dying. The relic is just the 'cleaner', more Apollonian version of that same mechanism, and in that sense the splitting of the split: it involves a cleansing of the dirty Dionysian fetish, as well as its elevation to the status of a true transcendental remedy. What makes Hiller's work all the more striking is that she chose vintage Victorian vials collected from dumping sites in the mud along the river Thames. The Victorian era was a transformative period where the newly developing mass society was trying to keep the symptoms of its secularisation and rationalisation in check with the help of all sorts of magic potions and neo-spiritualist pastimes. Its rationale for doing so was similar to that of the fetishist who knows the object of his obsession is only a fantasy and yet still feverishly believes in that fantasy.

Which is where Joseph Beuys comes in, a short century after the Victorians. It is relatively easy to dismiss the Beuysian strategy of charging ordinary materials with the aura of the relic (the artist as supreme choice-maker, the vitrine as warrantor of sacrosanct value) as being dubiously invested with a Wagnerian pathos of sublime profundity, or worse, an ambition to whitewash German guilt with shamanistic healing – while at the same time implying the kind of cleansing act that also produces the commodity fetish. But that dismissal only works at the price of ignoring Beuys's humour – in both senses of the word: mood and wit. Even those who can only see the shaman in Beuys would have to admit when listening to his sound piece *Ja ja ja ja ja, Nee nee nee nee nee* 1969 his unusual knack for parody: a stack of felt enfolds an audio-recording of Beuys muttering, for more than an hour, a playfully doubtful, mockingly deliberative succession of 'yes' and 'no', interrupted only by the odd involuntary chuckle.

The strategy of charging ordinary things with an aura of the sacred is ironically exposed as a machination in Beuys's work. But like the fetishist who insists on his fantasy despite knowing it to be one, this doesn't diminish the power of the work. The power of the mysterious in this sense is truly performative in the language-analytical sense of the word: it is called into being by being declared. Therefore Hiller's collection of Victorian vials – rubbish from the river bank filled with sacred water – is indeed an appropriate homage to Beuys. By making us aware of the collective willingness to believe, she makes this collective willingness visible as a 'social labour', the main means of production for which is the imagination. This not only provides a valuable critical insight into Beuys' concept of 'Social Sculpture', but highlights Hiller's continuing endeavour to unravel the fetishised Conceptual proposition.

From a leap of faith to Yves Klein's *Leap into the Void* 1960, and to Hiller's *Homage to Yves Klein: Levitations* 2008 (pp.118–19). In 1995, Hiller wrote a catalogue contribution for the Hayward Gallery's *Yves Klein Now: Sixteen Views* (1995) explaining that she first saw footage of his famous painting actions around 1962–3 in the context not of fine art, but of trash movie. Curiously, in *Mondo Cane* (1962) – an Italian exploitation-documentary delivering a wild collage of footage from around the world that shows sexual and violent customs in an attempt to both shock and entertain – there is a sequence showing one of Klein's *Anthropometries*, which involved covering naked women in paint and creating monoprints from their bodies. 'Klein protested about the way his work was shown in *Mondo Cane*', writes Hiller:

> but there is something very appropriate about its inclusion and its use
> as a kind of paradigm of the primitive within the modern – the artist as
> sexualized savage. Granted, the film tells us nothing about Klein's intentions,
> but equally, it doesn't tell us anything about the [African ethnic group]
> Nuer and theirs. It seems to me that a lot of what's happened since 1963 has
> been on behalf of reclaiming whatever intended meanings the behaviour
> of Klein and the Nuer might have had for them, releasing those meanings
> from the grip of a puritanical, colonial, sexist, middle-aged author with
> a privileged overview.[9]

In other words, *Mondo Cane* is a good example of how the process of fetishisation works by way of ignoring intentions and meanings. In regard to Klein, Hiller is interested in reversing that process.

Her springboard is the photograph 'documenting' Klein's *Leap into the Void* realised in October 1960 on Rue Gentil-Bernard, Fontenay-aux-Roses. This iconic

137

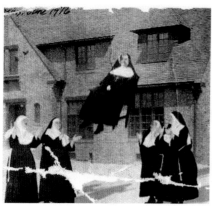

image shows the artist jumping off a wall, his arms stretched out and his head held upwards as if on an LSD trip that has made him believe he can fly, only to hit the hard tarmac the moment after the camera clicks. The image was published – as Hiller notes in the introductory text to her little book of levitations in homage to Klein[10] – with a caption explaining that the artist 'who is also a judo champion, black belt, 4th Dan, trains regularly in dynamic levitation (with or without a net!), at risk to his life.' However, the image is in fact a meticulously made montage: Klein actually jumped onto a tarpaulin. He had studied Judo in Japan, but that of course would not qualify anyone to actually levitate. With descriptions like this, Klein knowingly employs the language of the sideshow announcer in the realm of avant-garde art ('Step right up, don't miss the Bearded Lady, and the judo champion levitating at risk to his life!'). The photo is retouched, the 'social labour' of those fellow *judoka* holding the tarpaulin is made invisible, and yet with his playfully exaggerated tone Klein gives away the image's fabricated nature without explicitly admitting it.

Again, as in her Beuys homage, Hiller's intervention focuses on this connection between knowing that something is just a fantasy and yet still believing in it, which runs parallel to the connection between apparent mystery and unapparent humour. She collected from the internet a critical mass of images of people showing themselves supposedly levitating: there are the yogis with bad Photoshop skills; the Yves-Klein-Leap-Into-The-Void impersonators; those who horizontally levitate like the demonically possessed girl in *The Exorcist* (1973); those who levitate vertically like Jesus going to heaven; and those who simply jumped at the instant of exposure. Some images are historical, amongst the early attempts to use photography as a magician's tool (like the man jumping and releasing the shutter in front of an early twentieth-century audience with closed eyes, making them all believe he levitated), most are contemporary. These contemporary 'sometimes-enchanting, sometimes-ludicrous levitation images', as Hiller puts it, 'were not made to mislead viewers into believing their subjects possess the supernatural talent of overcoming gravity. Rather, on a more profound level, I think these pictures are expressing a collective aspiration for a revised version of the human being – poetic, imaginative and powerful, with as-yet unrealized abilities and potentials.'[11] By collecting these images and presenting them in a uniform grid – picture after picture – Hiller dismantles the fetishised singular artistic proposition; and yet she stops short of assuming the self-important posture of the myth-buster. Instead, she lets the fascination of the

**Levitations: Homage to
Yves Klein** 2008
details, see pp.118–19

mythical, in levitated suspense between the sublime and the silly, speak for itself in the public domain.

In the case of *Homage to Marcel Duchamp* 2008 (pp.120–3), Hiller did not choose one of the iconic works, but an early, less well-known painting: the *Portrait of Dr R. Dumouchel*. This work of 1910 was painted when Duchamp was still under the influence of late Impressionism, Symbolism and Fauvism – all of which can be seen in the slightly exaggerated facial features, the only partly natural iridescent colours, the solemn profile pose, and most notably, the strange halo-like sections outlining the body and especially highlighting the hand of Duchamp's childhood friend, an ambitious medical student working in the then-new field of radiology. It is as if the physician, screening and inspecting the body in a strictly rationalist way, has suddenly crossed with the layer-on of hands, and the idea of radiology with that of 'aura' radiation, the spiritual concept promoted by followers of Theosophy, who believed that we are surrounded by differently coloured luminous layers.[12]

From today's perspective, Duchamp's readymades – a urinal, a comb, a snow shovel, all ordinary manufactured objects – could not seem further away from such spiritualist pathos, or from any sense of 'aura'. And this was certainly part of Duchamp's idea. Walter Benjamin's oft-cited notion that in the age of mechanical reproduction the artwork had lost its 'aura' operated on the assumption that the awe and reverence a work inspired would not only have to do with its uniqueness but with its supposed connection to the spiritual or magic sphere, confirming existing power relations of religion and politics.[13] Benjamin was utopian-leftist in the sense that he saw the shattering of the aura through art's mechanical reproduction as a development emancipating the mass audience. His Frankfurt School fellow Theodor W. Adorno remained much more sceptical about mass consumption. The Marxian understanding also seems to contradict Benjamin in at least one way: it is precisely mass production that allows for the aura – what Marx called the 'metaphysical subtleties and theological niceties' – of the fetish commodity that the exchange value confers. In Duchamp's readymades, the seeming contradiction (unique art object versus reproduced commodity fetish) eventually collapses, which is the necessary precondition for Pop art and seriality, which further accelerated this collapse. Against this background, for Hiller to choose of all things Duchamp's aura painting, and to collect her own series of internet images of people depicted with their 'auras' (usually by way of photomechanical or digital montage) is yet another turn of the screw. Again she creates a series of images presented in a grid, this time

sorted according to the dominant colour (green, blue or red). Interestingly, most of the subjects are smiling in a kind of touristy, happy-go-lucky way, perhaps induced by the 'souvenir' aspect of being photographed with one's aura. These images are as 'colourful as a bag of sweets', says Hiller, and indeed they convey a sense of blissful banality that is close to Pop art (though, counter to 1960s Pop art, privileging the audience-as-makers over the artist-as-maker).

But perhaps more importantly, there is an implication here about Conceptualism: the canonical Conceptual view of Duchamp as the instigator of the de-fetishisation of the art object and of the shift from pure visual-physical presence to pure idea suddenly seems (productively) blurred by Hiller's insertion of the very factor that had seemingly been shattered along the way – aura – i.e., that strange connection to the magical, the unknown. Crucially, in Hiller's piece, aura appears not as the emanation of the unique artistic proposition in Benjamin's sense, but as a collective production in Marx's.

In comparison to Beuys, Klein and Duchamp, Marcel Broodthaers's work much more openly lends itself to favouring 'social labour' – detectable in the way ordinary objects are collected and organised – over the fetishised art object or fetishised idea. Hiller here takes as her starting point one of his best-known pieces, *Un Voyage en Mer du Nord* (A Voyage on the North Sea, 1973–4). This work consists of a book display on a shelf and a six-minute 16mm film that essentially shows the same thing in a different medium. It is at least a minute into the film – after numbers, empty frames and a title announcing 'page 1' – before anything 'happens': the still image of a white sailing boat on a quiet sea appears. More page numbers follow, and more still frames, until we get to see close-ups of an amateur nineteenth-century naval painting – some so close up that they abstract the painting to the grainy surface of the canvas – juxtaposed with more shots of the yacht, eventually seen against the backdrop of a contemporary city skyline.

At around the same time as Broodthaers realised this piece, Hiller was working on her major work *Dedicated to the Unknown Artists* 1972–6 (pp.52–5), collecting 305,

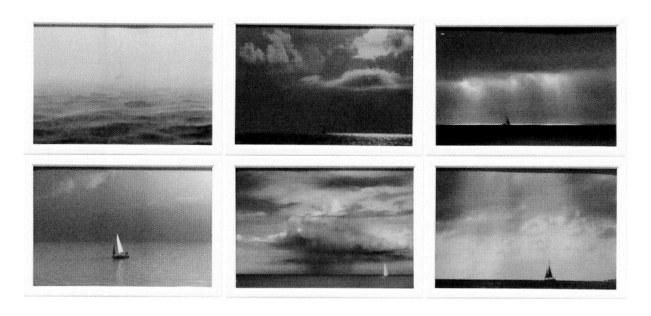

mostly vintage, postcards of rough-sea scenes of the British coast and defining the process of collecting and analysing them as 'curatorial'. The postcards are organised into a strict minimalist grid pattern (grouped into categories and themes) and analysed in accompanying charts and booklets. The images of great waves are combined with a generic title resonant with the famous British irony about bad weather, while the unknown colourists invest the work of the unknown photographers with a decorative hint of the painterly. Solitary, romantic contemplation of the ocean is duplicated a multitude of times. Hiller resists the temptation of delivering the loud impact achieved by grand individual images, opting instead for a quiet emphasis on duplication and serialisation. Thus the sublime or picturesque motifs – with their subtext, as clichéd as it may seem, of romantic desire, the soul in turmoil, and longing for nature – collide with the strict Conceptual methodology, resulting in a kind of affective restlessness.

This restlessness is close in spirit to Broodthaers's endeavour, which Hiller acknowledges by referring to a conversation between them that had taken place in London in 1972.[14] In 2009, she made a work in two parts – *Voyage: Homage to Marcel Broodthaers* and *Voyage on a Rough Sea: Homage to Marcel Broodthaers* (pp.116–17) – that are hybrids of her own piece and that of Broodthaers. The first is a series of colorised digital prints of single boats on a quiet sea; the second is of sailing ships in rough sea. Broodthaers's concern with the transformation of motif and media from nineteenth to mid-twentieth century is reframed and take into the twenty-first century. What becomes apparent is that Broodthaers's piece latently implies what Hiller's makes explicit: the dedication to unknown artists; or – to bring Marx's notion of the 'social character of men's labour' into play one last time – the dedication to the labours, of art as much as of love, feeding into the collective imagination.

With the Homage works, Hiller has cleared a ground and clarified an important issue, finally and firmly staking her claim. These works deflate the idea of the singular artist genius pulling off the magic trick, and they do so by bringing into play the public domain (for example the shared practice of all the people who have starred in the photos of the *Duchamp* and *Klein* series), and yet they still keep intact the allure of the works paid homage to. Hiller's works reveal a kind of irony that is equally devoted to the seriousness of a conceptual proposition – truth – and to undermining and exposing the suppressions that this very devotion to seriousness entails – humour. They make explicit what is implicitly present in Hiller's entire oeuvre throughout the decades: that one doesn't need to render invisible the social labour that went into producing the work in order for it to be powerful. In so doing she recovers and confers status on that which has been forgotten and overlooked.

Voyage on a Rough Sea:
Homage to Marcel Broodthaers
2009
detail, see p.117

well ... Here

We are your

Sister

from

Theresa

In an interview with Jörg Heiser and Jan Verwoert of 2007, looking back on the history of Conceptualism from the late 1960s to the present and her own changing position within it, Susan Hiller pinpoints a gender-specific pattern of marginalised alternative practice in which the unconscious was wilfully acknowledged, even at the expense of theoretical legitimation:[1] '[We] moved sideways … We wanted to say other things … other than what's already in language … not necessarily feminist political things, but other kinds of things, and you couldn't do that without inventing other ways of going about the whole procedure of making art.'[2]

As Adam Szmczyk noted: 'Retrospectively it is difficult to overlook the importance of Hiller's early decision to work with and on cultural materials whose meanings have been repressed, suppressed, censored or simply ignored.'[3] At the time, however, moving 'sideways' in order to act and be otherwise, sidestepping instead of turning away, was a prodigious response to exclusion. It calls to mind counter-cultural strategies that were enabled by the Women's Liberation Movement, if not always developed within it, as well as earlier radical projects of the 1960s such as the Peace movement and the Black Liberation movement. It evokes critiques of 'progress' and linearity and the rejection of vertical hierarchies in favour of the equality that lateral connections permit. It might be misleadingly narrow to brand such strategies as 'feminist', unless feminism is defined in terms of a continuous revolution of the everyday and in history, from the perspective of socially oppressed womanhood and culturally repressed femininity. The feminine itself stands for an exemplary manifestation of the repressed: not only is the feminine repressed but the repressed is feminine.

'Moving sideways' reveals a style of intervention that is typical of Hiller's thought and practice and reverberates with multiple significations. While it places her oeuvre in a historical canon from which it had been excluded, without erasing its previous exclusion or its specificity, it also signposts Hiller's affinity with second-wave feminist thought at its nascent, avant-garde moment. Furthermore, it alerts the reader/viewer to the importance of metaphors in Hiller's art and texts, the weight they hold in her perception of the world, and their analytical and transformative function in her practice. In 'Women, Language, Truth', a contribution to a panel discussion organised by the Women's Free Art Alliance in London, in 1977, Hiller deployed the same metaphor, albeit in disguise: 'Each of us is simultaneously the beneficiary of our cultural heritage and the victim of it. I wish to speak of a "paraconceptual" notion of culture derived from my experience of ambiguous

143

Sisters of Menon 1972/9
detail, see pp.62–5

Moving Sideways and Other 'Sleeping Metaphors': Susan Hiller's Paraconceptualism

Alexandra M. Kokoli

placement within this culture. This placement has been painful to recognise and difficult to express.'[4]

In retrospect, the neologism 'paraconceptual' does more than signify the ambiguous, ambivalence-inspiring mixture of belonging and not belonging, victimisation and complicity. These ambiguities have been extensively explored in Hiller's work, as they describe her poetics, and are politicised in her texts on the rejection of anthropology and the implications of primitivism in art.[5] Elsewhere, it is the possibilities opened up by this precarious self-positioning that are emphasised: 'like being a foreigner, being a woman is a great advantage'.[6] Just to the side of Conceptualism and neighbouring the paranormal, a devalued site of culture where women and the feminine have been conversely privileged, the 'paraconceptual' opens up a hybrid field of radical ambiguity where neither Conceptualism nor the paranormal are left intact: the prefix 'para' allows in a force of contamination through a proximity so great that it threatens the soundness of all boundaries. In this way, 'paraconceptualism' (if I may turn the adjective into the 'ism' that I believe it to be, however unstable and destabilising), evokes a familiar trope of violent defamiliarisation typical of the uncanny. The uncanny, a sub-species of that which inspires horror, 'is in reality nothing new or alien, but something which is familiar and old-established in the mind and which has become alienated from it only through the process of repression'.[7] In his famous essay 'The Sideshow, or: Remarks on a Canny Moment', Samuel Weber argues that the 'off-beat, off-sides' (*abseits*) fate of the concept of the uncanny in critical theory suggests an innate feature of the uncanny itself.[8] When Freud, in his essay of 1919, approached the topic from the margins (through semantics and etymology, while he claimed to be focusing on aesthetics), seemingly digressing from his thesis (the rather deflating assertion that the uncanny hinged on castration), and with the apprehension of someone who has veered off their area of expertise (a psychoanalyst commenting on aesthetics), he did not merely examine a concept but outlined a manner of investigation that is haunting because it is haunted by its troublesome subject matter.[9] Considered through this sideways approach, nothing is what it seems: 'Uncanny is a certain undecidability which affects and infects representations, motifs, themes and situations, which … always mean something other than what they are and in a manner which draws their own being and substance into the vortex of signification.'[10]

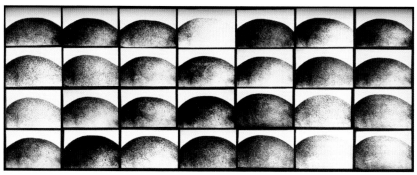

10 Months SIX

In using the expression 'moving sideways' in her discussion with Heiser and Verwoert, Hiller draws out and nearly literalises the spatial metaphor of the 'paraconceptual' employed thirty years earlier. Here lies yet another important layer of the significance and signification of metaphors in Hiller's work: by translating the Greek prefix 'para' verbatim and stripping it, for a moment, of its acquired connotations, Hiller slows down language and deprives its users of the conceptual shortcuts to which they are accustomed. She turns a dead metaphor, one that has had its figurative value suppressed through common usage, into live, vigorous signs. The poetic function of putting grit in the flow of everyday language was originally noted by the Russian Formalists, while its radical potential has been mined in feminist theory and creative practice. As Emily Martin has commented:

> One clear feminist challenge is to wake up sleeping metaphors … Although
> the literary convention is to call such metaphors 'dead', they are not so much
> dead as sleeping … and all the more powerful for it … Waking up such
> metaphors, by becoming aware of their implications, will rob them of their
> power to naturalise our social conventions about gender.[11]

Hiller's photograph and text installation *10 Months* 1977 (pp.58–61) conjures up a pair of heavily interconnected and, historically, mutually exclusive concepts: that of creation (creativity) and procreation.[12] By documenting and working through 'her observations of the bodily and psychic journeys she underwent during this fecund period' of pregnancy in a series of photographs and texts,[13] Hiller also charts, scrutinises, and by doing so resists, the operation of a gender-specific silencing, and exorcises a writer/artist's block exacerbated by women's procreative function. The text eloquently probes the mechanisms by which gestation, despite – or rather because of – serving as a pervasive metaphor for artistic and intellectual endeavour since Romanticism, enforces a sexual division of labour that neatly maps out male and female onto their metaphorical and literal significations. Women/mothers literally produce offspring; men/artists metaphorically give birth to ideas/art. 'There is nothing she can speak of "as a woman". As a woman, she cannot speak.' (Month Six). By writing in the third person, Hiller wards off the sentimentality that would stereotypically be read into a woman's artwork about pregnancy, yet also creates a more ambiguous lag between what is written and what remains outside/beside representation, not through lack of means but, on the contrary, due to a confining

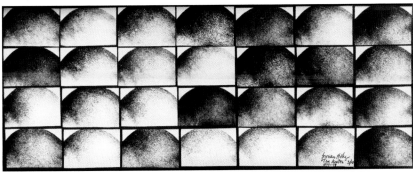

10 Months TEN

proliferation of multiple, incommensurable 'ways of knowing' (Month Ten). The work concludes on a positive note, by documenting the arrival not of a baby but of the epiphany that contradictions and inconsistencies need to, and will be, embraced. The (pro)creator artist/mother occupies the difficult yet also privileged subject position from which this becomes simultaneously necessary and possible. While seemingly being 'about' a pregnancy, *10 Months* also crucially represents the symbolic birth of what Hiller has often referred to as 'fruitful incoherence'.

In Hiller's work, written and oral forms of automatism are both objects and methods of investigation, often emerging as the royal road to this fruitful incoherence. In *Belshazzar's Feast, the Writing on Your Wall* 1983–4 (pp.78–9), a video work broadcast on Channel 4 and installed in galleries on TV monitors often placed in spaces organised like living rooms, the screen is taken up by a close-up of a burning fire, evoking the replacement of the hearth by the television set. The title refers to a biblical story from the book of Daniel about a feast, in the middle of which a hand mysteriously appeared and wrote on the wall '*Mene, mene, tekel, upharsin*'. According to the interpretation of the prophet Daniel, the only one capable of making out the writing's meaning, Belshazzar and his circle had been judged and found wanting for worshipping the false gods of gold and silver and would be punished. Daniel turned out to be correct and Belshazzar's kingdom was eventually destroyed, though what makes the story important to the work is 'the distinction between literally reading … and interpreting … signs or marks'.[14] On the soundtrack, two voices can be heard: of a child, the artist's son, describing from memory Rembrandt's painting of Belshazzar's feast, and that of the artist herself singing or chanting in an improvised non-language, an example of verbal automatism that references 'speaking in tongues' in mystical traditions as well as scat singing in improvised jazz. The 'voices of the dead' experiments of Latvian scientist Konstantin Raudive are also an important contextual reference for this work and for other sound installations like *Elan* 1982. Raudive believed that the voices of those long gone may still be detected if recordings of apparent silence are sufficiently amplified. The veracity of such claims is besides the point, although recording technology has made it possible – and ordinary – to listen to voices of people now deceased, with little recognition of the uncanny quality of this auditory channel between the dead and the living. What matters most for Hiller is that nothing is always something, from another perspective, simply hovering 'beneath or beyond recognition' and it is the job of the artist to make it visible or imaginable.[15] *Belshazzar's Feast* restores the possibility of reverie in front of the set, while acknowledging its multiple uses in everyday life. Hiller made this work after reading newspaper articles about people seeing ghost images in TV

146

static, after transmission was over. The broadcasting of *Belshazzar's Feast* on British television, into real living rooms, and its installation in mock living rooms, stages a deliberate home invasion of the forgotten, repressed function of the hearth. This is an exemplary case of the uncanny as something that is not frightening in and of itself but only becomes so through its repression, something that 'ought to have remained secret and hidden but has come to light'.[16] By being discarded as unexplained and thus assumed inexplicable, illogical and therefore illegitimate, the 'insights' that come from sensing without understanding, interpretation without reading, are rejected and as a result take 'warped and twisted' forms.[17] Besides, the mock living rooms of *Belshazzar's Feast* make a mockery of domesticity and its associations with family, familiarity, comfort and security. These deceptively cosy places translate the uncanny (*das Unheimliche*) verbatim as unhomely.

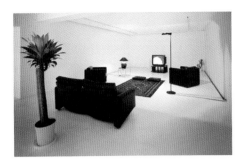

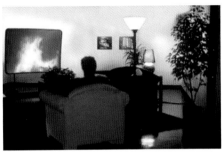

In Hiller's oeuvre, mining the cultural unconscious is a constant, almost a signature. The four-channel video installation *An Entertainment* 1990 (pp.82–5) teases out the almost demonic taciturnity, violence and power relations in Punch and Judy shows, with the sharpness of a foreigner's perspective. 'In the boxing match sequence … the screen is split between magic lantern slides of Death in boxing gloves … and an upper compressed section in which Punch and Judy move towards each other from opposite sides in slow motion.'[18] Yet this is no polemical critique of the popular spectacle but, strangely, an almost sympathetic and certainly respectful exploration of its potential for collective contemplation and lucid reverie. One interpretation of Hiller's self-designation as a populist is her appreciation of popular genres and forms of entertainment. *Psi Girls* 1999 (pp.96–9) also delves into and transforms the popular spectacle it revisits: large-scale projections of anthologised Hollywood film sequences of young girls with telekinetic powers, each suffused in a different primary colour and with a soundtrack of gospel clapping and singing, create a quasi-immersive environment of 'ludic wildness'[19] in which the dialectic between rationalism and supernatural belief is sublimated into a disquieting force that challenges (and awakens) the dead/sleeping metaphors that tie knowledge to vision. *Witness* 2000 (pp.100–3), a thicket of earphones suspended from above, is an audio archive of reported UFO sightings in a range of languages. As Louise Milne observes, 'the aesthetic effect of listening to these voices … has little to do with our categories – fact or fiction'[20] (thus provoking an evocative tension between testimony and fable, memory and creativity), or indeed understanding in the narrow sense. As in the improvised non- (or pre-?) linguistic chanting in *Belshazzar's Feast*, the voice is here restored to 'the material element recalcitrant to meaning',[21] an ideal vehicle for the return of the repressed.

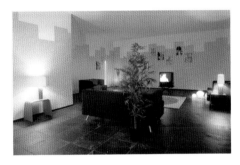

147

Belshazzar's Feast 1983
see pp.78–9
Installations at:
(top) Fundación Eugenio Mendoza,
Caracas, 2001
(middle) University Art Museum,
California State University,
Long Beach, 1988
(bottom) SMAK (Stedelijk Museum
voor Actuele Kunst.), Ghent, 2004

The infectious and destabilising vigour of Hiller's lateral, uncanny-ing strategies undermines the rationale, assumptions and modus operandi of disciplines and institutions by drawing attention to their lacunae: the archive, museological display, anthropology and psychoanalysis are all targeted. Writing on Hiller's *From the Freud Museum* 1991–6 (pp.86–9), Denise Robinson draws attention to the willful blurring of archive and debris.[22] An assortment of a few uncategorised fragments from Freud's collections (including replicas of Disney cartoon slides that belonged to the Freud family) and the artist's personal objects and annotations (water samples from sacred sites, accompanied by a typology of religious practitioners, for example) is displayed in custom-made archaeological collecting boxes. By focusing on the odd bits, the marginalia of Freud's archive, and punctuating them with her own, Hiller brings into question the precarious positioning of psychoanalysis as a science, on which Freud strongly insisted, to return it to its darker, devalued, repressed roots in myth and storytelling, animism and the paranormal.

'YOUR SISTERS FROM THEBES'[23]

The automatic-writing project, installation and artist's book *Sisters of Menon* 1972–9 (pp.62–5) is another work that deals with voices, automatism and the culturally repressed.[24] It operates in (at least) two registers, consisting of twenty pages of automatic writing, typed transcripts and *Notes*, each of which reflects on the work in a different style and tone, while also forming part of it. Completed in 1979, when Hiller undertook the transcription of the retrieved automatic scripts made seven years earlier and wrote the accompanying *Notes*, *Sisters of Menon* spans a crucial decade for feminist art practice and extends into the 1980s, with its publication as an artist's book in 1983 by Gimpel Fils. In installation, the scripts are arranged in cruciform, with the *Notes* and transcripts positioned at the edges of the horizontal axis. The shape of the cross is repeated in the background of the typed transcripts and appears again as a grapheme within the automatic script. In the transcripts, all automatically produced marks that do not correspond with letters are replaced by dashes, apart from the encircled 'X', which is a Cathar symbol and copied intact. This symbol provides a link between the work and the location where the scripts were made, the French village of Loupien in the Cathar region, where Hiller was staying in 1972: 'Cathars followed a Gnostic tradition, which leads to interesting ideas about religion and gender.'[25] Certain Gnostic sects 'speak of the feminine element in the divine, celebrat[ing] God as Father and Mother'.[26]

Notes I serves as an introduction to the work, explaining its method (automatic writing combined with gestural automatism, resulting in hybrid letter-drawings) and its history: the scripts were produced 'automatically', in a state of altered consciousness (which, however, as Hiller insists, 'didn't seem freaky')[27] during the artist's stay in Loupien. The scripts had been lost and only 're-appeared … almost exactly seven years after their transmission'.[28] They were not rediscovered, but found their way back from oblivion 'automatically', as if of their own accord. The Greek word *automatos* contains the meaning 'self-acting', with the 'self' being, however, devoid of consciousness. The handwriting and 'voice' in which the inscriptions were made are not Hiller's typical style, even though her hands did the writing. When used, the possessive pronoun ('"my" hands') is suspended in quotation marks. Whereas the automatic scripts stand for the artist's participation in an altered state of consciousness, the *Notes* that frame it reveal a systematic and informed reflection on automatism and the work itself: *Sisters of Menon* proposes that these two positions (scientist and artist vs. medium and lunatic) need not be incommensurable, but can be occupied alternatively and at will, while at the same time acknowledging that social and cultural conditions rob certain social groups of such flexibility. The work, which may or may not be read as 'primitive' self-expression or an '"occult" phenomenon', poses and responds to the question: 'Who is this one?'[29] Already embroiled in the dissolution of subject positions, Hiller tackles this question in the first-person singular, which is however again provisional, suspended in quotation marks: '"I" feel more like a series of activities than an impermeable, corporeal unit … or rather, "I" AM NOT A CONTAINER.'[30]

If the *Notes* constitute the rational periphery or theoretical framing of *Sisters of Menon*, the name 'Menon' forms its indecipherable navel. 'Menon' remains un-gendered and is never identified except through indefinable shifters (i.e., personal pronouns but also terms such as 'here/there', 'now/then', that only acquire meaning in the context of a known situation) and self-referential predicates:

——/ who is this one/ I am this one/ Menon is
Menon is this one/ you are this one/

Menon is introduced only relationally and, crucially, not in terms of either patrilineality or matrilineality but laterally, on an equal plane, along sibling lines:

I am the sister of Menon / I am your sister / the sister of — everyone's
sister / I am Menon's sister
we are the sisters of Menon / everyone is the sister / everyone is the sister /
love oh the sisters /

Lucy Lippard has noted that 'Menon' is an anagram of *nomen*, Latin for name,[31] while Hiller has playfully suggested 'no men'.[32] The automatic message indeed reinforces the vacuity of the Lacanian Name of the Father by not literally excluding men but by challenging the symbolic function of patrilineality. Moreover, the allusion to the historical second-wave 'sisterhood' cannot be denied.[33] In this kinship network, there is no marriage, no exchange of women and thus no economy, either in social terms or on the level of the symbolic, culture and language.[34]

> Menon / we three sisters are your sister / this is the nothing that we are / the riddle is the sister of the zero / we are the mother of men / we are the sister of men / o the sisters

Automatic transmission and the reception of automatically produced texts break with rationalist codes of interpretation to create a semiotic inflation where seemingly contradictory propositions are valid at the same time. Lacan ties kinship and especially the exchange of women to language, since they are both 'imperative for the group in [their] forms, but unconscious in [their] structure'.[35] Kinship lays down not only the social but also the symbolic law. On the level of kinship, such semiotic inflation becomes almost incestuous: we/you/I are both the mother and the sister of men (or of Menon: 'we are the sister of *men*/ *o* the sisters'). Such clues, including the reference to a 'riddle' in the tenth instalment, foreshadow the strongest allusion to the myth of Oedipus, dramatised by Sophocles and upon which Freud based the 'Oedipus Complex', one of his most criticised yet fundamental theories of the construction of desire and the human subject itself. The last instalment of the automatic script locates this anarchic network of relations at the site of the Oedipus myth:

> ————/ we are your sisters from THEBES/ thebes[36]

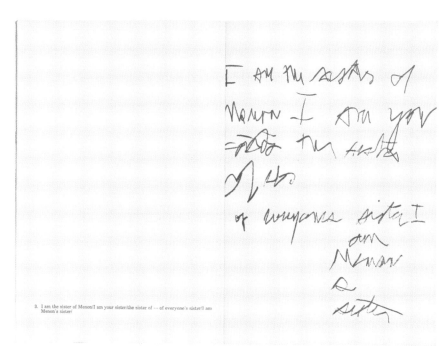

3. I am the sister of Menon/I am your sister/the sister of — of everyone's sister/I am Menon's sister/

In an interview with Rozsika Parker, Hiller concedes that *Sisters of Menon* 're-formulates the encounter between the Sphinx and Oedipus'.[37] Yet there are (at least) two Thebes. Elsewhere, she identifies Thebes without hesitation as an ancient Egyptian burial ground: '[It] is of course the necropolis in Egypt which undoubtedly I had already read about'.[38] In the Egyptian Thebes, now Luxor, there is a precinct dedicated to Memnon, son of Eos (Dawn), a Greek mythological hero whose name is only a letter away from Menon. Legend has it that the Northern statue of the two 'Colossi of Memnon' flanking the gateway of the mortuary temple of Amenhotep III emits a high note at daybreak in salutation of Memnon's mother. In the second interview, Hiller slips from the locus of the Oedipal drama to the Egyptian necropolis, from Oedipus's arrogant eloquence to the inarticulate lament of a son for his mother, unearthing a near-homonym between the mythical hero and the obscure navel of *Sisters of Menon*.

In *Oedipus Philosopher*, Jean-Joseph Goux proposes that the formulation of the Oedipus complex in psychoanalysis is constitutive of the 'conscious/unconscious cleavage',[39] a cleavage that is no mere partition but institutes a range of hierarchical relations, sacrificing the pre-Oedipal affinity with the maternal body for the sake of networks of kinship, privileging logos over the unrepresentable and logic over the paranormal, and instituting the divided and polarised 'mode of subjectivity that characterises Cartesian societies'.[40] In tracing the Oedipean 'autocentered' subject in the Western philosophical tradition, Goux pays special attention to Hegel, who is credited with the transformation of Oedipus into 'a shadowless, fully inaugural figure' and of his encounter with the Sphinx into 'the primitive scene of philosophy'. Hegel casts Oedipus's encounter with the Sphinx as a confrontation between two different discursive regimes, out of which the rational hero emerges triumphant, but having sacrificed otherness: 'The light of consciousness, which is consciousness of self, obliterates all enigmatic alterity, suppressing the dimension of the unconscious.' The birth of Western philosophy coincides with 'the exit of Egypt'.[41] *Sisters of Menon* revises the encounter between Oedipus and the Sphinx by giving voice to a different kind of disarticulated subjectivity and by prying open the lag between the Greek and the older Egyptian city, the locus of Oedipus's intellectual victory and the burial site that is buried – repressed – by Oedipus and his warped family romance. The implications of this piece are not only feminist but also psychoanalytical, philosophical and postcolonial.

In invoking the two cities and at least two different ways of knowing, Hiller wakes up another sleeping metaphor, 'metaphor' itself. *Metaphora*, Greek for transfer, conveyance, transition, is transformed into a journey crossing the Mediterranean

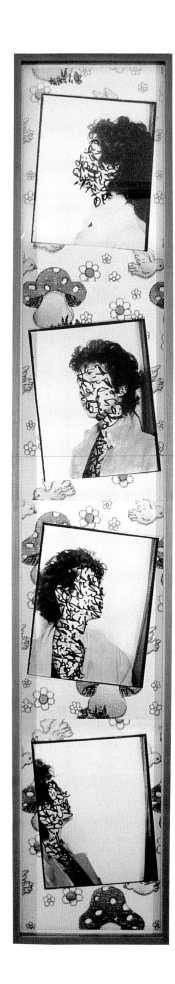

southwards, coasting from the master's discourse to the repressed aspects of the Freudian episteme, oscillating between automatism and theoretical and political reflection, connecting THEBES to thebes. As the lateral Conceptualist that she is, Hiller draws attention to the ordinarily repressed truism that all language is metaphorical, not by striving after the unrepresentable sublime but by blurring the boundaries between the terrain of representation and what lies beyond it. Suspended between writing and drawing, knowing and sensing, the familiar and the uncanny, her work populates the world with 'enigmatic signifiers'[42] and intertextual rivets where resonant aesthetic, theoretical and political insights converge.

CODA: DEAD PRESIDENT

Sometimes I Think I'm a Verb Instead of a Pronoun 1981–2 (pp.76–7) is quite clearly an autobiographical work, if not a straightforward exercise in self-portraiture.[43] It belongs to a series of works using photomat self-portraits produced mainly in the early 1980s. *Sometimes I Think I'm a Verb Instead of a Pronoun* consists of twelve panels, each comprising eight frames (two foursomes of photomat pictures) that have been layered with script and paint, and subsequently rephotographed. The conventions of identification photography are thwarted on two levels: the photo-graphed subject either averts her gaze or, as in this work, presents body parts other than the face to the camera, while the photographic print is veiled in writing and colour. The automatism of the illegible script is relayed by the absence of a seeing, conscious agent behind the camera of the photomat. 'Clearly what's happening here has got to do with the question of, say, presence or absence of the female subject, the female person who is the subject of these works, namely me', Hiller has commented.[44]

Hiller identifies the title as a quotation by American General and eighteenth President Ulysses S. Grant. Once again, the question of self-identity passes through the other in a most pronounced way: the artist encounters a dead father of a nation, not simply a sovereign figure but a symbol of sovereignty. Yet Grant carves out an odd patriarchal figure. Emerging from the American Civil War a hero, his presidency was marred by numerous financial scandals. In late life, unwise investments 'impoverished the entire Grant family and tarnished Grant's reputation',[45] and his presidency has even been described in terms of confusion, inefficiency and impotence.

The trajectory from the Greek to the Egyptian Thebes, from Oedipus to Memnon and then to President Grant, also marks another transition. Hiller's

Midnight, Farringdon 1985
C-type prints,
enlarged form handworked
photobooth images and
mounted on panel
304.8 × 50.8

automatic script morphs from relative decipherability in *Sisters of Menon* to a primordial cryptolinguistic mark-making that seems closer to drawing than to writing but is, perhaps, neither. This new script principally documents the physical act of mark-making that produced it and, in this sense, it is 'indexical'; it conveys little other than the act of mark-making.[46] The index not only sidesteps language but, in doing so, disrupts the authorial function of the subject and dispels its authoritative aura. Ulysses Grant, named after another mythological fortune-seeker, becomes the anti-Oedipus, marking the point of dissolution of the Western subject just as Oedipus marked its emergence. A year before his death and while struggling to complete his memoirs, which were to be such a big success that they nearly made up for his bankruptcy, Grant was diagnosed with throat cancer that resulted in the complete loss of his voice. Reduced to communicating principally through writing, and in considerable pain, he wrote in a note to his physician: 'I do not sleep though I sometimes doze a little. If up I am talked to and my efforts to answer cause pain. The fact is I think I am a verb instead of a personal pronoun. A verb is anything that signifies to be; to do; or to suffer. I signify all three.'[47]

On the brink of death, the index overtakes the symbol, the intelligible sign; the body overwhelms the subject, verbs take over from pronouns. In *Sometimes I Think I'm a Verb Instead of a Pronoun*, sensations speak louder than words – the subject is flesh again, beneath and beyond language. Just as the script devolves into indecipherability, the body parts replacing the face in the photomat frames now remain just that: fragmented, barely identifiable, not stapled together by the 'I'. More than any work from the series of photomat self-portraits, *Sometimes I Think I'm a Verb Instead of a Pronoun* celebrates the sensual pleasures of painting with thick, textured layers of colour – pleasures prohibited in orthodox Conceptualism and (some) second-wave feminist art practice alike. As Judith Mastai whimsically put it, 'the Law of the Mother' was 'thou shalt not paint'.[48] Hiller does, but her stance does not coincide with lawlessness or having no rules. For her performance-lecture 'Duration and Boundaries', for example, Hiller imposed two rules on herself, in acknowledgement of the opportunities and limitations of language: 'to tell the truth', and 'to speak without using any first-person pronouns'.[49] Neither on the wrong nor the right side of the law, 'fruitful incoherence' is always beside(s) it. '[A]lthough "I" must be in some sense co-determinate with this culture, and my expression, *to be comprehensible to any degree*, merely an aspect of it … I can find myself ONLY in refusing to speak in readymade terms as an example, representative or instance.'

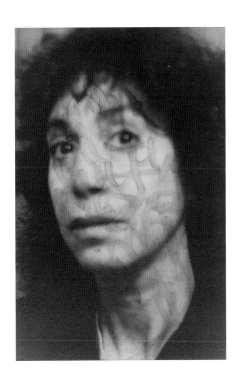

153

Midnight, Waterloo 1985
C-type print,
enlarged from handworked
photobooth image
76.2 × 52

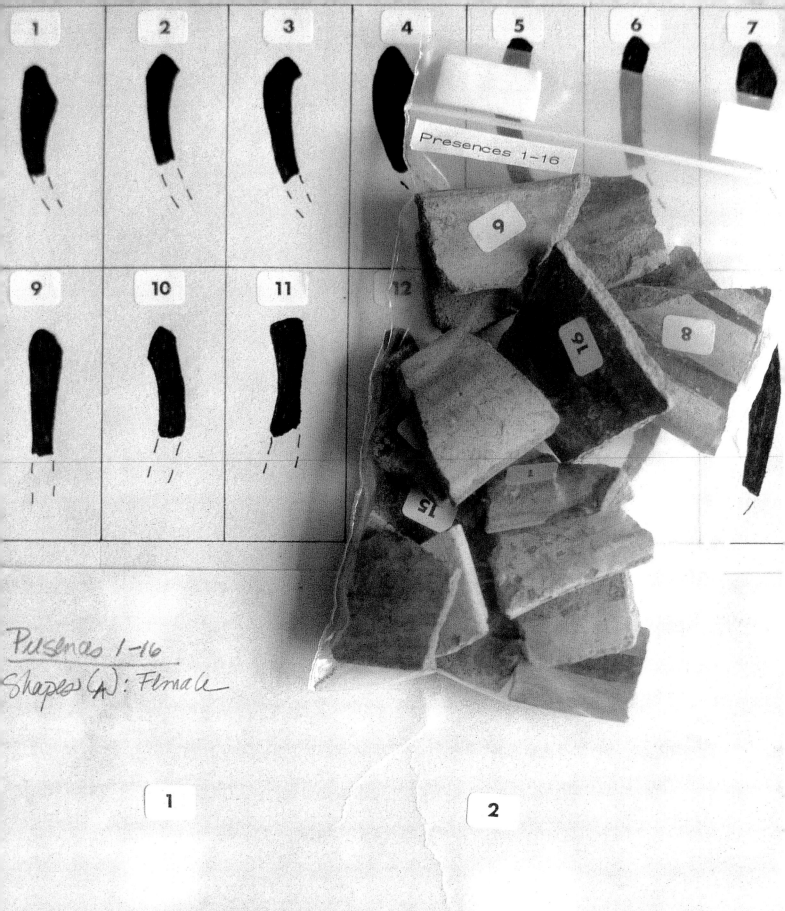

Presences 1-16

Presences 1-16
Shapes (N): Female

1

2

5

What if that which you thought was yours was also mine, but not only mine, because someone else shared it with me, and therefore with you, without our knowing and without their being fully conscious of it either, since what they passed on to us had been in turn transferred to them in a similarly undetectable manner? Now what if that which, escaping full recognition, circulates among you, me and them is precisely what, on a subliminal yet most foundational level, constitutes our culture and its traditions (tradition itself being the medium for the uninterrupted continuation of unconscious transfers)? If that should indeed be so, then how can we confront this invisible economy of transference? Mapping the direct lineage and legacy of ideas, beliefs and emotions that spread among people like rumours is tricky when neither authors, channels nor occasions of transfer can officially be identified. How do you chart undercurrents that remain perpetually in motion? If something is neither just mine nor yours while surely being ours (but also theirs), *where* is it then? Conventional scientific, juridical, or medical procedures of locating the object of inquiry within classificatory systems fail when what we look for is at the same time here and everywhere, sited and siteless, embodied and disembodied, assuming a particular place and role in individual biographies while also lingering indeterminately in the spaces of culture, like a wandering spirit in search of houses to haunt. The very authority of the regime of modern rationality is in fact in jeopardy when its condition of objective verifiability looses credibility in the light of other forces obviously being at play. Just picture the archetypal scene of a contentious conversation cut off by the head of the family by putting his hand down and decreeing 'This cannot be true.' The volume of his raised voice in itself will give those assembled around the dinner table reason enough to consent, in silence, that, of course, it can.

With a certain calm insistence and truly philosophical humour, Susan Hiller has been tapping into precisely those zones of collective experience where the draught of the cultural undercurrents and forces of transference become tangible. This zone is the sphere of phenomena that modern culture calls *sub*conscious, *arche*typical, *para*psychological, *super*natural etc. Her approach to these matters has involved taking a considerable risk. Since modern culture draws a line between what it deems rationally verifiable and what it marks out as obtusely irrational, artists and thinkers have traditionally been made to side with either one or the other principle. Both choices are equally safe though, since the institutional career path of the clearheaded truth-seeker is culturally as securely predetermined as that of the mad-genius type. The position that Hiller has been taking, however, is to reject these options as a false alternative and instead to inhabit a third space that opens up around the

Science and Sentience

Jan Verwoert

threshold between the opposed spheres. She candidly engages with phenomena that elude the logic of hard facts, yet she does so using techniques of analytical description, organisation and contextualisation from the arsenal of scientific discourse. She collects and displays source materials as a form of evidence. In this process, however, she refrains from categorising the material according to scientific, juridical or medical truth conditions as either fact or fiction, true or false testimony, authentic experience or delusion. To prove or disprove the phenomena with which she engages is not her primary concern. Rather, Hiller *avows* them from a perspective akin to what, in philosophy, is called *epoché*, the suspension of immediate judgement in favour of enhanced perceptiveness. Subliminally, this stance resonates with Socratic irony, a humour that is knowing only in its distrust of institutionally instilled knowledge, and otherwise almost insouciant in its openness to encounters. To take such a Socratic position and hold it in practice, however, means perpetually to be out on a limb, since it implies a renunciation both of the scientific authority of the teller of objective truth *and* of the religious aura of the madman/prophet. Instead of such claims to authority, what characterises Hiller's approach is a commitment to bearing witness by keeping one's eyes and ears open.

In the context of the immanent politics of art after the 1960s, the philosophy of Hiller's work therefore stands out in terms of its decisively different approach to interpreting the modernist legacy of critical art practice. Her use of analytic techniques of display as well as her continuous engagement in critical discourse through publishing, teaching and participating in public discussions testify to her intimate allegiance to the modernist ideal of art becoming a medium of intellectual emancipation. At the time, it was a project whose aesthetics and politics were most closely associated with Conceptual art. However, by addressing – from this emancipatory perspective – that which enlightenment discourse conventionally considers beyond its limits, Hiller equally points to the blind spot in the dominant interpretation of how Conceptual art was to realise the ideal of criticality. What if the conditions for art to be a pronounced force of critical thought entailed more than just mimicking the latest codes of intellectual sobriety? In the Anglo-American canon, the school of thought that arguably did determine how Conceptual art was interpreted by its most vocal apologists, artists and critics was that of analytic reductivism. Its main objectives were to deflate myths and ideologies, embrace the material world and seek truth in hard facts organised by formal logic (the writings of Ludwig Wittgenstein at the time being a popular port of entry for artists to this modern philosophical tradition).[1] If, as Wittgenstein wrote, 'The world is all that is the case', the most appropriate manner to implement this laconic truth condition into art would have

seemed to be the casual, matter-of-fact aesthetics of typewritten documents and documentary photos with which Conceptual art came to been identified. If one is sensitive to the social and psychological undercurrents that propel philosophies and art movements alike, however, the ambition to assert an untouchable position of cool sobriety smacks strongly of denial. To feel its emotional charge (and hear the raised voice of paternal authority) one only needs to accentuate slightly the prescriptive tone of Wittgenstein's famous dictum: 'Whereof one cannot speak, thereof one must be silent.' Experience of the social dynamics surrounding the unspeakable would then make one want to specify: 'Whereof one cannot speak, thereof the neighbours gossip.' What polite society excludes from conversation effectively fuels its lively imagination. Rather than flirting with either one or the other force in this equation, Hiller addresses their nexus as a whole. Thus she situates her practice directly in the interstices between structured discourse and its phantasmatic other.

The installation *Witness* 2000 (pp.100–3) is iconic in this regard. It is composed of numerous small, bare speakers suspended from the ceiling of a darkened room on sound-lead cables at various heights. Entering the installation as you would step under willow branches is to be engulfed by the murmur of a multiple voices coming from the speakers. If you pick up a speaker and hold it to your ear, you can listen to the individual recordings: witness accounts of UFO sightings from countries around the world, told in the languages spoken in the respective places. Each is infinitely detailed and specific, yet all share the hair-raising quality that testimonies of such encounters generate by virtue of the fact that they describe the brief moment when the inexplicable all of a sudden enters the world of everyday experience, only to disappear in an instant, without verifiable traces, and most likely without fellow witnesses being present at the scene of one's tête-à-tête with the supernatural. What are left are memories of hyper-vivid sensations, which, tangibly, hold a traumatic charge, precisely because of the irresolvable contradiction between their vividness and their unverifiability. Being a witness with no witnesses is the most agonising experience. The act of giving your account will always be saddled with the contradiction that you perform it in the hope of finding other witnesses to *confirm* your story, yet with full knowledge that this story will, due to its nature, probably produce the exact opposite effect in the listener and *jeopardise* your credibility.

It is precisely this experience of witnessing witnesses' search for a witness that Hiller's installation conveys in a most concentrated manner. The need to judge whether their stories are true or not is suspended. Veracity, as such, is not the issue here. There would be no higher ground from which to assess it anyhow, since one literally stands fully immersed in a cloud of voices that together create a space of

Detail of installation and documents used for
Witness 2000
see pp.100–3

collective experience, a zone of sentience, as it were. What Hiller's installation makes you feel then, first and foremost, is that there is a collective mode of experience, a certain modality in which things are being felt, that is characterised by the existential ambiguity of sensations being *equally* vivid *and* unverifiable. So to ask whether, according to scientific truth conditions, these sensations are true or false is to miss the point. Their reality is of a different order (not unlike that of Schrödinger's infamous cat, being simultaneously dead and alive). It is characteristic of the very reality of certain experiences that they are, at the same time, real *and* unreal, tangible *and* ungraspable. Irresolvable ambiguity is the modality of their existence. The point is therefore not to judge but to find a way to relate. Entering the zone of sentience created by the installation, you encounter the appeal of other witnesses to share a memory with them that might remain unshareable. How do we relate to this appeal? The ethical challenge that Hiller's work formulates is to activate a particular kind of emotional intelligence that would allow us to witness what will remain unverifiable even through witnessing, by sharing precisely what is unshareable: that opaque momentum at the heart of certain experiences that cannot be resolved but only avowed as such.

Encounters with the supernatural are particularly exemplary of this dimension of vivid yet unverifiable experiences. In the overall context of Hiller's work, however, the engagement with them is but one port of entry to that zone of sentience that she has continuously explored in a much wider sense. A striking equivalent in the history of art to people's accounts of paranormal experiences, for instance, is the ideas and techniques associated with the moment of artistic inspiration. The dilemma here is similar: on the one hand, modern society looks towards the artist as a medium who can tap into and channel its collective psychosocial disposition (the zeitgeist), while its enlightened critics on the other hand denounce higher intuition as an artistic myth and untenable conceit. Here again Hiller takes a path that allows her to sidestep the false alternative of cult or denial, and instead, in a key that is equally deadpan and empathetic, to avow the existence of certain modes of experience in art that defy conventional modes of verification.

As she recounts in a conversation with Roger Malbert,[2] Hiller began experimenting with telepathy in the project *Draw Together* 1972, in the context of which she agreed with friends from around the world on a time at which she would concentrate on a magazine image and the others would try to sense what it was and draw it. In the aftermath of these sessions, Hiller recalls, she happened to produce a piece of automatic writing that became the first in the series of notations forming the work called *Sisters of Menon* 1972/9 (pp.62–5). The traces of a pen, moving erratically over

the paper to produce half-legible words dissolving into scribble, are displayed on light blue, mauve or ochre stationery paper. The papers are mounted in custom-built frames of angular shapes comparable to those that Minimalist painters like Frank Stella used for their shaped canvases.

On the one hand, this framing technique constitutes an effective way to organise and display automatic writing in a manner that conveys how such writing does not lead to a linear text but rather generates a force-field of words and zone of intensities not unlike the configuration of a colour-field painting. On the other hand, to invoke the shaped canvas here can also be read as a gesture that (not without mockery) flags up a reminder that colour-field painting itself was deeply conflicted in terms of how it sought to approach the truth of painting analytically, yet still convey sublime experiences. Counter to the tendency to clean up the past of abstract painting through interpreting its inherent project as a pursuit of analytic clarity only, Hiller – in the *Sisters of Menon* as well as in her remarks on the Surrealist legacy of critical art practice[3] – shows that the nature of avant-gardist inquiry has always been a little more complex, and messy, and therefore not easy to legitimate in terms of rational progress. Her comments on the modernist legacy of artists and intellectuals working with telepathy are particularly interesting with regard to the fact that these experiments also had strong resonances with Socialist ideas of activating the potential of collective thought and sentiment in art. *Draw Together*, for instance, was initially inspired by the attempts made by the pivotal American social-reformist writer Upton Sinclair together with his wife Mary Craig to facilitate collective thinking through telepathy.[4]

In her paper 'Before and After Science', Hiller draws attention to the fact that Freud, in the 1920s, approached telepathy with growing interest and, in 1933, stated that, from a psychoanalytic point of view, he was prepared to accept its possibility – a position that, as Hiller observes, has rarely been acknowledged.[5] Similarly, she points out (citing Bruno Bettelheim's discussion of the subject) that the translation of Freudian terminology in the Standard English edition shows a bias towards putting a technical/medical spin on key terms that in German have more spiritual connotations. A striking example is that 'mind' is used for *Seele* instead of its literal equivalent 'soul'.[6] What Hiller homes in on here is a crucial conflict at the heart of psychoanalysis regarding the legitimisation of its authority as a scientific/medical discipline. In the history of modern culture, psychoanalysis stands out as a practice that seeks to convert sentience into science and therefore continues to hover awkwardly on the threshold that Hiller explores in her work. The crux lies in the fact that psychoanalysis constitutively relies on a moment of transference occurring

From the Freud Museum
1991–6
Stills from video taken
of the installation at
Hayward Gallery, London,
1997
see pp.86–9

between analysand and analyst in the moment of the therapeutic session. The analysand has to empower the analyst by allowing the latter to access the dimension of his or her most subliminal sentiments. Their exchange is thus premised on sentience rather than science.

In his lecture on transference (*Übertragung*), one of a series of talks introducing psychoanalysis held in Vienna between 1915 and 1917, Freud candidly admits that there can be no analysis without transference, whereupon he struggles to distinguish the form of liminal exchange that he deems vital from forms that are commonly suspected of being dubiously unscientific and manipulative. In this case it is not telepathy but hypnosis that he discusses, since it was at the time still prominently used as a therapeutic technique. Freud repudiates hypnosis for providing only short-term relief, but does so explicitly to counter allegations that psychoanalysis was a hoax and closer to shady magic than science. Nonetheless, he concedes that the forces at play in the moment of transference are difficult to contain, the risk being that unresolved emotions are literally transferred upon the analyst so that he is cast in the role of a stand-in on whom the issues are then taken out. Lacan goes even further in avowing the problem that transference poses for the authority of the analyst. When the very act of trust that authorises the analyst as a professional witness may draw him into a game of role-play in which he serves as a surrogate for someone or something else, the question that will always haunt the analyst, Lacan says, is: 'How can we be sure that we are not impostors?' And he continues: 'imposture looms overhead – as a contained, excluded, ambiguous presence against which the psychoanalyst barricades himself with a number of ceremonies, forms and rituals.'[7]

It was exactly on the grounds of these 'ceremonies, forms and rituals' that Hiller entered the terrain of psychoanalysis in her piece *From the Freud Museum* 1991–6 (pp.86–9), not to disprove its legitimacy, but to engage with it on a different set of terms. The work consists of a long vitrine in which, on two shelves, a vast series of small cardboard boxes are arranged, each opened, with its lid propped up against its back. The boxes contain a variety of little, carefully crafted and assembled objects, including porcelain animals, phials of curious fluids, dice and colour-coded cards, samples of soil, ornamented eggs, props from a Punch and Judy show and a collection of what might be ancient arrow-heads gathered from an archaeological dig. All objects are accompanied by texts, charts or black and white images, all on dark cream-coloured paper, glued to the inside of the lid like an explanatory reference to the objects. How these indices relate to the artefacts in the boxes, however, is never unambiguous. A box with four phials containing, as their labels say, water from different holy springs is matched by a list of terms for sentient people, going from

Seer to Hierophant, four of them (Saint, Oracle, Sibyl and Goddess) being ticked. The soil samples are accompanied by a photo of people queuing in front of a shop whose sign reads 'Bombs or No Bombs – Business As Usual', while two small porcelain cows are combined with a picture of a woman in a spotted sundress and Stetson hat, casually holding a revolver. To connect index to artefact is a matter of intuitive association and thus literally a transference of meaning that is set into play between objects, texts and images.

What the work evokes as a whole is a both a sense of a special economy of transference – a system of gift exchange in which boxes with collectible items circulate – and a sense of historicity, created by the overall *mise-en-scène* of selected artefacts, preserved in archive boxes for future generations to see. Although the strictly formalised quality of the museum-like display and the use of one box model with the same size throughout would suggest an equally contained field of study, the opposite is actually the case. Since the materials on display range from archaeological finds to contemporary chachkas, it becomes clear that the economy of exchange and transference that we are dealing with here may be that of (modern) culture in general (in the sense of Hiller's remark 'I think we all live inside the Freud museum, metaphorically').[8] At the same time, the title would suggest that it is on the site of psychoanalysis that these boxes have passed from one hand to another. In this sense, the act of handing over and opening the box can be read as a material metaphor for the moment of transference. Crucially though, Hiller interprets this act not simply as one of disclosure. In the associative combination of indexes and objects there is as much concealing as revealing at play, and even the revelations might not readily add up to unambiguous conclusions or warrant authoritative inferences.

On a subliminal level, a sense of non-identity continues to prevail in the relations between indices and artefacts as well as between the individual boxes. The one key feature that the work foregrounds is that the economy of transference that we encounter here (whether the scene of psychoanalysis in particular, or modern culture in general) is not an economy governed by the principle of quid pro quo, or

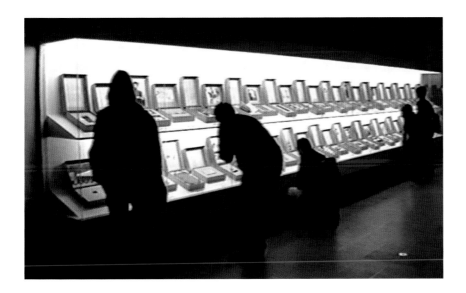

tit for tat. Speculatively speaking, this would imply that, when entering the zone of sentience, what you give is never what you get and what you get is never what you expected to receive; one is never unrelated to the other but never just identical. Still the transfers happen, and to grasp their logic would call for a particular science of sentience (a special sense of humour being part and parcel of it).

The stakes of such a science of sentience are high. Hiller poignantly addresses them: "'Can we reform ourselves politically?' is one question, but 'can the cultural unconscious learn anything?' is another question of more disturbing significance.'[9] Indeed, to understand the forces of transference is only one factor. An ever-pressing demand beyond this is to interrupt the cycle in which one generation hands down the burden of its unresolved conflicts to the next, and to stop the violence that potentially lurks in the act of transference. A singularly cruel example of this is the ritual of transferring society's discontents onto creatures or people marked out as scapegoats in order to indulge in the illusion that killing them would cleanse the community.

To bear witness to the atrocities committed against those who, against their will, have been assigned the role of the scapegoat is an enormous challenge, precisely because in this case the ritual of transference entails the elimination of the subject of transference, the killing and disappearance of the primary witness. In *The J. Street Project* 2002–5 Hiller performs this gesture of testifying to the disappearance of those on whom modern society took out its conflicts in an incommensurably atrocious way. The piece is a collection of 303 photos taken across Germany of street signs including the word 'Jude' (Jew), designating places that would have been, and – as the pictures make obvious, no longer are – the Jewish quarters of that city. What is vividly present while being physically invisible in these pictures is the absence of a culture annihilated while witnessing the systemic violence that a modern state apparatus can unleash.

One way of looking at Hiller's work, then, is to grasp how she portrays scenarios and events of transference. At the same, it is crucial to see how she also policitises the manner in which the role of subject of transference (i.e. the witness) is socially assigned. Traditionally, it is women onto whom society transfers the task of performing the affective labour of being sentient: of feeling what the community feels and bearing the load of these feelings. Hiller's *Psi Girls* 1999 (pp.96–9) is a concise and potent gesture towards the politics of this role-assignment. In a multi-channel projection set-up the video-installation shows a selection of scenes compiled from different movies, all of which depict the motif of a sentient woman exercising her telepathic or telekinetic powers. Monochromatic colour filters superimposed on

the material foreground the question of visibility itself. It is key to sentience that it straddles the divide between the visible and invisible. Objects may appear or move to prove telekinetic powers (or as gifts exchanged in the act of transference), yet, crucially, what is felt in the zone of sentience tends partially to resist the demand of visualisation as verification. To give visual proof of sentient powers is notoriously fraught with difficulties.

This constitutive association with invisibility has strong implications for the gender divide that society enforces in relation to the power of sentience. Conventionally it is the prerogative of the (self-styled) male martyr to act out the embodiment of collective pain in the spotlight, on the cross, in the arena of public visibility, guaranteeing symbolic recognition as a hero. The role of the woman in this tradition, however, is that of the weeping widow, the witness to disaster accomplished, who takes care of what remains when the dramatic performance of martyrdom ends and the damage done needs cleaning up. Hers is an off-stage operation and she traditionally wears a veil, so that her practice is situated on the threshold to invisibility. The political as well as ethical challenge here would be to avow the extraordinary worth of this partially invisible affective labour of sentience that has traditionally been assigned to women, but at the same time to break the chain and liberate this form of labour from its confinement within a patriarchal hierarchy.

Hiller's *Fragments* 1976–8 (pp.56–7) is a powerful move in this direction. The installation comprises a floor display, a low platform, on which shards of unclear origins are laid out on white sheets of paper like findings from an archaeological dig. On the walls, documents are hung in clusters, among them one titled *13 male absences*. Four strips of paper are glued onto a document, and on these, numbered from 1 to 13, are thirteen white patches suggesting that an amorphous object (a shard maybe) has been there long enough to prevent the light from discolouring the paper and then removed. Another document, *Link*, shows two found images,

Hiller working on
Fragments, 1976

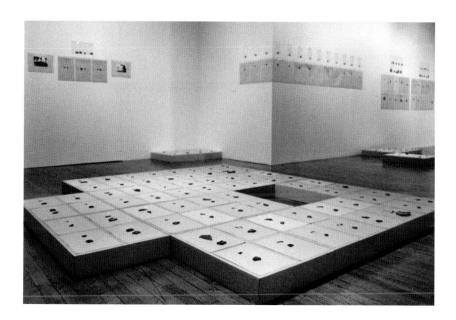

163

Fragments 1976–8
detail of the installation
at Hayward Gallery,
London, 1978
see pp.56–7

most likely magazine or newspaper photos, each showing a woman immersed in the labour of organising shards of ceramics in a scientific study and on an excavation site. A certain pride of profession could be seen to underpin the irony of this work. The female protagonists at work on this site of cultural archaeology take care of the fragments, relics and remainders that past economies of trade and transfer have left behind. They do so, however, not under the sign of a patriarchal history to be continued through the mourning of mythic male martyrs and heroes. The men are absent and so are their myths. In their place there are only stains and shards. Organising them is a material science. Yet this is also a science of the invisible, an endeavour hinting at absences through organised fragments. One could imagine this excavation site to be another portal into the zone where the subliminal forces of transference at play in culture are being witnessed and registered by a different kind of scientist, in this case, two autonomous women, working in a different spirit, as scientists of sentience.

One way to understand the challenge that Hiller has been formulating through her work is to grasp how to confront the powers that, on the most foundational level, determine the politics of our culture. The project of rational analysis (in art) would need to be augmented by a refined receptiveness for – that is, a capacity to witness – the vivid, yet only ever partially visible and verifiable dynamics of affects circulating and being transferred between people throughout history. In other words, what Hiller can be seen to enact in her work is a form of criticality in art that comprises yet also goes beyond a critique of representation, by proposing terms for the critical engagement with those forces of transference that partially elude the visible and therefore can only by accessed in terms of a politics of sentience.

SHAPE SHIFTING (pp.11–23)

1 Invited talk at *The Great Divide* science-art conference, organised by Denise Robinson at the Bristol Science Centre, 12 August 1999. Reprinted in Alexandra Kokoli (ed.), *Susan Hiller: The Provisional Texture of Reality: Selected Talks and Texts, 1977–2007*, Zurich and Dijon 2008, pp.23–30.

2 In Lippard's preface to Barbara Einzig (ed.), *Thinking About Art: Conversations with Susan Hiller*, Manchester 1996, pp.xi–xxi.

3 James Lingwood (ed.), *Susan Hiller: Recall. Selected Works 1969–2004*, exh. cat., Baltic, Gateshead 2004, pp.9–11.

4 Kate Bush, *Susan Hiller; Freud Museum*, *Untitled: A Review of Contemporary Art*, no.5, Summer 1994, p.12.

MESSAGES SUPPRESSED BY CULTURE DO NOT CEASE TO EXIST (pp.129–41)

1 Sigmund Freud, 'Die Verdrängung' (1915), http://www.textlog.de/freud-psychoanalyse-verdraengung-metapsychologische-schriften.html (accessed 16 Feb. 2010).

2 Ibid. and Sigmund Freud, 'Fetischismus' (1927), http://www.textlog.de/freud-psychoanalyse-fetischismus.html (accessed 16 Feb. 2010).

3 http://www.marxists.org/archive/marx/works/1867-c1/ch01.htm#S1

4 Quoted from typewritten notes by the artist included in the completed work.

5 Susan Hiller in an email to the author, 26 April 2010.

6 Conversation with the author, London, 3 March 2010.

7 Susan Hiller, http://www.susanhiller.org/Info/artworks/artworks-HomageJB.html (accessed 17 March 2010).

8 Conversation with the author, 3 March 2010.

9 Susan Hiller, 'Yves Klein Now', in Alexandra Kokoli (ed.), *Susan Hiller: The Provisional Texture of Reality: Selected Talks and Texts, 1977–2007*, Zurich and Dijon 2008, p.54.

10 Susan Hiller, *Auras and Levitations: Homage to Yves Klein/Homage to Marcel Duchamp*, Institute of Contemporary Arts, London, with Book Works Press, London, 2008.

11 Ibid.

12 Theosophy was a movement founded in New York in 1875 promoting a doctrine of trans-religious, cosmological striving towards human perfection, which later, after diverse schisms, branched out into, amongst others, Rudolf Steiner's Anthroposophy, as well as the proto-fascist Ariosophy.

13 Walter Benjamin, 'The Work of Art in the Age of Its Technological Reproducibility' (1935), in *The Work of Art in the Age of Its Technological Reproducibility and Other Writings on Media*, Belknap Press of Harvard University Press, Cambridge MA 2008.

14 http://www.susanhiller.org/Info/artworks/artworks-HomageMB.html [accessed 8 July 2010]

MOVING SIDEWAYS AND OTHER 'SLEEPING METAPHORS': SUSAN HILLER'S PARACONCEPTUALISM (pp.143–53)

1 In the words of Jan Verwoert, '3,512 words: Susan Hiller with Jörg Heiser and Jan Verwoert', in ed. Alexandra Kokoli (ed.), *Susan Hiller: The Provisional Texture of Reality: Selected Talks and Texts, 1977–2007*, Zurich and Dijon 2008, p.129.

2 Ibid., pp.129–30.

3 Adam Szymczyk, 'The Archive and its Lacunae', *Susan Hiller*, exh. cat., 'Concept, Body and Dream' series, Castello di Rivoli and Museo d'Arte Contemporanea, Turin 2006, n.p.

4 Hiller, 'Women, Language and Truth', *The Provisional Texture of Reality*, p.115.

5 Notably 'Sacred Circles' (1978) and 'An Artist Looks at Ethnographic Exhibitions' (1986), ibid., and a volume edited and introduced by Hiller, *The Myth of Primitivism*, London 1991.

6 Hiller, 'Susan Hiller in Conversation with Andrew Renton', in Adrian Searle (ed.), *Talking Art I*, London 1993, p.99.

7 Sigmund Freud, 'The "Uncanny"' (1919), in *Art and Literature*, Penguin Freud Library, vol.14, 1990, p.364.

8 Weber, 'The Sideshow, or: Remarks on a Canny Moment', *Modern Language Notes*, no.88, 1973, p.1103.

9 The suggestion that Freud's essay 'The "Uncanny"' is itself an example of the uncanny thanks to its form and telling silences was originally put forward by Hélène Cixous in 'Fiction and its Phantoms: A Reading of Freud's Das Unheimliche (The "Uncanny")', trans. Robert Dennomé, *New Literary History*, vol.7, no.3, 1976, pp.525–48.

10 Weber 1973, p.1132.

11 Emily Martin, 'The Egg and the Sperm: How Science Has Constructed a Romance Based on Stereotypical Male-Female Roles', *Signs*, vol.16, no.3, 1991, p.31.

12 Penelope Kenrick, 'Susan Hiller, Automatic Writing and Images of Self', in Gabrielle Griffin (ed.), *Difference in View: Women and Modernism*, London 1994, pp.112–14.

13 Andrea Liss, *Feminist Art and the Maternal*, Minneapolis and London 2009, p.12.

14 Hiller, '*Belshazzar's Feast*/The Writing on Your Wall: An Interview with Catherine Kinley', in Barbara Einzig (ed.), *Thinking About Art: Conversations with Susan Hiller*, Manchester 1996, p.89.

15 On sound in Hiller's work, see her interview with Mary Horlock, *Paletten*, Summer 2001; reprinted in Jim Drobnick (ed.), *Aural Cultures*, Banff 2005, pp.136–45, and available online: http://www.susan-hiller.org/index.html under 'Interviews', and 'On "Sound Art"', *The Provisional Texture of Reality*, pp.233–8.

16 Schelling, cited in Freud 1990, p.345.

17 Hiller, '*Belshazzar's Feast*', p.91.

18 Ian Hunt, 'Wicked Beauty: An Entertainment', in James Lingwood (ed.), *Susan Hiller: Recall: Selected Works 1969–2004*, exh. cat., Baltic, Gateshead 2004, p.64.

19 Louise Milne, 'On the Side of Angels: Witness and Other Works', in Lingwood 2004, p.149.

20 Ibid., p.142.

21 Mladen Dolar, *A Voice and Nothing More*, Cambridge MA 2006, p.15.

22 Robinson, 'scarce stains the dust', in Lingwood 2004, p. 101. Hiller's work with, on and in the Freud Museum consists of three incarnations: *At the Freud Museum*, exhibited at the Freud Museum in London, 1994; the book *After the Freud Museum*, London 1995; and subsequent versions of the exhibition, including that in Tate Modern, under the title *From the Freud Museum*.

23 Hiller, *Sisters of Menon* 1972/9, 'Translation 5.79 and Installation Notes'. All automatic script 'translations' come from this part of the installation, bottom left of the horizontal axis, also included in *Sisters of Menon*, artist's book, London 1983.

24 For a more detailed reading of this work, see Kokoli, 'Susan Hiller's Paraconceptualism', in Jennifer Fisher (ed.), *Technologies of Intuition*, Toronto 2006, pp.119–39.

25 Stuart Morgan, 'Beyond Control: An Interview with Susan Hiller', in *Susan Hiller*, exh. cat., Tate Gallery Liverpool 1996, p.42.

26 Elaine Pagels, *The Gnostic Gospel*, London 1979, p.xxxv.

27 Morgan 1996, p.41.

28 Hiller, 'Notes II', *Sisters of Menon*, n.p.

29 Hiller, 'Notes IV', *Sisters of Menon*, n.p.

30 Ibid.

Notes

31 Lippard 1986, n.p.

32 Morgan 1996, p.42.

33 Rosemary Betterton, 'Susan Hiller's Painted Works: Bodies, Aesthetics and Feminism', in Lingwood 2004, pp.18–19.

34 See Luce Irigaray, 'Commodities among themselves', in *This Sex Which Is Not One*, trans. Catherine Porter with Carolyn Burke, Ithaca, NY 1985, pp.192–7.

35 Jacques Lacan, 'Function and Field of Speech and Language in Psychoanalysis', in *Écrits: A Selection*, trans. Alan Sheridan, London 2001, p.72.

36 I'm correcting Hiller's transcript '———/ we are your sisters from Thebes/ Thebes' (*Sisters of Menon*, n.p.), which conceals the different spellings of the name of the city in the automatic script.

37 Hiller, 'Looking at New Work: An Interview with Rozsika Parker', in Einzig 1996, p.51.

38 Morgan 1996, p.42.

39 Jean-Joseph Goux, *Oedipus Philosopher*, trans. Catherine Porter, Stanford CA 1993, p.201.

40 Ibid.

41 All Goux 1993, pp.159–66.

42 Jean Laplanche, *New Foundations for Psychoanalysis*, trans. David Macey, Oxford 1989, p.45.

43 This section is adapted from Kokoli 2006, pp.131–5.

44 Hiller, 'Portrait of the Artist as a Photomat', *Thinking About Art*, p.63.

45 Ulysses S Grant, Biography.com, http://www.biography.com/articles/Ulysses-S-Grant-9318285, accessed 15 Feb. 2010.

46 See C. S. Peirce, 'The Icon, Index and Symbol', in *The Collected Papers of Charles Sanders Peirce*, vol. II, ed. Charles Harthorne and Paul Weiss, Cambridge MA 1990, pp.156–73.

47 Cited in Thomas E. Sebeok, *I Think I Am a Verb: More Contributions to the Doctrine of Signs*, New York and London 1986, p.2.

48 Mastai, 'Thou Shalt Not… The Law of the Mother', in *Women and Paint*, exh. cat., Mendel Art Gallery, Saskatoon 1995, pp.8–14.

49 Hiller, 'Duration and Boundaries' (1975), in Einzig 1996, p.170, editor's note.

SCIENCE AND SENTIENCE (pp.155–65)

1 Along these lines, I recall a member of Art and Language joking at a 1995 conference at the ICA in London that there had been 'one book by Wittgenstein in the local library and Joseph Kosuth had borrowed it first'.

2 *On Surrealism*, Susan Hiller in conversation with Roger Malbert, in Alexandra Kokoli (ed.), *Susan Hiller: The Provisional Texture of Reality: Selected Talks and Texts, 1977–2007*, Zurich and Dijon 2008, pp.213–31.

3 Ibid.

4 Ibid., p.215.

5 Hiller, 'Before and After Science', in Kokoli 2008, pp.239–43.

6 Hiller, 'Body and Soul', in ibid., pp.24–9.

7 Jacques Lacan, *The Four Fundamental Concepts of Psycho-Analysis*, London 1994, p.263.

8 Hiller in conversation with Malbert, in Kokoli 2008, p.229.

9 Hiller, 'The Multiple Ethics of Art', in ibid., p.143.

1940

Born in Tallahassee, Florida; grows up in and around Cleveland, Ohio

1950

Moves to Coral Gables, Miami, Florida

1957

Graduates from Coral Gables High School

1961

B.A. from Smith College, Northampton, Massachusetts

1961–2

Lives for a year in New York, works at part-time jobs and undertakes intensive self-devised art education (including photography and film at Cooper Union, and drawing at the Art Students League); also studies archaeology and linguistics at Hunter College

1962–5

Postgraduate study at Tulane University, New Orleans, with a National Science Foundation fellowship in anthropology

Completes fieldwork in Mexico, Guatemala and Belize, with a grant from the Middle American Research Institute

Decides to become an artist during a slide lecture on African art: 'My previous inchoate thoughts and feelings about anthropology as a practise and about art as a practise seemed to fall into place in one complex moment of admiration, empathy, longing, and self-awareness. I promised myself to happily abandon the writing of a doctoral thesis whose objectification of the contrariness of lived events was destined to become another complicit thread woven into the fabric of "evidence" that would help anthropology become a "science". In contrast, I felt art was, above all, irrational, mysterious, numinous: the images of African sculpture I was looking at stood as a sign for all this, a sign whose meaning, strangely, was already in place awaiting my long-overdue recognition. I decided I would become not an anthropologist but an artist: I would relinquish factuality for fantasy.' (Hiller in *The Myth of Primitivism: Perspectives on Art*, New York 1991, p.2)

1965–7

Stays briefly in London, working in various jobs; lives in Cornwall for a year and then in Paris; paints

1968

Paints during Joseph Károlyi Foundation Residency Grant, Vence, France

1969

Paints during residency at Ministère des Beaux Arts, Morocco

Settles in London

Makes her first video work, *Pray/Prayer*, a three-hour interactive video event for ten participants, using the new medium of video to investigate and record group behaviour

1973

Organises group work, *Street Ceremonies*, in the open air in Notting Hill, involving around 200 people. Another much smaller group is involved in *The Dream Seminar* later in the year

Susan Hiller, Gallery House, London. This exhibition includes *Transformer*, shown under the artist's name, and *Enquiries* (not yet joined by *Inquiries*, its American counterpart, see p.46) shown under the pseudonym 'Ace Posible'

Photography Into Art: An International Exhibition of Photography, Camden Arts Centre, London (under pseudonym 'Ace Posible') (group exhibition)

1974

Organises group investigation *Dream Mapping*

Enquiries, Royal College of Art Gallery, London

Susan Hiller, Garage Art Ltd., London

Have Artists Discovered the Secrets of the Universe?, Artists Meeting Place Gallery, London (group exhibition)

1975

Artist in Residence, University of Sussex, Brighton

Dedicated to the Unknown Artists, Gardner Centre for the Arts, University of Sussex, Brighton

Artists' Bookworks, The British Council, London (touring group exhibition)

From Britain '75, Taidehalli, Helsinki (group exhibition)

The Video Show: Festival of Independent Video, Serpentine Gallery, London (group exhibition)

1976

Gulbenkian Foundation Visual Arts Award

Susan Hiller, Hester van Royen Gallery, London

Susan Hiller, Serpentine Gallery, London

6 Times: Performances and Installations Exploring Duration and Change, Arts Council of Great Britain exhibition, Serpentine Gallery, London. In the show the slide installation *Enquiries* (British version) is joined by *Inquiries* (American version) for the first time

American Artists in Britain, The University Gallery, Leeds (group exhibition)

1977

Birth of son, Gabriel

Artists Books, Museum of Modern Art, New York (group exhibition)

Künstlerinnen International 1877–1977, Neue Gesellschaft für bildende Kunst, Berlin; Frankfurter Kunstverein, Frankfurt am Main (group exhibition)

On Site, Arnolfini, Bristol (group exhibition)

Reflected Images, Kettle's Yard, Cambridge (group exhibition)

1978

Susan Hiller, Hester van Royen Gallery, London

Susan Hiller, Peterloo Gallery, Manchester

Susan Hiller: Recent Works, Kettle's Yard, Cambridge; Museum of Modern Art, Oxford

Hayward Annual '78, Hayward Gallery and Arts Council of Great Britain, London (group exhibition)

1980

Appointed Lecturer at the Slade School of Art, University College London (1980–91)

Week long performance, *Work in Progress*, at Matt's Gallery, London

Susan Hiller: 'Dedicated to the Unknown Artists', 'Ten Months', and Other Recent Works, Spacex, Exeter

Susan Hiller: Mayan Fragments, etc, Gimpel Fils, London

About Time: Video, Performance and Installation by 21 Women Artists, Institute of Contemporary Arts, London; Arnolfini Gallery, Bristol; Liverpool Academy; Arts Lab, Birmingham; Project Arts Centre, Dublin (group exhibition)

168

Chronology

Compiled by Sofia Karamani

British Art 1940–1980, The Arts Council Collection, Hayward Gallery, London (group exhibition)

1981

Susan Hiller, A Space, Toronto, Canada

Susan Hiller: 'Monument', Ikon Gallery, Birmingham; Arnolfini, Bristol; Rochdale Municipal Gallery

A Mansion of Many Chambers: Beauty and Other Works, Arts Council of Great Britain (touring group exhibition)

Books by Artists, Winnipeg Art Gallery; National Gallery of Canada, Ottawa; Norman Mackenzie Art Gallery; Saskatchewan; Musée d'Art Contemporain Montreal; Dalhousie Art Galley, Halifax, Nova Scotia; Emily Carr College of Art, Vancouver (group exhibition)

Landscape: Ritual and Ephemeral Structures, Touchstone Gallery, New York (group exhibition)

New Works of Contemporary Art and Music, Fruitmarket Gallery, Edinburgh (group exhibition)

We'll Make it Up When We Meet/aka LA-London Lab (co-curated by Susan Hiller and Suzanne Lacey), Franklin Furnace, New York (group exhibition). This exhibition features women artists using film, video and related media, and is conceived as a response to the all-male show of British artists at the Guggenheim.

1982

National Foundation for the Arts Fellowship, USA

Visual Arts Board Travelling Fellowship, Australia

Susan Hiller, Akumulatory, Warsaw

Susan Hiller, André Emmerich, Zurich

Susan Hiller, Australian Experimental Art Foundation, Adelaide

Susan Hiller, Gimpel Fils, London

Susan Hiller, Piwna lo/26, Poznan

Susan Hiller/Monument, Eyelevel Gallery, Halifax, Nova Scotia

Artists' Books: From the Traditional to the Avant-Garde, Rutgers University, New Jersey (group exhibition)

Sense and Sensibility In Feminist Art Practice, Midland Group, Nottingham (group exhibition)

Through Children's Eyes: A Fresh Look at Contemporary Art, Arts Council of Great Britain (group exhibition)

Vision in Disbelief, 4th Biennale of Sydney (group exhibition)

1983

Susan Hiller, Gimpel Fils, London

Susan Hiller: Monument, Roslyn Oxley Gallery, Sydney

20 Artists: Printmaking, Royal College of Art/Barbican Art Gallery, London, (group exhibition)

Photo(graphic) Vision, Winchester Gallery, Winchester College of Art (group exhibition)

Place, Gimpel Fils, London (group exhibition)

Private Lives, Arts Council of Great Britain (touring group exhibition)

1984

Susan Hiller, Gimpel Fils, London

Susan Hiller, Vivienne Esders Galerie, Paris

Susan Hiller: 1973–1983: The Muse My Sister, Orchard Gallery, Londonderry, Northern Ireland; Third Eye Centre, Glasgow

Susan Hiller, Inside a Cave Home, Interim Art, London

The British Art Show: Old Allegiances and New Directions 1979–1984, Arts Council of Great Britain, City of Birmingham Museums and Art Gallery and Ikon Gallery, Birmingham; Royal Scottish Academy, Edinburgh; Mappin Art Gallery, Sheffield; Southampton Art Gallery (group exhibition)

Demarcation '84, an Edinburgh International Festival programme of exhibitions and events at Edinburgh College of Art presented by the Richard Demarco (group exhibition)

Home & Abroad, Serpentine Gallery, London (group exhibition)

New Media 2, Malmö Konsthall, Sweden (group exhibition)

The Selector's Show, Camerawork, London (group exhibition)

Sensations of Reading, Waterfront Gallery, Toronto (group exhibition)

Strip Language, Gimpel Fils, London (group exhibition)

1985

British Film and Video 1980–1985: The New Pluralism, Tate Gallery, London (group exhibition)

The British Show, Art Gallery of Western Australia, Perth; Art Gallery of New South Wales; Queensland Art Gallery, Brisbane; Royal Exhibition Building, Melbourne; National Gallery of Art, Wellington (group exhibition)

Facts about Psychic Television, The Arts Gallery at Harbourfront, Toronto (group exhibition)

Hand Signals, Ikon Gallery, Birmingham; Milton Keynes Exhibition Gallery; Chapter, Cardiff (group exhibition)

Human Interest: Fifty Years of British Art About People, Cornerhouse, Manchester (group exhibition)

The Irish Exhibition of Living Art, Hop Store, Dublin (group exhibition)

Kunst mit Eigen-Sinn: Aktuelle Kunst von Frauen, Museum Moderner Kunst/Museum des 20. Jahrhunderts, Vienna (group exhibition)

Livres d'artistes, Bibliothèque publique d'information, Musée National d'art moderne, Centre Pompidou, Paris (group exhibition)

Un Seul Visage, Centre National de la Photographie, Paris (group exhibition)

1986

Belshazzar's Feast, the Writing on Your Wall 1983–4 is broadcast by Channel 4 and by WNET New York.

Susan Hiller, Institute of Contemporary Arts, London

Between Identity and Politics, Gimpel Fils, London; Gimpel Weizenhoffer, New York (group exhibition)

Conceptual Clothing, Ikon Gallery, Birmingham; Harris Museum and Art Gallery, Preston; Peterborough City Museum and Art Gallery; Spacex Gallery, Exeter; Stoke-on-Trent City Museum and Art Gallery; Cartwright Hall Art Gallery, Bradford (group exhibition)

Contrariwise: Surrealism in Britain 1930–1986, Glynn Vivian Art Gallery, Swansea, Wales (group exhibition)

The Elements, Milton Keynes Exhibition Gallery; Ramsgate Library Gallery; City Museum and Art Gallery, London; Plymouth Arts Centre; John Hansard Gallery, Southampton; Ikon Gallery, Birmingham (group exhibition)

The Flower Show, Arts Council of Great Britain (touring group exhibition)

Force of Circumstance, P.P.O.W. Gallery, New York (group exhibition)

Fure, Victoria Miro Gallery, London (group exhibition)

Staging the Self: Self-Portrait Photography 1840s–1980s, National Portrait Gallery, London; Plymouth Arts Centre; John Hansard Gallery, Southampton; Ikon Gallery, Birmingham (group exhibition)

1987

Susan Hiller Magic Lantern Whitechapel Art Gallery, London (commissioned slide/audio work)

Susan Hiller, Pat Hearn Gallery, New York

Current Affairs: British Painting and Sculpture in the 1980s, Museum of Modern Art, Oxford; Národrú Galerie, Prague; Zacheta, Warsaw; Mucsarnok, Budapest (group exhibition)

New Works, Pat Hearn Gallery, New York (group exhibition)

Photomotion: A Contemporary Survey of Photobooth Art, Pyramid Arts Center, New York (group exhibition)

State of The Art: Ideas and Images, Institute of Contemporary Arts, London; Laing Art Gallery, Newcastle; Harris Museum and Art Gallery, Preston; Cartwright Hall, Bradford; Sainsbury Centre for Visual Arts, Norwich (group exhibition)

Which Side of the Fence?, Imperial War Museum, London (group exhibition)

1988

Appointed 'Distinguished Visiting Professor' at the Department of Art, California State University, Long Beach

Susan Hiller, University Art Museum, California State University, Long Beach

100 Years of Art in Britain, Leeds City Museum and Art Gallery, centennial exhibition (group exhibition)

British Art: The Literate Link, Asher/Faure Gallery, Los Angeles (group exhibition)

Britische Sicht! Photografie aus England, Museums für Gestaltung, Zurich (group exhibition)

The New Urban Landscape, World Financial Center, New York (group exhibition)

1989

Susan Hiller, Galerie Pierre Birtschansky, Paris

Susan Hiller, Kettle's Yard, Cambridge

Susan Hiller, Pat Hearn Gallery, New York

A New Language of Desire, University of Essex Gallery, Colchester (group exhibition)

And They See God, Pat Hearn Gallery, New York (group exhibition)

Americans Abroad, Smith's Gallery, Covent Garden, London (group exhibition)

Lifelines/Lebenslinien: 4 Four British Artists, BASF-Feierabendhaus, Ludwigshafen; Tate Gallery Liverpool

Picturing People: British Figurative Art Since 1945, The British Council: National Art Gallery, Kuala Lumpa; Hong Kong Museum of Art; The Empress Place, Singapore (group exhibition)

Signs of Language, Harris Museum & Art Gallery, Preston, UK (group exhibition)

Through the Looking Glass: Photographic Art in Britain 1945–1989, Barbican Art Gallery, London; Manchester City Art Gallery (group exhibition)

Towards A Bigger Picture: Contemporary British Photographs, Victoria & Albert Museum, London, England; Tate Liverpool (group exhibition)

1990

Susan Hiller: The Revenants of Time, Mappin Gallery, Sheffield; Matt's Gallery, London; Third Eye Centre, Glasgow

Glasgow's Great British Art Exhibition, Glasgow Museums and Art Galleries (group exhibition)

Now for the Future, Hayward Gallery, London (group exhibition)

Signs of the Times: Video Installations of the 1980s, Museum of Modern Art Oxford (group exhibition)

Women Artists of the Day, Seibu Seison, Tokyo (group exhibition)

1991

Appointed 'Visiting Art Council Chair' at the Department of Art, University of California, Los Angeles

Appointed Professor at the Faculty of Art and Design, University of Ulster, Belfast (1991–8)

Susan Hiller, (In conjunction with Pat Hearn Gallery), Nicole Klagsbrun Gallery, New York

Susan Hiller, Pat Hearn Gallery, New York, New York

A Place for Art?, The Showroom, London (group exhibition)

At One/At War with Nature, Pratt Manhattan Gallery, New York (group exhibition)

Crossover, Anderson O'Day, London (group exhibition)

Exploring the Unknown Self: Self-Portraits of Contemporary Women, Tokyo Metropolitan Museum of Photography (group exhibition)

Incognito, Curt Marcus Gallery, New York (group exhibition)

Present Continuous, The Bath Festival, Bath (group exhibition)

Shocks to the System: Social and Political Issues in Recent British Art, Arts Council of Great Britain (touring group exhibition)

1992

Appointed Visiting Professor at the Department of Art, University of California, Los Angeles

Susan Hiller, Tom Solomon's Garage Gallery, Los Angeles, California

Completing the Circle: Artists' Books on the Environment, Minnesota Centre for Book Arts (group exhibition)

Dark Décor, Independent Curators touring exhibition: Hope College Holland, Michigan; San Jose Museum of Art, California; Florida Gulf Coast Art Center (group exhibition)

In Vitro de les mitologie del ferilitat als limits de ciència, Departmenta de Cultura de Generalitat de Catalunya, Fundació Joan Miró Barcelona (group exhibition)

Speak, Randolph Street Gallery, Chicago (group exhibition)

1993

An Artist's Choice, Fenderesky Gallery at Queen's University, Belfast (group exhibition)

Art in Boxes, England & Co., London; Nottingham Castle Museum (group exhibition)

Declarations of War, Kettle's Yard, Cambridge (group exhibition)

Moving into View: Recent British Painting, Royal Festival Hall, London (group exhibition)

Signes du Temps, Le centre d'art contemporain, Musée de la Ferme Buisson, Paris (group exhibition)

1994

Susan Hiller, Entwistle Gallery, London

Susan Hiller at the Freud Museum, commissioned by Book Works and Freud Museum, London

Susan Hiller's Brain, Gimpel Fils, London

Inside the Visible: An Elliptical Traverse of 20th Century Art in, of, and from the Feminine, Béguinage of Saint-Elizabeth, Kortrijk; The Institute of Contemporary Arts, Boston; Museum of Women in the Arts, Washington D.C.; Art Gallery of Western Australia, Perth; Whitechapel Gallery, London (group exhibition)

Punishment + Decoration, Hohenthal und Bergen, Cologne (group exhibition)

The Reading Room, Book Works: London, Glasgow, Oxford (group exhibition)

Worlds in a Box, Arts Council of Great Britain, (touring group exhibition)

1995

Susan Hiller, Gimpel Fils, London

Anti-Slogans, Cairn Gallery, Nailsworth, Gloucester (group exhibition)

Drawn Together: Works on Paper, Middlesborough Art Gallery (group exhibition)

Monochrome, Gimpel Fils, London (group exhibition)

Rites of Passage: Art for the End of the Century, Tate Gallery, London (group exhibition)

Selected Works, Tom Solomon Gallery, Los Angeles (group exhibition)

1996

Susan Hiller, Tate Gallery, Liverpool

Susan Hiller: Dream Screens, Dia Center for the Arts, New York (commissioned internet work)

Against: Thirty Years of Film and Video, Anthony d'Offay Gallery, London (group exhibition)

Itinerant Texts, Camden Arts Centre, London (group exhibition)

Jurassic Technologies Revenant, 10th Biennale of Sydney, Art Gallery of New South Wales, Artspace and Ivan Dougherty Gallery, Sydney (group exhibition)

NowHere, Louisiana Museum of Modern Art, Humlebaek, Denmark (group exhibition)

Styki/Contact Prints, Foksal Gallery, Warsaw (group exhibition)

The Inner Eye: Art Beyond the Visible, City Art Galleries, Manchester; Museum and Art Gallery, Brighton; Glynn Vivian Art Gallery, Swansea; Dulwich Picture Gallery, London (group exhibition)

1997

Susan Hiller, Oriel Gallery, Cardiff

Susan Hiller: Wild Talents, Foksal Gallery, Warsaw; Institute of Contemporary Art, Philadelphia; Australian Experimental Art Foundation, Adelaide

A Little Object, The Centre for Freudian Analysis and Research, London (group exhibition)

Collected, The Royal College of Surgeons of England, Hunterian Museum, organised by Photographers' Gallery, London (group exhibition)

History: The Mag Collection: Image-based Art in Britain in the Late Twentieth Century, Ferens Art Gallery, Kingston-upon-Hull (group exhibition)

In Visible Light: Photography and Classification in Art, Science and the Everyday, Museum of Modern Art, Oxford; Moderna Museet, Stockholm (group exhibition)

Irredeemable Skeletons, Shillam + Smith, London (group exhibition)

Livres d'artistes. L'invention d'un genre 1960–1980, Bibliothèque nationale de France, Galerie Mansart, Paris (group exhibition)

Material Culture: The Object in British Art of the 1980s and '90s, Hayward Gallery, London (group exhibition)

1998

Guggenheim Fellowship in Visual Art Practice, USA

Appointed Baltic Chair of Contemporary Art, University of Newcastle (1999–2004)

Susan Hiller, Delfina, London

Susan Hiller, Northern Gallery for Contemporary Art, Sunderland

Susan Hiller: Lucid Dreams, Henie Onstad Kunstsenter, Oslo

Susan Hiller, Psi Girls, Site Gallery, Sheffield; Tensta Konsthall, Stockholm

Backspace, Matt's Gallery, London (group exhibition)

Chora, 30 Underwood Street Gallery, London; Hotbath Gallery, Bath; South Hill Park, Bracknell; Abbot Hall, Kendal (group exhibition)

Drawing Thinking, RHA Gallagher Gallery, Dublin (group exhibition)

Dumbfounded, Battersea Arts Centre, London (group exhibition)

E.S.P., Ikon Gallery, Birmingham (group exhibition)

The Museum as Muse: Artists Reflect, The Museum of Modern Art, New York (group exhibition)

Sordide Sentimental, Holden Gallery, Manchester (group exhibition)

Sublime: The Darkness and the Light, Arts Council of England (touring group exhibition)

2000

Organises *The Producers: Contemporary Curators in Conversation,* a series of panel discussions, and edits the accompanied series of books, Baltic Centre for Contemporary Art, Gateshead (2000–3)

Represents Britain in the 7th Havana Biennial, *One Closer to the Other (Uno más cerca del otro)*

Susan Hiller: Witness, Artangel commission at The Chapel, London

Amateur/Eldsjäl: Variable Research Initiatives 1900 and 2000, Göteborgs Konstmuseum, Gothenburg (group exhibition)

The British Art Show 5, Hayward Touring exhibition: City Art Centre, Edinburgh; John Hansard Gallery, Southampton; Centre for Visual Arts, Cardiff; Birmingham Museums and Art Gallery (group exhibition)

Dream Machines, selected by Susan Hiller, a National Touring Exhibition organised by the Hayward Gallery, London, for Arts Council of England. Dundee Contemporary Arts; Mappin Art Gallery, Sheffield; Camden Arts Centre, London (group exhibition)

In Memoriam, The New Art Gallery, Walsall (group exhibition)

Intelligence: New British Art 2000, Tate Britain, London (group exhibition)

Live in Your Head: Concept and Experiment in Britain 1965–75, Whitechapel Gallery, London; Museu Nacional de Arte Contemporânea, Museu do Chiado, Lisbon (group exhibition)

2001

Susan Hiller: Video-Instalaciones, Fundación Eugenio Mendoza, Caracas

Susan Hiller, Gagosian Gallery, New York

East Wing Collection, Courtauld Institute of Art, London (group exhibition)

Empathy: Beyond the Horizon, Pori Art Museum, Finland (group exhibition)

The Map Is Not the Territory, England & Co., London (group exhibition)

Strip, National Portrait Gallery, London (group exhibition)

2002

DAAD Fellowship, Berlin

Susan Hiller, Galerie Volker Diehl, Berlin

Susan Hiller: Psi Girls/Witness/Wild Talents/Dream Screens, Museet for Samtidskunst, Roskilde, Denmark

Apparition: the action of appearing, Arnolfini, Bristol; Kettles Yard, Cambridge (group exhibition)

Real Life: Film and Video Art, Tate St Ives (group exhibition)

Self Evident: The Artist as the Subject 1969–2002, Tate Britain, London (group exhibition)

(The World May Be) Fantastic, 2002 Biennale of Sydney (group exhibition)

2003

Kulturstiftung des Bundes, Halle, Germany

Susan Hiller, Galerie Volker Diehl, Berlin

A Bigger Splash: British Art from Tate 1960–2003, Pavilhão Lucas Nogueira Garcez-Oca/Instituto Tomie Ohtake, São Paulo (group exhibition)

Arrangement: The Use of Flowers in Art, Rhodes + Mann, London (group exhibition)

Genius Loci: Kunst und Garten, Stadtpark Lahr, Germany (group exhibition)

The Museum of the Mind: Art and Memory in World Cultures, British Museum, London (group exhibition)

Science Fictions, Earl Lu Gallery, Lasalle College of the Arts, Singapore Arts Festival (group exhibition)

Taster, DAAD Gallery, Berlin (group exhibition)

Twilight, Gimpel Fils, London (group exhibition)

Your Memorabilia, NICAF, Tokyo International Forum (group exhibition)

2004

Susan Hiller: Recall: Selected Works 1969–2004, Baltic Centre for Contemporary Art, Gateshead; Museu Serralves, Porto; Kunsthalle Basel

A European Portrait #2, Rohkunstbau XI, Wasserschloss Gross Leuthen, Spreewald, Germany (group exhibition)

Art of the Garden: The Garden in British Art, 1800 to the Present Day, Tate Britain, London; Ulster Museum, Belfast; Manchester Art Gallery (group exhibition)

Artists' Favourites, Institute of Contemporary Arts, London (group exhibition)

Dream Extensions, SMAK (Stedelijk Museum voor Actuele Kunst), Ghent (group exhibition)

Haunted Media Group Exhibition, Site Gallery, Sheffield

Outside of a Dog: Paperbacks and Other Books by Artists, Baltic, Gateshead (group exhibition)

Unframed, Standpoint, London (group exhibition)

2005

Residency at Couvent des Récollets, Paris

Projection of *J. Street Project* at The Prince Charles Cinema, London

Susan Hiller, DAAD Gallery, Berlin

Susan Hiller: The J. Street Project, Compton Verney/Peter Moores Foundation, Warwickshire

Susan Hiller: The J. Street Project, Wexner Centre for the Arts, Columbus, Ohio

Susan Hiller: The J. Street Project, Timothy Taylor Gallery, London

Blur of the Otherworldly: Contemporary Art, Technology and the Paranormal, Center for Art Design and Visual Culture, Baltimore (group exhibition)

Itinerarios del Sonido, Centro Cultural Conde Duque, Residencia de Estudiantes, Madrid (group exhibition)

Looking at Words, Andrea Rosen Gallery, New York (group exhibition)

Monuments for the USA, CCA Wattis Institute for Contemporary Arts, San Francisco; White Columns, New York (group exhibition)

Ordering the Ordinary, Timothy Taylor Gallery, London (group exhibition)

Thinking of the Outside: New Art and the City of Bristol, commissioned by Bristol Legible City/Picture This/Situations. Hiller shows *Psychic Archaeology* at Castle Vaults, Bristol (group exhibition)

2006

Susan Hiller, Concetto: Corpe e Sogno, Castello di Rivoli Museo d'Arte Contemporanea, Turin

Susan Hiller: Outlaws and Curiosities, Galerie Volker Diehl, Berlin

Susan Hiller: The J. Street Project, Galerie Liane and Danny Taran Gallery, Centre des Arts Saidye Bronfman, Montreal

A Secret Service: Art, Compulsion, Concealment, Hayward Touring exhibition: Hatton Gallery, Newcastle; De La Warr Pavilion, Bexhill-on-Sea; Whitworth Art Gallery, Manchester (group exhibition)

Fast and Loose (My Dead Gallery) London 1956–2006, The Centre of Attention at Fieldgate Gallery, London (group exhibition)

Forms of Classification: Alternative Knowledge and Contemporary Art, cifo (Cisneros Fontanals Art Foundation), Miami (group exhibition)

Ghosting: In the Dark, Arnolfini, Bristol (group exhibition)

How to Improve the World: 60 Years of British Art, Arts Council Collection, Hayward Gallery, Southbank Centre, London (touring group exhibition)

Sonambiente berlin 2006, Akademie der Künste, Berlin, (group exhibition)

The Signing, Keith Talent Gallery, London (group exhibition)

Sonic Presence, Bergen Kunsthall, Norway (group exhibition)

This Land is My Land, Kunsthalle Nürnberg; NGBK und Projektraum 1 des Kunstraum Kreuzberg/Bethanien Berlin, (group exhibition)

2007

Susan Hiller, The Curiosities of Sigmund Freud and Other Works, Moderna Museet, Stockholm

After The News BankART1929, Yokohama, Japan (group exhibition)

Critically Correct (2), Givon Art Gallery, Tel Aviv (group exhibition)

Gartenlust: Der Garten in der Kunst, Belvedere, Vienna (group exhibition)

Now You See It, Graduate Thesis Exhibition, Hessel Museum of Art and CCS Galleries, New York (group exhibition)

Résidents 2003–2007, L'Espace EDF Electra, Paris (group exhibition)

Romantic Conceptualism, Kunsthalle Nürnberg; BAWAG Foundation, Vienna (group exhibition)

Wack! Art and the Feminist Revolution, The Geffen Contemporary at Museum of Contemporary Art, Los Angeles; MoMA PS1, New York (group exhibition)

2008

Susan Hiller, The J. Street Project, Kunst-Raum des Deutschen Bundestages, Berlin

Susan Hiller, Outlaw Cowgirl and Other Works, BAWAG, Generali Foundation, Vienna

Susan Hiller, Psi Girls, Joy Art, Beijing

Susan Hiller: Journey to the Land of the Tarahumara, Galerie Volker Diehl, Berlin

Susan Hiller: Proposals and Demonstrations, Timothy Taylor Gallery, London

Susan Hiller: The J. Street Project, The Jewish Museum, New York

Susan Hiller: The Last Silent Movie, Matt's Gallery, London

Translation Paradoxes and Misunderstandings, Shedhalle, Zurich (group exhibition)

Building Bridges: 8 Visions, One Dream, Today Art Museum, Beijing (group exhibition)

Hidden Narratives, Graves Art Gallery, Sheffield (group exhibition)

The Hidden Trace: Jewish Paths through Modernity, Felix-Nussbaum-Haus, Osnabrück, Germany (group exhibition)

Insomniac Promenades: Sleeping/Dreaming in Contemporary Art, Passage de Retz, Paris (group exhibition)

Martian Museum of Terrestrial Art, Barbican Art Gallery, London (group exhibition)

Oggetti Smarriti (Lost and Found), Galleria Gentili, Prato (group exhibition)

Ours: Democracy in the Age of Branding, Sheila C. Johnson Design Center, Parsons The New School for Design, New York (group exhibition)

Unreliable Witness, Tramway, Glasgow (group exhibition)

When Things Cast no Shadow, 5th Berlin Biennial for Contemporary Art (group exhibition)

Wild Signals: Artistic Positions between Symptom and Analysis, Württembergischer Kunstverein, Stuttgart (group exhibition)

2009

Susan Hiller, The Last Silent Movie, 101 Projects, Reykjavik

Susan Hiller, Index – The Swedish Contemporary Art Foundation, Stockholm

Susan Hiller: The J. Street Project, A Photographic Journey through the Streets of Germany, Contemporary Jewish Museum, San Francisco

At the Edge: British Art 1950–2000, Touchstones, Rochdale; Harris Museum and Art Gallery, Preston; Gallery Oldham; Bolton Museum, Art Gallery and Aquarium (group exhibition)

'Awake Are Only the Spirits': On Ghosts and Their Media, Hartware MedienKunstVerein, Dortmund (group exhibition)

Boule to Braid, curated by Richard Wentworth, Lisson Gallery, London (group exhibition)

British Subjects: Identity and Self-Fashioning 1967–2009, Neuberger Museum of Art, New York (group exhibition)

Collage, London/New York, FRED Gallery, London (group exhibition)

El pasado en el presente y lo propio en lo ajeno, Laboral Centro de Arte y Creacion Industrial, Gijón-Asturias, Spain (group exhibition)

elles@centrepompidou, Artistes Femmes dans les Collections du Musée National d'Art Moderne, Musée national d'art moderne, Centre Pompidou, Paris (group exhibition)

Is Self-Consciousness a Sufficient Option?, part of 'The Uncertainty Principle' programme, The MACBA Chapel, Barcelona (group exhibition)

Magic Show, Arts Council of England (touring group exhibition)

Moby-Dick, CCA Wattis Institute for Contemporary Arts, San Francisco (group exhibition)

Not Created By A Human Hand, Wilfried Lentz, Rotterdam (group exhibition)

Polyglottolalia, Tensta Konsthall, Spånga, Sweden (group exhibition)

The Quick and the Dead: Rites of Passage in Art, Spirit and Life, Ivan Dougherty Gallery, Sydney (group exhibition)

What a Wonderful World, Gothenburg International Biennial for Contemporary Art (group exhibition)

2010

Susan Hiller: An Ongoing Investigation: "Rough Sea" and "Addenda" (1976–2010), Galerie Karin Sachs, Munich

What I See: Susan Hiller, Centro Cultural Montehermoso, Vitoria-Gasteiz, Spain

The Alchemy of Things Unknown (and a Visual Transformation on Meditation), Khastoo Gallery, Los Angeles (group exhibition)

Art Sheffield 2010: Life: A User's Manual, Graves Art Gallery, Sheffield (group exhibition)

Artists' Choices: Susan Hiller: A Work in Progress (selected by Susan Hiller and Kobi Ben Meir), The Israel Museum, Jerusalem (group exhibition)

Atlas. How to Store de World?, Museo Nacional Centro de Arte Reina Sofia, Madrid (group exhibition)

The Beauty of Distance, 17th Biennale of Sydney (group exhibition)

Bilder in Bewegung: Kunstler & Video/Film, Museum Ludwig, Cologne (group exhibition)

Broken Fall (Geometric), Galleria Enrico Astuni, Bologna (group exhibition)

Childish Things: Fantasy and Ferocity in Recent Art, Fruitmarket Gallery, Edinburgh (group exhibition)

Dig Down in Time, Man & Eve, London (group exhibition)

En Miroir, Projections sur le Folklore, Centre d'art de Fribourg, Switzerland (group exhibition)

Extra-Ordinary: Alternative Perspectives on the Everyday, from the Arts Council Collection, Apthorp Gallery, Artsdepot, London (group exhibition)

The Glass Delusion, National Glass Centre, Sunderland (group exhibition)

Polytechnic, Raven Row, London (group exhibition)

The Right to Protest, Museum on the Seam: Socio-Political Contemporary Art Museum, Jerusalem (group exhibition)

Sámi Art Festival, Saemien Sijte, Snåsa, Norway (group exhibition)

Simon Starling: Never The Same River (Possible Futures, Probable Pasts), Camden Arts Centre, London (group exhibition)

Super Farmer's Market, Handel Street Projects, London (group exhibition)

Talking of Yves: Friendships and Connections in Paris, New York & London, England & Co., London (group exhibition)

The Unknown Group, FRAC – Bourgogne, Dijon (group exhibition)

Yesterday Will be Better, Aargauer Kunsthaus, Aarau, Switzerland (group exhibition)

2011

The Deconstructive Impulse: Women Artists Reconfiguring the Signs of Power, 1973–1992, Neuberger Museum of Art, New York (group exhibition)

(We have attempted, where possible, to verify listings using multiple sources)

173

CATALOGUES OF
SOLO EXHIBITIONS

1978
Susan Hiller: Recent Works, Kettle's Yard, Cambridge (and touring); 14 b/w and col. illus. inc. cover, biog., intro. by David Elliott, texts by the artist and Caryn Faure-Walker.

1981
Susan Hiller 'Monument', Ikon Gallery, Birmingham (and touring); 2 col. illus., intro. by Tim Guest, text by artist (text in French and English).

1984
Susan Hiller 1974–1984: The Muse My Sister, Orchard Gallery, Londonderry (and touring); 70 b/w and col. illus. inc. cover, biog., bibl., texts by Guy Brett and John Roberts, interview with the artist by Rozsika Parker.

1985
Belshazzar's Feast, Tate Gallery, London; Tate New Art: The Artist's View series; 4 b/w illus., biog., bibl., transcript of conversation between the artist and Catherine Lacey.

1986
Susan Hiller, Institute of Contemporary Arts, London; 61 b/w and col. illus. inc. cover, exhibs., bibl., texts by James Lingwood, Lucy Lippard and the artist.

1989
Susan Hiller, Galerie Pierre Birtschansky, Paris; 3 col. illus., biog., filmog., exhibs., bibl., text by Jill Lloyd, text in French, English, Spanish and German

1990
Susan Hiller: The Revenants of Time, Matt's Gallery, London (and touring); 24 b/w and col. illus. inc. cover; text by Jean Fisher.

1994
Susan Hiller's Brain, Gimpel Fils, London; 15 b/w illus. inc. cover, text by Michael Corris.

1996
Susan Hiller, Tate Gallery, Liverpool; 64 col. illus. inc. cover, biog., exhibs., bibl., texts by Nicholas Serota, Lewis Biggs, Fiona Bradley, Guy Brett, interview with the artist by Stuart Morgan, catalogue of the artist's works by Rebecca Dimling Cochrane.

1998
Susan Hiller: Wild Talents, Foksal Gallery, Warsaw (and touring); 12 col. illus. inc. cover, interview with the artist by Stuart Morgan, text by Denise Robinson, text in English and Polish.

Susan Hiller: Wild Talents and From the Freud Museum, Australian Experimental Art Foundation, Adelaide; 4 col. illus. inc. cover, text by Richard Grayson.

1999
Susan Hiller: Lucid Dreams, Henie Onstad Kunstsenter, Oslo; 26 b/w and col. illus. inc. cover, exhibs., bibl., texts by Guy Brett, Tim Guest, Richard Grayson, Denise Robinson (text in English and Norwegian).

2000
Susan Hiller: Psi Girls, Site Gallery, Sheffield (and touring); 23 col. illus. inc. cover, text by Christopher Turner, interview by Matthew Higgs (text in English and Swedish).

2001
Susan Hiller: Video-Instalaciones, Sala Mendoza, Caracas; 12 col. illus. inc. cover, exhibs., bibl., texts by Cecilia Fajardo-Hill, Richard Grayson and Denise Robinson (text in Spanish).

2002
Susan Hiller: Witness, Dream Screens, Psi Girls, Wild Talents, Museet for Samtidskunst, Roskilde; 7 col. illus., accompanying CD., texts by Marianne Bech, Mette Marcus and Louise Milne (text in Danish and English).

2004
Susan Hiller: Recall: Selected Works 1969–2004, Baltic, Gateshead (and touring); 75 col. illus., bibl., texts by Stephen Snoddy, James Lingwood, Rosemary Betterton, Guy Brett, Ian Hunt, Jean Fisher, Denise Robinson, Stella Santacatterina and Louise Milne.

2006
Susan Hiller: The Curiosities of Sigmund Freud, (to accompany *Outlaws and Curiosities*), Galerie Volker Diehl, Berlin; 9 col. illus., intro. by artist (in English), texts by Jörn Ebner, Axel Hahn and Gabriele Hahn (text in German).

2008
Susan Hiller: The Last Silent Movie, Matt's Gallery, London; 1 b/w illus. inc. cover, text by Mark Godfrey.

Outlaw Cowgirl and Other Works, BAWAG Foundation, Vienna; 33 b/w and col. illus., exhibs., texts by Christine Kintisch and Rachel Withers (text in English and German).

Psi Girls, Joy Art, Beijing; 7 col. illus., exhibs., bibl., text by Christopher Turner, interview with artist by Lui Ding and Su Wei (text in English and Mandarin).

ARTIST'S BOOKS

Rough Sea, (to accompany the exhibition *Dedicated to the Unknown Artists*), Gardner Arts Centre Gallery, University of Sussex, Brighton 1976; 56 b/w illus.

Enquiries/Inquiries, Gardner Arts Centre Gallery, University of Sussex, Brighton, with The Arts Council of Great Britain 1979; texts as illus.

Sisters of Menon, Coracle Press for Gimpel Fils, London 1983; facsimile of handwritten texts and charts as illus., hand-painted board covers.

After the Freud Museum, Book Works, London 1995, reprinted 2000; 79 b/w illus. inc. cover, text by Susan Hiller.

Witness, Artangel, London 2000; 21 b/w and col. illus., accompanying CD, transcripts of selected excerpts from the soundtrack of the installation, text by James Lingwood, drawings and notes by the artist.

Split Hairs: The Art of Alfie West, self-published, Berlin 2004, co-authored with David Coxhead, 9 col. illus.

The J. Street Project, 2002–2005, Compton Verney, Warwickshire, and Berlin Artists-in-Residence Programme/DAAD, Berlin 2005; 303 col. illus., intro. by Susan Hiller, afterword by Jörg Heiser (text in English and German).

Levitations: Homage to Yves Klein/Auras: Homage to Marcel Duchamp, Institute of Contemporary Arts with Book Works, London 2008; 70 b/w and col. illus., texts by Susan Hiller.

Selected Bibliography

SELECTED WRITINGS
(*Including anthologised talks and interviews*)

Barbara Einzig (ed.), *Thinking About Art: Conversations with Susan Hiller*, Manchester University Press, Manchester and New York 1996, texts by Lucy Lippard, texts by the editor introducing interviews, discussions and talks by the artist 1973–1996.

Susan Hiller and David Coxhead, *Dreams: Visions of the Night*, The Illustrated Library of Sacred Imagination series, Thames and Hudson, London, and Avon, New York 1976, subsequently published in Spanish, French, Dutch, German, Portuguese and Japanese.

Susan Hiller (ed. and comp.), *The Myth of Primitivism: Perspectives on Art*, Routledge, New York 1991, an anthology of texts by anthropologists, artists, art critics, with introductory texts by the artist.

Susan Hiller 'Monument' (incl. transcript of audio tape), in Liam Kelly (ed.), *The City as Art: Interrogating the Polis*, AICA Ireland, Dublin 1994, pp.22–31.

Susan Hiller, untitled essay, in *Yves Klein Now: Sixteen Views*, exh. cat., Hayward Gallery, The South Bank Centre, London 1995, unpag.

Susan Hiller, 'The Dream and the Word', in Pavel Büchler and Nikos Papastergiadis (eds.), *Random Access: On Crisis and its Metaphors*, Rivers Oram Press, London 1995, pp.131–49.

Susan Hiller: Freudsche Objekte, Institut für Buchkunst, Leipzig 1998, transcripts of three discussions, interview with the artist by Stuart Morgan (text in German).

Susan Hiller, *Dream Machines*, exh. cat., Hayward Gallery Touring exhibition curated by the artist, 2000, texts by the artist, Jean Fisher, Susan Brades and Fiona Bradley.

Susan Hiller and Sarah Martin (eds.), *The Producers: Contemporary Curators in Conversation (nos. 1–5)*, nos.2, 4, 5, 7 and 8 in B.READ series, Baltic in collaboration with the University of Newcastle, Department of Fine Art, Gateshead, 2000–2; a series of five books transcribing public discussions among established curators analysing their varied functions and roles.

Alexandra Kokoli (ed.), *Susan Hiller: The Provisional Texture of Reality: Selected Talks and Texts 1977–2007*, Positions series, JRP Ringier, Zurich 2008, text by the editor introducing an anthology of Susan Hiller's essays, interviews, and personal notes on cultural politics, magic, feminism and psychoanalysis.

CATALOGUES OF
GROUP EXHIBITIONS

1973
Photography Into Art: An International Exhibition of Photography, Camden Arts Centre, London; ed. Shiela Watkins.

1977
Künstlerinnen international 1877–1977: Frauen in der Kunst, Neue Gesellschaft für bildende Kunst, Berlin 1977; texts by Dorothea Muenk et al. (text in German and English).

1978
Hayward Annual '78, Hayward Gallery and Arts Council of Great Britain, London; texts by Lucy Lippard and Sarah Kent, pp.46–9.

1980
About Time: Video, Performance and Installation by 21 Women Artists, Institute of Contemporary Arts, London (and touring); texts by Lynn MacRitchie and Susan Hiller.

1981
New Works of Contemporary Art and Music, Fruitmarket Gallery, Edinburgh; text by Susan Hiller.

Books by Artists, National Gallery of Canada, Ottawa (and touring); texts by Tim Guest and Germano Celant (text in English and French).

1982
Sense and Sensibility in Feminist Art Practice, Midland Group Gallery, Nottingham; biog., exhibs., bibl., filmog., extracts from Griselda Pollock, *Block (3)* 1980 and Susan Hiller (incorrectly attributed to David Brown), *A Mansion of Many Chambers: Beauty and Other Works* (1981).

1984
The British Art Show: Old Allegiances and New Directions 1979–1984, Arts Council of Great Britain touring exhibition; text by Jon Thompson.

1985
The British Show, Art Gallery of Western Australia, Perth (and touring); biog., text on Hiller by Lynne Cooke.

British Film and Video 1980–1985: The New Pluralism, Tate Gallery, London, text by Michael O'Pray.

Human Interest: Fifty Years of British Art About People, Cornerhouse, Manchester; text by Norman Lynton.

Identités de Disderi au Photomaton, Centre National de la Photographie, Paris; texts by Michel Frizot, Serge July, Christian Phéline and Jean Sagne (text in French).

Kunst mit Eigen-Sinn: Aktuelle Kunst von Frauen: Texte und Dokumentation Museum Moderner Kunst/Museum des 20. Jahrhunderts, Vienna; biog., exhibs., bibl., filmog., text by Guy Brett.

1986
Staging the Self: Self-Portrait Photography 1840s–1980s, National Portrait Gallery, London (and touring); texts by James Lingwood and Susan Butler.

1987
Current Affairs: British Painting and Sculpture in the 1980s, Museum of Modern Art, Oxford (and touring); exhibs., texts by Lewis Biggs, David Elliott, and Andrew Brighton.

1989
Lifelines/Lebenslinien: Four British Artists, BASF-Feierabendhaus, Ludwigshafen (and touring); biog., exhib., bibl., texts by Lewis Biggs and Jean Fisher (text in English and German).

Picturing People: British Figurative Art Since 1945, The British Council touring exhibition; biog., texts by Norbert Lynton and Sarah Kent.

Through the Looking Glass: Photographic Art in Britain 1945–1989, Barbican Art Gallery, London (and touring); ed. Gerry Badger and John Benton-Harris.

1990
Glasgow's Great British Art Exhibition, Glasgow Museums and Art Galleries; 1 col. illus., biog., exhibs., bibl., text by Julian Spalding.

1991
Shocks to the System: Social and Political Issues in Recent British Art, Royal Festival Hall, London (and touring); text by Lisa Tickner.

Exploring the Unknown Self: Self-Portraits of Contemporary Women, Tokyo Metropolitan Museum of Photography; biog., bibl., extract from Susan Butler's text in *Staging the Self*, 1987 (text in English and Japanese).

1994
Inside the Visible: An Elliptical Traverse of 20th Century art: in, of, and from the feminine, Béguinage of Saint-Elizabeth, Kortrijk; (exhibition further expanded) The Institute of Contemporary Arts, Boston (and touring); biog., bibl., ed. M. Cathering de Zegher, 2 texts by Jean Fisher, one expanded and repr. from *Lifelines/Lebenslinien*,1989; both repr. in Fisher, *Vampire in the Text* 2003.

1995
Rites of Passage: Art for the End of the Century, Tate Gallery, London; ed. Stuart Morgan and Frances Morris.

1996
The Inner Eye: Art Beyond the Visible, City Art Galleries, Manchester (and touring), text by Marina Warner.

Jurassic Technologies Revenant: The 10th Biennale of Sydney 1996, Art Gallery of New South Wales, Artspace and Ivan Dougherty Gallery; biog., bibl., text by Lynne Cooke.

NowHere, Louisiana Museum of Modern Art; Humlebaek, Denmark, 2 vols., biog., exhibs., bibl. Texts by Iwona Blazwick, Bruce W. Ferguson and Laura Cottingham et al. (text in English and Danish)

1997
Esthétique du livre d'artiste, (to accompany *Livres d'artistes. L'invention d'un genre 1960–1980*), Bibliothèque nationale de France, Galerie Mansart; ed. Anne Moeglin-Delcroix.

In Visible Light: Photography and Classification in Art, Science and the Everyday, Museum of Modern Art, Oxford (and touring); bibl., ed. Chrissie Iles and Russell Roberts

Material Culture: The Object in British Art of the 1980s and '90s, Hayward Gallery, London; biog., texts by Michael Archer and Greg Hilty.

1998
Chemical Traces: Photography and Conceptual Art 1968–1998, Ferens Art Gallery, Kingston-upon-Hull; text by David Alan Mellor.

Out of Actions: Between Performance and the Object 1949–1979, Museum of Contemporary Art, Los Angeles (and touring); texts by Kristine Stiles et al.

Sacred and Profane: 1998 Telstra Adelaide Festival of Visual Arts Program, Telstra Adelaide Festival; text by Richard Grayson.

1999
The Museum as Muse: Artists Reflect, The Museum of Modern Art, New York; texts by Susan Hiller and Kynaston McShine.

2000
Amateur/ Eldsjäl: Variable Research Initiatives 1900 and 2000, Göteborgs Konstmuseum, Gothenburg, vol.1, includes extracted text from *Intelligence: New British Art 2000*, 2000 (see below).

The British Art Show 5, Hayward Touring exhibition; texts by Pippa Coles, Matthew Higgs and Jacqui Poncelet.

Intelligence: New British Art 2000, Tate Britain, London; ed. Virginia Button and Charles Esche.

Live in Your Head: Concept and Experiment in Britain 1965–75, Whitechapel Gallery, London; text by Andrea Tarsia.

Uno más cerca del otro: Séptima Bienal de la Habana, Centro de Arte Contemporáneo Wifredo Lam for the 7th Havana Biennial; texts by Nelson Herrara Ysla et al.

2001
Live in Your Head: Conceito e experimentação na Grã-Bretanha 1965–75, Museo do Chiado, Lisbon; (text in Portuguese, previously published by Whitechapel Gallery, London in 2000)

2002
Real Life: Film and Video Art, Tate St Ives; texts by Susan Daniel-McElroy and Andrew Dalton.

Self Evident: The Artist as the Subject 1969–2002, Tate Britain, London; texts by Mary Horlock, Michela Parkin, Kathryn Rattee and Katharine Stout.

2003
A Bigger Splash: British Art from Tate 1960–2003, Pavilhão Lucas Nogueira Garcez, São Paulo (and one other venue); texts by Simon Casimir Wilson, Elizabeth Manchester et al. (text in English and Portuguese)

2004
Dream Extensions, S.M.A.K. (Stedelijk Museum voor Actuele Kunst), Ghent; texts by Ken Hillis and Filip Luyckx (text in English and Dutch).

2005
Blur of the Otherworldly: Contemporary Art, Technology and the Paranormal, Center for Art, Design and Visual Culture, Baltimore; biog., texts by Mark Alice Durant, Jane D. Marsching, Lynne Tillman and Marina Warner.

Thinking of the Outside: New Art and the City of Bristol, Arnolfini, Bristol; text by Jörg Heiser.

2006
Concetto: Corpe e Sogno, Castello di Rivoli Museo d'Arte Contemporanea, Turin (Boxed set of 5 pamphlets on Susan Hiller, Lawrence Weiner, Dan Graham, Joseph Kosuth and Joan Jonas); exhibs., bibl., text by Adam Szymczyk (text in English and Italian).

Forms of Classification: Alternative Knowledge and Contemporary Art, cifo – Cisneros Fontanals Art Foundation, Miami; biog. ed. Cecilia. Fajardo-Hill.

How to Improve the World: 60 Years of British Art, Hayward Gallery, Southbank Centre, London; texts by Marjorie Allthorpe-Guyton, Michael Archer and Roger Malbert.

A Secret Service: Art, Compulsion, Concealment, Hayward Touring exhibition; biog., texts by Richard Grayson, Clare Carolin, Roger Cardinal.

This Land is My Land, Kunsthalle Nürnberg, Nuremberg (and touring); ed. Dorothée Bienert and Marina Sorbello (text in German).

2007
Gartenlust: Der Garten in der Kunst, Belvedere, Vienna; 1 col. illus. (text in German)

Romantic Conceptualism, Kunsthalle Nürnberg, Nuremberg (and touring); biog., exhibs., bibl., interview with Susan Hiller by Jörg Heiser and Jan Verwoert.

Residents 2003–2007, Espace EDF Electra, Paris; interview with Hiller (text in English and French).
Wack! Art and the Feminist Revolution, The Museum of Contemporary Art, Los Angeles (and touring); biog., exhibs., bibl., texts by Cornelia Butler et al.

2008

Encyclopaedia of Terrestrial Life Volume VIII: Art (to accompany *Martian Museum of Terrestrial Art*), Barbican Art Gallery, London; texts by Francesca Manacorda, Lydia Yee and Tom McCarthy.

When Things Cast No Shadow, 5th Berlin Biennial for Contemporary Art; ed. Adam Szymczyk and Elena Filipovic.

Building Bridges: 8 Visions, One Dream, Today Art Museum, Beijing; biog., exhibs., bibl., interview with the artist by Isabelle Chalard.

Moving Horizons: The UBS Art Collection: 1960s to the present day, National Art Museum of China, Beijing ; text by Joanne Bernstein (text in English and Chinese).

2009

elles@centrepompidou: Artistes Femmes dans les Collections du Musée National d'Art Moderne, Centre Pompidou, Paris; texts by Camille Morineau et al. (text in French. English edn. 2010)

Fact and Fiction: Recent Works from The UBS Art Collection, Guangdong Museum of Art; texts by Joanne Bernstein and Wang Huangsheng (text in English and Chinese).

The Quick and the Dead: Rites of Passages in Art, Spirit and Life, Ivan Dougherty Gallery, Sydney; text by David Elliot.

What a Wonderful World: Göteborg International Biennial for Contemporary Art, multiple venues in Gothenburg; interview with the artist by Mary Horlock expanded and repr. from *Paletten* 2001, see Articles (text in Swedish and English).

2010

Childish Things, Fruitmarket Gallery, Edinburgh; bibl., text by David Hopkins.

BOOK REFERENCES

1983
Lucy R. Lippard, *Overlay: Contemporary Art and the Art of Prehistory*, Pantheon Books, New York 1983, pp.61–2 and 160–1.

1986
Val Williams, *Women Photographers: The Other Observers 1900 to the Present*, Virago Press, London 1986, pp.170–2, 183.

1987
Susan Butler, 'So How Do I Look? Women Before and Behind the Camera', in *Staging The Self: Self-Portrait Photography*, National Portrait Gallery, London 1987, pp.51–9, repr. from *Photo Communiqué*, vol.9, no.3, Autumn 1987.

Sandy Nairne, *State of the Art: Ideas and Images in the 1980s*, Chatto and Windus, London 1987, pp.120–6, 200.

Rozsika Parker and Griselda Pollock (eds.), *Framing Feminism: Art and the Women's Movement 1970–1985*, Pandora, London and New York 1987, pp.283–6.

1988
Susan Butler, 'Between Frames', in David Mellor et. al., *British Photography: Towards a Bigger Picture*, Aperture Foundation Inc., London 1988, pp.31–9.

Lisa Tuttle, 'Susan Hiller', in *Heroines: Women Inspired by Women*, Harrap, London 1988, pp.118–28.

1990
Tony Godfrey, *Drawing Today: Draughtsmen in the Eighties*, Phaidon Press, London 1990, pp.41–2.

John Roberts, *Postmodernism, Politics and Art*, Manchester University Press, Manchester 1990, pp.85–90, 104–10, see index for additional references.

1993
'Susan Hiller in Conversation with Andrew Renton', in Adrian Searle (ed.), *Talking Art 1*, Institute of Contemporary Arts, London 1993, pp.85–100.

1994
Penelope Kenrick, 'Susan Hiller, Automatic Writing and Images of Self', in Gabriele Griffin (ed.), *Difference in View: Women and Modernism*, Taylor and Francis, London 1994, pp.108–29.

1996
'Susan Hiller', in Jane Rolo and Ian Hunt (eds.), *Book Works: A Partial History and Sourcebook*, Book Works, London 1996, pp.44–5, 87–90.

1997
Michael Archer, *Art Since 1960*, Thames and Hudson, London 1997, pp.132–4, 212.

Louisa Buck, *Moving Targets: A User's Guide to British Art Now*, Tate Publishing, London 1997, pp.22–4, see index for additional references.

James Clifford, 'Immigrant', in *Routes: Travel and Translation in the Late Twentieth Century*, Harvard University Press, Cambridge, MA, and London 1997, pp.278–97.

Gavin Jantjes, 'Susan Hiller', in Gavin Jantjes (ed.), *A Fruitful Incoherence: Dialogues with Artists on Internationalism*, Institute of International Visual Arts, London 1997, pp.18–31.

1998
'Dream Screens: A Project for the World Wide Web' in Melanie Keen (ed.), *Frequencies: Investigations into Culture, History and Technology (Annotations 3)*, Institute of International Visual Arts, London 1998, pp.62–72.

Richard Grayson, 'Susan Hiller' and Susan Hiller 'Ideal Work', in Richard Grayson, *Ideal Work*, Australian Experimental Art Foundation, Adelaide 1998, pp.75–9.

2000
Siân Ede (ed.), *Strange and Charmed: Science and the Contemporary Arts*, Calouste Gulbenkian Foundation, London 2000, pp.91–5.

'Collected Dream Maps', in *The Redstone Diary 2001: Odysseys and Other Journeys*, Redstone Press, London, 2000, unpag.

2001
Helena Reckitt (ed.), *Art and Feminism*, Phaidon Press, London 2001.

2002
Peter Osbourne, *Conceptual Art*, Phaidon Press, London 2002, pp.36, 143.

Richard Cork, 'Susan Hiller', in *Everything Seemed Possible: Art in the 1970s*, Yale University Press, London and New Haven, CT, 2003, pp.173–6.

Richard Cork, 'Witness', in *Annus Mirabilis?: Art in the Year 2000*, Yale University Press, London and New Haven, CT, 2003, pp.240–2.

Jean, Fisher, 'Susan Hiller: Élan and Other Evocations' and 'The Echoes of Enchantment', in *Vampire in the Text: Narratives of Contemporary Art*, Institute of International Visual Arts, London 2003, pp. 17-24, 178-187, see index for additional references, 1 col. illus. Repr. of essays in *Lifelines/Lebenslinien*, 1989, and *Inside the Visible*, 1994.

Factor 1991, Foundation for Art and Creative Technology, Liverpool (no.2 in a series of publications on the 'Video Positive' festivals); ed. Claire Doherty, text on Hiller by Ian Hunt.

2003
Mary Horlock, 'The Voice as Body' (interview with the artist), in Jim Drobnick (ed.), *Aural Cultures*, YYZ Books, Toronto 2003, pp.137–45, 1 b/w illus., excerpts from the 'Witness' archive on attached CD.

Simon Morley, *Writing on the Wall: Word and Image in Modern Art*, Thames and Hudson, London 2003, pp.181–3.

Barbara Schellewald, 'Susan Hiller: From the Freud Museum', and Céline Kaiser, 'After the Freud Museum: A Conversation with Susan Hiller', in Céline Kaiser and Marie-Luise Wünsche (eds.), *Die „Nervosität der Juden" und andere Leiden an der Zivilisation: Konstruktionen des Kollektiven und Konzepte individueller Krankheit im psychiatrischen Diskurs um 1900*, Ferdinand Schöningh, Paderborn, Munich, Vienna and Zurich 2003, pp.111–19, 121–9 (text in English and German).

2004
Rosemary Betterton, 'Susan Hiller's Painted Work: Bodies, Aesthetics and Feminism', in Rosemary Betterton (ed.), *Unframed: Practices and Politics of Women's Contemporary Painting*, I.B. Tauris, London 2004, pp.79–91.

Guy Brett, 'Wicked, wicked, wicked', in *Carnival of Perception: Selected Writings on Art*, Institute of International Visual Arts, London 2004, pp.106–16.

Alicia Foster, *Tate Women Artists*, Tate Publishing, London 2004, pp.209–11, see index for additional references.

2005
'Dedicated to the unknown artists', in Richer, Francesca and Matthew Rosenzweig (eds.), *No.1: First Works by 362 Artists*, Distributed Art Publishers, New York 2005, pp.174–5.

2006
Alexandra M. Kokoli, 'Susan Hiller's Paraconceptualism', in Jennifer Fisher (ed.), *Technologies of Intuition*, YYZ Books, Toronto 2006, pp.118–40.

Charles Mereweather (ed.), *The Archive: Documents of Contemporary Art*, Whitechapel, London 2006.

Stuart Morgan, 'Beyond Control: an interview with Susan Hiller', in Ian Hunt (ed.), *Inclinations: Further Writings and Interviews by Stuart Morgan*, Frieze, London 2006, pp.387, 392–400.

Denise Richardson, 'Encounters with the Work of Susan Hiller', in Arnd Schneider and Christopher Wright (eds.), *Contemporary Art and Anthropology*, Berg, Oxford and New York 2006, pp.71–84.

2007
Mark Godfrey, 'New Roads of Memory', in *Abstraction and the Holocaust*, Yale University Press, London and New Haven, CT, 2007, pp.254–65.

2008
Beth Anne Lauritis, 'In the Words of Susan Hiller and Annette Messager: Conceptualism and Feminism in Dialogue', in Alexandra M. Kokoli (ed.), *Feminism Reframed: Reflections on Art and Difference*, Cambridge Scholars Publishing, Newcastle 2008, pp.227–47.

'Women in Art: Revolution or Evolution?', in *Art Basel Miami Beach: 6–9 Dec 2007*, Hatje Cantz, Ostfildern 2008, pp.91–107, transcript of panel discussion (8 Dec. 2007): Marina Abramovic, VALIE EXPORT, Susan Hiller, Catherine Morris, Peter Aspden.

'Remaking Art?', in Harald Falckenberg and Peter Weibel (eds.), *Paul Thek: Artist's Artist*, ZKM Center for Art and Media Technology, Karlsruhe 2008, pp.403–16, transcript of panel discussion (3 Sept. 1995): Chris Dercon, Susan Hiller, James Lingwood, Christian Scheidemann, repr. from *Witte de With Cahier*, no.4, March 1996.

2009
Giovanni Iovane, 'Curiosities of Sigmund Freud', in Giovanni Iovane and Filipa Ramos, *Lost and Found: Crisis of Memory in Contemporary Art*, Silvana Editoriale Spa, Milan 2009, pp. 108–115, see index for additional references (text in English and Italian).

Andrea Liss, *Feminist Art and the Maternal*, University of Minnesota Press, Minneapolis 2009, pp.12–17, 103.

Aimee Selby (ed.), *New Art and Text*, Black Dog Publishing, London 2009, pp.148–9, pp.164–5.

'The Last Silent Movie', in Aleksandra Wagner (ed.), *Considering Forgiveness*, Vera List Center for Art and Politics, The New School, New York 2009, pp.94–108.

2010
Susan Hubbard, 'Susan Hiller: *The J: Street Project*', in *Adventures in Art: Selected Writings 1910–2010*, Other Criteria, London 2010, pp.180–3.

ARTICLES
(*Including interviews, excluding online articles, see below*)

1976
John Sharkey, 'In pancake making, it's the mix that is important', *Musics*, no.9, Sept. 1976, pp.3–6.

1977
Caryn Faure-Walker, 'In the Beginning was the Word: Susan Hiller's Recent Work', *Artscribe*, no.5, Feb. 1977.

Richard Cork, 'Storm in a postcard', *Evening Standard*, 17 March 1977, p.23.

1978
Rozsika Parker, 'Dedicated to the unknown artist' (interview), *Spare Rib*, no.72, July 1978, pp.28–30

1979
Paul Buck, 'Thirteen Male Absences' (interview), *Centrefold*, vol.4, no.1, 1979, pp.39–42.

1980
Barbara Einzig, 'Postface to Dream-Works', *New Wilderness Letter*, no.10, 1980, pp.82–5.
Waldemar Januszczak, 'You've got to face the problem that you are the subject matter of art', (interview), *Guardian*, 8 Aug. 1980, p.8.

1981
Tony Godfrey, 'Susan Hiller, Simon Read at Arnolfini', *Artscribe*, no.31, Oct. 1981, pp.57–8.

Griselda Pollock, 'The Politics of Art or an Aesthetic for Women?', *FAN (Feminist Arts News)*, no.5, 1981, pp.15–19

Lisa Liebmann and Tony Whitfield, 'Susan Hiller' (interview), *Fuse*, Toronto, vol.5, nos.8–9, Nov.–Dec. 1981, pp.257–61. Repr. in *Flue*, Summer 1982, pp.14–15.

1982
'Susan Hiller on her work: I don't care what it's called', *Artlink*, Adelaide, Sept.–Oct. 1982.

1983
John Roberts, 'Susan Hiller', *Patrons of New Art Newsletter*, Tate Gallery, March–April 1983, unpag.

1984
Annette van den Bosch, 'Desire/Language/Struggle', illus. by Susan Hiller, *Art and Text*, Melbourne, nos.12–13, Summer 1983/Autumn 1984, pp.100–9.

Annette van den Bosch, 'Susan Hiller: Resisting Representation', *Artscribe*, no.46, May–July 1984, pp.44–8.

Stuart Morgan, 'Susan Hiller: Gimpel Fils', *Artforum International*, vol.22, no.10, Summer 1984, p.100.

1986
Desa Philippi, 'The Writing on the Wall', *The Media Education Journal*, no.5, 1986, pp.44–6.

Guy Brett, review of 'Home Truths: Love, Death, Language' at Gimpel Fils Gallery, *Studio International*, vol.199, no.1012, March 1986, pp.60–1.

John Roberts, 'Different Pleasures', *Artscribe*, no.58, June–July 1986, pp.40–1.

1987
Jean Fisher, 'Susan Hiller: Institute of Contemporary Arts', *Artforum International*, vol.25, no.5, Jan. 1987, p.129.

Alex Potts, 'Whitechapel Art Gallery: Susan Hiller's *Magic Lantern*', *Burlington Magazine*, vol.130, no.1018, Jan. 1988, p.51.

Roberta Smith, 'Susan Hiller', *New York Times*, 15 April 1987.

1988
Gary Indiana, 'Wave Theory', *Village Voice*, 12 April 1988, pp.103–4.

1989
Nancy Princenthal, 'Susan Hiller at Pat Hearn', *Art in America*, vol.77, no.1, Jan. 1989.

Guy Brett, 'Earth and Museum – Local and Global?', *Third Text*, no.6, Spring 1989, pp.89–96. Repr. in *Magiciens de la Terre*, exh. cat., Centre Georges Pompidou, Summer 1989, pp.93–102 (text in French).

1991
Roberta Smith, 'Susan Hiller/Pat Hearn Gallery/Nicols Klagsbrun', *New York Times*, 25 Jan. 1991.

Guy Brett, 'Susan Hiller's Shadowland', *Art in America*, vol.79, no.4, April 1991, pp.136–43.

Barbara Einzig, 'Within and Against: Susan Hiller's Non-Objective Reality', *Arts Magazine*, vol.66, no.2, Oct. 1991, pp.60–5.

1992
Marina Warner, 'Penis Plenty or Phallic Lack: Exit Mister Punch', *Parkett*, no.33, Sept. 1992, pp.8–19.

1994
Guy Brett, 'That Inner Vision Thing at Freud's', *Guardian*, 19 April 1994, p.29.

Kate Bush, 'Susan Hiller: Automatic Writing and Images of the Self', *Untitled: A Review of Contemporary Art*, no.5, Summer 1994, p.12.

1995
Stuart Morgan, 'Beyond Control', (interview), *Frieze*, no.23, Summer 1995, cover and pp.52–8. Repr. in Kokoli 2008.

James Clifford, 'Immigrant', *Sulfur: A Literary Bi-Annual of the Whole Art*, Autumn 1995, pp.32–52.

1996
Guy Brett, 'Susan Hiller at Gimpel Fils', *Art in America*, vol.84, Jan. 1996, pp.110, 127.

Robert Clark, 'Magical mystery tour de force', *Guardian*, 23 Jan. 1996.

Richard Cork, 'Haunted by imitations of mortality', *The Times*, 23 Jan. 1996, p.38.

Padraig Timoney, 'The Sun is Flat', *L:Scene*, no.32, Feb. 1996, pp.6–7.

Michael Archer, 'Framed: Susan Hiller', *Tate: The Art Magazine*, no.8, Spring 1996, pp.16–18.

Christine Reynolds, 'Susan Hiller', *Contemporary Art*, vol.3, no.3, Late Spring 1996, pp.78–9.

'Susan Hiller: Works', in Gloria Chalmers (ed.), *The Catalogue of Contemporary Photography in Britain*, no.23, June 1996, pp.18–23.

Jean Fisher, 'Light and Its Double', *Portfolio*, no.23, June 1996, pp.52–3, col. illus. on pp.18–23

Denise Robinson, 'A discussion between Denise Robinson and Susan Hiller on the Susan Hiller retrospective at the Tate Gallery, Liverpool', *Coil*, no.3, Summer 1996, unpag.

Alan Wood, 'Susan Hiller' (interview), *Transcript*, vol.2, no.1, Summer 1996, pp.50–70 and cover.

Denise Robinson, 'Thought Burned Alive: The Work of Susan Hiller', *Third Text*, no.37, Winter 1996–7, pp.37–52.

1998
Cath Kenneally, 'Susan Hiller: Being Rational about the Irrational' (interview), *Artlink*, Adelaide, vol.18, no.1, March 1998, pp.55–7.

Edward J. Sozanski, 'Where dream touches reality', *Philadelphia Inquirer*, 29 March 1998.

Miriam Seidel, 'Soul Digging', *Philadelphia Weekly*, 1 April 1998, pp.41–2.

Rachel Withers, 'Art for smart's sake', *Guardian*, 18 July 1998.

Guy Brett, 'Susan Hiller: The Secrets of Sunset Beach', *Grand Street*, no.66 (thematic issue: 'Secrets'), Autumn 1998, pp.64–70.

179

Eileen Neff, 'Susan Hiller: Institute of Contemporary Art, University of Pennsylvania', *Artforum International*, vol.37, no.1, Sept. 1998, p.159.

Guy Brett, 'Susan Hiller: The Secrets of Sunset Beach', *Grand Street 66*, vol.17, no.2, Fall 1998, pp.64–70.

1999
Gregor Muir, 'Psychic TV' (interview), *Dazed & Confused*, no.55, June 1999, pp.110–15.

Siri Blakstad, 'Pioneren Susan Hiller', *Vi ser pa Kunst*, no.1, 1999, pp.26–9, text in Norwegian.

John Tozer, 'Susan Hiller', *Art Monthly*, no.228, July–Aug. 1999, pp.43–4.

Michael Archer, 'Susan Hiller', *Untitled*, no.20, Autumn 1999, p.33.

Neal Brown, 'Susan Hiller', *Frieze*, no.45, Sept. 1999, p.109.

Josie Lambert, 'Beyond belief', *Independent* (magazine), 23 Oct. 1999, p.47.

2000
Jonathan Jones, 'Warning: this woman is inside your head', *Guardian*, 10 Feb. 2000, pp.10–11.

Tom Lubbock, 'The stuff that dreams are made on', *Independent*, 22 Feb. 2000, p.12.

Filip Luycdx, 'Susan Hiller: Wild Talents', *Sint-Lukasgalerij Brussel*, no.4, March 2000, pp.12–13 (text in Dutch).

Dr. Louise S. Milne, 'Dream on', *Make*, London, no.87, March–May 2000, pp.22–3.

Elisabeth Mahoney, 'Dream Machines: Dundee Contemporary Arts', *Art Monthly*, no.235, April 2000, pp.24–6.

Tom Lubbock, 'Close encounters of the transcendental kind', *Independent* (Review), 23 May 2000, p.12.

Richard Dorment, 'Close encounters of the aural kind', *Daily Telegraph*, 31 May 2000, p.19.

Sue Hubbard, 'Susan Hiller', *Contemporary Visual Arts*, no.30, Sept. 2000, pp.30–5.

Louisa Buck, 'Sweet dreams are made of this', *Evening Standard*, 14 Sept. 2000, p.28.

Claire Bishop, 'Susan Hiller: Witness', *Make*, no.89, Sept.–Nov. 2000, p.32.

2001
Juan Antonio Gonzalez, 'Los fascinantes espantos mediáticos de Susan Hiller', *El Nacional*, Caracas, 20 Feb. 2001.

Mary Horlock, 'Magiska Röster, Magiskt Ljus [Magic Voices, Magic Light]' (interview), *Paletten*, no.245–6, April/May 2001, pp.22–7, text in Swedish, English version as separate pamphlet.

2002
Olesya Turkina and Victor Mazin, 'Susan Hiller in Freud's Dream[s] Museum' (transcript of lectures 28 Oct. 2001), *Kabinet*, no.12, Autumn 2002, pp.213–27.

Stella Santacatterina, 'Susan Hiller: Anamorphosis of the Gaze', *Portfolio*, no.36, Dec. 2002, pp.54–6, col. illus. on pp.26–7.

2003
Jörn Ebner, 'The J.Street Project', *Springerin*, Vienna, Winter 2003, pp.65–6.

2004
Adrian Searle, 'Tall stories', *Guardian* (G2), 4 May 2004, pp.12–13.

Tom Lubbock, 'In the twilight zone', *Independent* (Review), 4 May 2004, pp.12–13.

Rachel Campbell-Johnston, 'Prospero's Paintbox', *The Times* (T2), 15 May 2004, pp.12–13.

Richard Dorment, 'Tales of the unexpected', *Daily Telegraph*, 12 May 2004, p.19.

Laura Cumming, 'Then I saw this beautiful white light', *Observer* (Review), 23 May 2004, p.10.

Rachel Withers, 'Speaking Volumes: Rachel Withers on the Art of Susan Hiller', *Artforum International*, vol.43, no.3, Nov. 2004, pp.182–7.

2005
Stuart Ferrol, 'The Susan Hiller project', *Fortean Times*, April 2005, p.51.

Jessica Berens, 'The Invisible Woman', *Observer* (Magazine), 3 April 2005, pp.16–20.

Charles Darwent, 'A crime on every street corner', *Independent on Sunday* (ABC section), 17 April 2005, p.22.

Sue Hubbard, 'Signs of past lives', *Independent*, 25 April 2005.

Richard Cork, 'The echoing streets', *New Statesman*, 2 May 2005, p.44

Denise Robinson, 'Transmissions', *Framework: The Finnish Art Review*, no.3, June 2005, p.29.

Michael Hübl, 'Susan Hiller', *Frieze*, no.92, June–Aug. 2005, p.159.

Julia Weiner, 'Bearing Witness' (interview), *Jewish Quarterly*, no.199, Autumn 2005, pp.28–34.

2006
John Zepetelli, 'Lost and Found', *Hour*, Montreal, 19 Oct. 2006, p.21.

Paula Carabell, *The J. Street Project 2002–2005* by Susan Hiller, *Art Book*, vol.13, no.4, Nov. 2006, p.71.

2007
Felix Ensslin, Jörg Heiser, Juliane Rebentisch, André Rottmann and Jan Verwoert, 'Powered by Emotion?', transcript of conversation, in André Rottmann and Mirjam Thomann (eds.), *Texte Zur Kunst*, March 2007, pp.34–55, 2 col. illus.

Brian Dillon, 'Second Sight', *Frieze*, no.109, Sept. 2007, pp.154–9.

2008
Geneviève Cloutier, 'Spatial Narratives: Susan Hiller's "From the Freud Museum" and the Mechanisms of Narrativity', *n.paradoxa: international feminist art journal*, vol.22, July 2008, pp.36–43.

Jan Verwoert, 'Without Oedipus', *Parkett*, no.82, 2008, pp.213–15.

Lilian Chee, 'Living with Freud', in Helen Castle (ed.), *Architectural Design*, vol.78, no.3, May–June 2008, pp.78–81.

Laura Cumming, 'They're truly leaps of imagination', *Observer* (Review), 9 Nov. 2008, pp.18–19.

Tom Lubbock, 'Seeing but not believing', *Independent* (Life), 10 Nov 2008, pp.14–15.

2009
Sue Hubbard, 'Susan Hiller: Psi Girl', *Art World*, no.8, Dec. 2008 – Jan. 2009, pp.138–43.

FILM, AUDIO, WEB

Audio: Susan Hiller and Mary Kelly in conversation with William Furlong discussing women's practice in art, *Audio Arts*, London, vol.3, no.3, 1977.

Film: Chris Swayne (dir.), *Susan Hiller: A Provisional Portrait*, 17 min, The Arts Council of Great Britain, 1980.

Film: Susan Hiller, *Belshazzar's Feast*, 20 min, Channel 4, aired 29 Jan. 1986.

Film: Gina Newsom (dir.) and Marina Warner, *Imaginary Women*, Channel 4, aired 13 July 1986

Film: Sandy Nairne (prod.), 'Imaginations', *State of the Art: Ideas and Images in the 1980s* (series), Channel 4, aired 25 Jan. 1987

Audio: Claudia Gould (ed.), 'An Anthology of Audio by Artists', *Tellus: The Audio Magazine*, New York, no.21, 1988.

Audio: Michael Archer interviewing Susan Hiller, *Audio Arts*, London, vol.14, no.1, 1994.

Video: Susan Hiller in conversation with Frances Morris, *Tate Online*, webcast, 13 June 2006.
http://channel.tate.org.uk/media/26649808001

Web journal: 'Susan Hiller in conversation with Roger Malbert', in *Papers of Surrealism*, web journal, no.5, Spring 2007.
http://www.surrealismcentre.ac.uk/papersofsurrealism/journal5/index.htm

Audio: Adrian Searle, 'Susan Hiller', *guardian.co.uk*, The Guardian Culture Podcast, 11 Nov. 2008.
http://www.guardian.co.uk/culture/audio/2008/nov/11/susan-hiller-podcast

Video: Susan Hiller in conversation with Christoph Grunenberg, *Tate Online*, webcast, 5 May 2008.
http://channel.tate.org.uk/media/30182637001

Video: Susan Hiller in conversation with Richard Grayson, *Tate Online*, Talking Art series, webcast, 11 April 2009.
http://channel.tate.org.uk/media/28164531001

Video: Susan Hiller in conversation with Dan Schifrin, webcast, 18 June 2009.
http://www.youtube.com/watch?v=594aCcLjHgs

PRINT PROJECTS

'More Excerpts from "Dream Mapping"', in *Wallpaper*, London and New York, nos.5 and 6, 1976, 2p, unpag.

'Saving: A Study in the Visible World', in *City Limits*, London, no.12, 24 Dec.– 6 Jan. 1982, pp.76–7.

'Séance (Seminar)', *Reaktion 7*, Verlaggalerie Leamen, Alsbach, 1983, boxed magazine, 5 b/w illus., unpag.

'Susan Hiller: *Midnight Baker Street*', in *Eau de Cologne*, Monika Sprüth Galerie, Cologne, no.1, Nov. 1984, illus., pp.52–4.

'Mother Tongue', in *Circa*, Dublin, no.27, March–April 1986, 1 b/w illus., pp.24–5.

Record covers for Tom Verlaine, *A Town Called Walker*, *Cry Mercy Judge*, *Flash Light*, Phonogram Records, New York 1987.

'Susan Hiller: *Monument*', in *Eau de Cologne*, Monika Sprüth Galerie, Cologne, no.2, Oct.– Nov. 1987, illus. and text, p.60.

'Dream Mapping', in *Metronome*, London, no.1, Feb. 1997, pp.8–11.

'Psychoanalysis and the Occult', double page commissioned photograph in *Dazed & Confused*, London, no.34, Sept. 1997, pp.80–1.

'Aquarius New Age Typewriter', in *The Redstone Diary 1999: Messages to a Future*, Redstone Press, London, 1998, unpag.

'Dream Maps', in *British Journal of Psychotherapy*, vol.14, Summer 1998, pp.445–52.

'The J. Street Project', plates 14–23, in *Éditions des Cahiers intempestifs 19*, Paris, 2006.

Painting Blocks 1970–84
Oil on canvas, cut
and bound with
thread into blocks

Painting Block 1970
10.5 × 10.5 × 6

48" × 48" 1974/5
15.9 × 15.9 × 4.2

54" × 36" 1974/7
15.9 × 8.9 × 8.9

60" × 51" 1974/80
17.2 × 13.3 × 6.4

42" × 60" 1974/81
11.5 × 16.5 × 7.3

60" × 48" 1974/82
17.2 × 11.5 × 8.5

48" × 48" 1974/83
11.5 × 11.5 × 8.5

36" × 54" 1974/84
7.6 × 16.5 × 8.3

Courtesy the artist
p.39

Hand Grenades 1972
(from paintings made in 1969)
Ashes of paintings, 12 glass jars, rubber
stoppers, labels, Pyrex bowl
approx. 11 × 18 × 18
Private Collection, New York
p.41

Enquiries/Inquiries 1973–5
2 carousels, each with 80 slides, neon sign
Dimensions variable
Courtesy the artist
pp.46–7

Dream Mapping 1974
7 dream notebooks, 3 group dream maps,
and other documentation of 3 night event
Dimensions variable
pp.48–51

Dedicated to the Unknown Artists 1972–6
305 postcards, charts and maps mounted on
14 panels; book, dossier
Each panel 66 × 104.8
Courtesy the artist
pp.52–6

Big Blue 1976
(from painting made in 1973)
Bound segments of painting, slide
22.5 × 35 × 7
Museum of Art, Rhode Island School of
Design, Providence. Richard Brown Baker Fund
for Contemporary British Art 2008.62
p.38

10 Months 1977–9
Ten black and white composite photographs
and ten captions
Installed size 203 × 518
Moderna Museet, Stockholm.
Acquisition 2007 with means from
The Second Museum of Our Wishes
pp.58–61

Sisters of Menon 1972/9
4 L-shaped panels: blue pencil on A4 paper
with typed labels, each 91.2 × 64.2 (1972);
4 panels: typescripts and gouache on paper
each 31.8 × 23 (1979)
Courtesy the artist
pp.62–4

My Dearest 1975/81
First panel: pencil on paper under pink perspex
107 × 61.5 (1975)
Second panel: typescript and watercolour on
pink paper 54.6 × 31.8 (1981)
Gimpel Fils, London
p.66

Get William 1975/81
First panel: pencil on paper under pink perspex
65.3 × 91.2 (1975)
Second panel: photocopy and watercolour on
pink paper 34.4 × 47 (1981)
Courtesy the artist
p.67

Mary Essene 1975/81
First panel: pencil on paper under blue perspex
64.9 × 91 (1975)
Second panel: typescript and watercolour on
blue paper 33.2 × 46.4 (1981)
Courtesy the artist
p.66

So Don't Let It Frighten 1975/81
First panel: pencil on paper under blue perspex
64 × 91 (1975)
Second panel: typescript and watercolour on
blue paper 32.5 × 46 (1981)
Courtesy the artist

Exhibited Works

Work in Progress 1980
Installation of thread works, made from
deconstructed painting
Dimensions variable
Courtesy the artist
pp.68–9

Monument 1980–1
41 photographs, each approx. 50 × 100,
overall 457.2 × 685.8; park bench with audio
component, 14 min 23 sec
Tate. Purchased 1994
pp.70–3

Midnight, Baker Street 1983
C-type prints enlarged from handworked
photobooth images
Each 71 × 51
Arts Council Collection, Southbank Centre,
London
p.75

Belshazzar's Feast, the Writing on Your Wall 1983–4
12 collages, each approx. 51 × 41; video with
sound, 21 min 52 sec; interior furnishings
Tate. Purchased 1984
pp.78–9

Magic Lantern 1987
3 channel 35 mm slide projection with sound,
synchronised, 12 min
Commissioned by Whitechapel Gallery, London
Courtesy the artist
pp.80–1

An Entertainment 1990
4 channel video installation with sound,
synchronised, 25 min 59 sec
Each projected image approx. 260 × 480
Commissioned by Matt's Gallery, London
Tate. Purchased 1995
pp.82–5

From the Freud Museum 1991–6
Vitrine 220 × 1000 × 60 containing 50 boxes,
each 25 × 32.5; video, 15 min
Commissioned by Book Works and Freud
Museum, London
Tate. Purchased 1998
pp.86–9

Psi Girls 1999
5 channel video projection with sound,
sychronised, 15 min
Each projected image approx. 266 × 355
Commissioned by Delfina/Millwall
Productions, London
Tate. Presented by Digby Squires 2004,
accessioned 2007
pp.96–9

Witness 2000
Approx. 400 speakers, 10 audio tracks,
each with multiple recordings; wires, lights
Installed size approx. 1800 × 900
Commissioned by Artangel
Courtesy the artist
pp.100–3

The Last Silent Movie 2007
Single channel projection, with sound, 20 min;
24 etchings on paper (produced with James Hill
at St Barnabas Press, Cambridge), each 37 × 42.5
British Council Collection
pp.114–15

Auras: Homage to Marcel Duchamp 2008
50 digital prints, each 30.4 × 30.4
Overall 190 × 380
Courtesy the artist
pp.120–3

Levitations: Homage to Yves Klein 2008
150 digital prints in 25 framed composites,
each 10.2 × 15
Overall 170 × 170
Courtesy the artist
pp.118–19

Voyage: Homage to Marcel Broodthaers 2009
24 digital prints, each 10 × 15
Overall 66.5 × 64
Private Collection, St Moritz
p.116

*Voyage on a Rough Sea: Homage to
Marcel Broodthaers* 2009
20 digital prints, each 30 × 40
Overall 157 × 164
Courtesy the artist
p.117

The Tao of Water: Homage to Joseph Beuys
1969–2010
Felt-lined cabinet, felt squares, bottles of
water collected from holy wells
Cabinet 56 × 84 × 28.5
Private Collection, London
pp.124–7

PREVIOUSLY PUBLISHED TEXTS

With thanks to the following authors and publishers for permission to republish extracted texts. Listed in order of appearance

Rosemary Betterton, 'Susan Hiller's Painted Works: Bodies, Aesthetics and Feminism', *Susan Hiller: Recall; Selected Works, 1969–2004*, 2004, pp.16, 17.

Michael Corris, 'Susan Hiller's Brain', *Susan Hiller*, 1994, p.13.

Rebecca Dimling Cochran, entry in *Susan Hiller*, 1996, p.61.

Caryn Faure Walker, 'In the Beginning was the Word: Susan Hiller's Recent Work', *Artscribe*, no.5, Feb. 1977, p.9.

Lucy Lippard, 'Out of Bounds', *Susan Hiller*, 1986, p.9.

John Sharkey, 'In Pancake making, it's the Mix that is Important', *Musics*, no.9, Sept. 1976, p.3.

Brian Dillon, 'Second Sight', *Frieze*, no.109, Sept. 2007, p.156.

David Elliott, introduction, *Susan Hiller: Recent Works*, 1978, p.6.

Lisa Tickner, '"10 Months', Susan Hiller", *Block (3)*, 1980, p.27.

Stuart Morgan, 'Susan Hiller, Gimpel Fils', *Art Forum*, Summer 1984, p.100.

John Roberts, 'Lucid Dreams', *Susan Hiller 1973–83: The Muse My Sister*, 1984, pp.40–2.

Jean Fisher, 'Work in Progress', *Susan Hiller: The Revenants of Time*, 1990, p.15.

Tony Godfrey, 'Susan Hiller, Simon Read at Arnolfini', *Artscribe*, no.31, Oct. 1981, p.57.

Annette van den Bosch, 'Susan Hiller: Resisting Representation', *Artscribe*, no.46, May – July 1984, pp.45–8.

Lynne Cooke, 'Susan Hiller', *The British Show*, 1985, pp.72–3.

Lucy Lippard, 'Out of Bounds', *Susan Hiller*, 1986, p.10.

Alex Potts, 'Susan Hiller's "Magic Lantern"', *The Burlington Magazine*, Jan. 1988, p.51.

Ian Hunt, 'An Entertainment', *Factor*, 1991, n.p.

Stephen Kelly, 'The Sight of an Old Pair of Shoes', in Tara Hamling and Catherine Richardson (eds.), *Everyday Objects: Medieval and Early Modern Material Culture and its Meanings*, Ashgate, London 2010, p.67.

Jean Fisher, 'Truth's Shadows', *Dream Machines*, 2000, p.122.

Denise Robinson, 'Wild Talents', *Susan Hiller: Wild Talents*, 1998, p.3.

Christopher Turner, introduction, *Psi Girls: Susan Hiller*, 2000, pp.7–8.

Louise Milne, 'On the Side of Angels: Witness and Other Works', *Susan Hiller: Recall; Selected Works, 1969–2004*, 2004, p.141.

Renee Baert in *Susan Hiller: The J.Street Project* (exhibition leaflet), 2006, p.3.

Christine Nippe in *When Things Cast No Shadow. Short Guide: Day*, 5th Berlin Biennial for Contemporary Art 2008, pp.112–13.

Rachel Campbell-Johnston, 'Prospero's Paintbox', *The Times*, 15 May 2004, p.12.

Mark Godfrey, 'The Last Silent Movie', *Susan Hiller: The Last Silent Movie*, 2008, pp.1–2.

For full book and catalogue references see bibliography, pp.174–181.

FILM EXTRACTS

Psi Girls

Brian De Palma, *The Fury* (1978), 20th Century Fox

Andrew Fleming, *The Craft* (1996), Columbia

Danny De Vito, *Matilda* (1996), TriStar Pictures
Mark Lester, *Firestarter* (1984), Universal

Andrei Tarkowsky, *Stalker* (1979), Mosfilm (Russia)

Wild Talents

Roger Christian, *Nostradamus* (1993), Vereinigte

Ken Russell, *Mindbender* (1996), Buena Vista

Stanley Kubrick, *The Shining* (1980), Warner Bros.

Tobe Hooper, *Poltergeist* (1982), Metro-Goldwyn-Mayer

Emir Kusturica, *Time of the Gypsies* (1989), Forum (Sarajevo)

Carl Schultz, *The Seventh Sign* (1988), Columbia Tristar

John Hough, *Escape to Witch Mountain* (1964), Buena Vista

Peter Brook, *Meetings with Remarkable Men* (1978), Fox

Frank Oz, *The Indian in the Cupboard* (1995), Paramount

David Lean, *Blithe Spirit* (1945), J. Arthur Rank

Brian De Palma, *Carrie* (1976), Metro-Goldwyn-Mayer

John Hough, *The Watcher in the Wood* (1982), Buena Vista

Mark Lester, *Firestarter* (1984), Universal

Andrei Tarkowsky, *Stalker* (1979), Mosfilm (Russia)

Brian De Palma, *The Fury* (1978), 20th Century Fox

Lewis Gilbert, *Haunted* (1995), Lumière/Zootrope

Jorge Montesi, *Visitors of the Night* (1997), Marquee

Credits

It has not always been possible to trace copyright-holders in order to gain permission for the use of copyright material. Please contact Tate Publishing with any omissions or clarifications.

186

Index

Tate relies on a large number of supporters – individuals, foundations, companies and public sector sources – to enable it to deliver its programme of activities, both on and off its gallery sites. This support is essential in order for Tate to acquire works of art for the Collection, run education, outreach and exhibition programmes, care for the Collection in storage and enable art to be displayed, both digitally and physically, inside and outside Tate. Your donation will make a real difference and enable others to enjoy Tate and its Collection both now and in the future. There are a variety of ways in which you can help support Tate and also benefit as a UK or US taxpayer. Please contact us at:

Development Office	American Patrons of Tate
Tate	520 West 27 Street Unit 404
Millbank	New York, NY 10001
London SW1P 4RG	USA
Tel 020 7887 4900	Tel 001 212 643 2818
Fax 020 7887 8098	Fax 001 212 643 1001

Donations, of whatever size, are gratefully received, either to support particular areas of interest, or to contribute to general activity costs.

Gifts of Shares

We can accept gifts of quoted share and securities. All gifts of shares to Tate are exempt from capital gains tax, and higher rate taxpayers enjoy additional tax efficiencies. For further information please contact the Development Office.

Gift Aid

Through Gift Aid you can increase the value of your donation to Tate as we are able to reclaim the tax on your gift. Gift Aid applies to gifts of any size, whether regular or a one-off gift. Higher rate taxpayers are also able to claim additional personal tax relief. Contact us for further information and to make a Gift Aid Declaration.

Legacies

A legacy to Tate may take the form of a residual share of an estate, a specific cash sum or item of property such as a work of art. Legacies to Tate are free of inheritance tax, and help to secure a strong future for the Collection and galleries. For further information please contact the Development Office.

Offers in lieu of tax

Inheritance Tax can be satisfied by transferring to the Government a work of art of outstanding importance. In this case the amount of tax is reduced, and it can be made a condition of the offer that the work of art is allocated to Tate. Please contact us for details.

Tate Members

Tate Members enjoy unlimited free admission throughout the year to all exhibitions at Tate, as well as a number of other benefits such as exclusive use of our Members' Rooms and a free annual subscription to *Tate Etc.* Whilst enjoying the exclusive privileges of membership, you are also helping secure Tate's position at the very heart of British and modern art. Your support actively contributes to new purchases of important art, ensuring that the Tate's Collection continues to be relevant and comprehensive, as well as funding projects in London, Liverpool and St Ives that increase access and understanding for everyone.

Tate Patrons

Tate Patrons share a strong enthusiasm for art and are committed to giving significant financial support to Tate on an annual basis. The Patrons support the acquisition of works across Tate's broad collecting remit, as well as other areas of Tate activity such as conservation, education and research. The scheme provides a forum for Patrons to share their interest in art and to exchange knowledge and information in an enjoyable environment. United States taxpayers who wish to receive full tax exempt status from the IRS under Section 501 (c) (3) are able to support the Patrons through the American Patrons of Tate. For more information on the scheme please contact the Patrons office.

Corporate Membership

Corporate Membership at Tate Modern, Tate Britain and Tate Liverpool offers companies opportunities for corporate entertaining and the chance for a wide variety of employee benefits. These include special private views, special access to paying exhibitions, out-of-hours visits and tours, invitations to VIP events and talks at members' offices.

Corporate Investment

Tate has developed a range of imaginative partnerships with the corporate sector, ranging from international interpretation and exhibition programmes to local outreach and staff development programmes. We are particularly known for high-profile business to business marketing initiatives and employee benefit packages. Please contact the Corporate Fundraising team for further details.

Charity Details

The Tate Gallery is an exempt charity; the Museums & Galleries Act 1992 added the Tate Gallery to the list of exempt charities defined in the 1960 Charities Act. Tate Members is a registered charity (number 313021). Tate Foundation is a registered charity (number 1085314).

American Patrons of Tate

American Patrons of Tate is an independent charity based in New York that supports the work of Tate in the United Kingdom. It receives full tax exempt status from the IRS under section 501(c)(3) allowing United States taxpayers to receive tax deductions on gifts towards annual membership programmes, exhibitions, scholarship and capital projects. For more information contact the American Patrons of Tate office.

Supporting Tate

Mr Phillip Keir
Maria and Peter Kellner
Miss Helene Klausner
Mr and Mrs Eskandar Maleki
Panos and Sandra Marinopoulos
Nonna Materkova
Mr and Mrs Scott Mead
Mrs Megha Mittal
Ms Alexandra Mollof
Mr Donald Moore
Mr and Mrs Paul Phillips
Ms Charlotte Ransom and Mr Tim Dye
Ramzy and Maya Rasamny
Simon and Virginia Robertson
Mr and Mrs Richard Rose
The Rumi Foundation
Maria and Malek Sukkar
Mr and Mrs J Shafran
Mrs Andrée Shor
Ghazwa Mayassi Abu-Suud
Mr and Mrs Stanley S Tollman
Michael and Jane Wilson
Poju and Anita Zabludowicz
and those who wish to remain anonymous

GOLD PATRONS

Elena Bowes
Beth and Michele Colocci
Alastair Cookson
Haro Cumbusyan
Ms Carolyn Dailey
Maryam Homayoun Eisler
Mr and Mrs A Ramy Goldstein
Mr Michael Hoppen
Mrs Petra Horvat
Anne-Marie and Geoffrey Isaac
Mrs Heather Kerzner
Mr Eugenio Lopez
Fiona Mactaggart
Maria de Madariaga
Mrs Bona Montagu
Mr Francis Outred
Simon and Midge Palley
Catherine and Franck Petitgas
Mathew Prichard
Mr David Roberts
Mr Charles Roxburgh
Mrs Rosario Saxe-Coburg
Carol Sellars
Flora Soros
Mrs Celia Forner Venturi
Iwan and Manuela Wirth
Barbara Yerolemou
and those who wish to remain anonymous

SILVER PATRONS

Agnew's
Helen Alexander, CBE
Harriet Anstruther
Toby and Kate Anstruther
Mr and Mrs Zeev Aram
Mr Giorgio Armani
Edgar Astaire
Mr Nicholas Baring
Mrs Jane Barker
Mr Edward Barlow
Victoria Barnsley, OBE
Jim Bartos
Mrs Nada Bayoud
Mr and Mrs Paul Bell
Mr Harold Berg
Ms Anne Berthoud
Madeleine Bessborough
Janice Blackburn
Mr and Mrs Anthony Blee
Mr Brian Boylan
Mrs Lena Boyle
Ivor Braka
Viscountess Bridgeman

The Broere Charitable Foundation
Ben and Louisa Brown
Mr and Mrs Charles Brown
Michael Burrell
Mrs Marlene Burston
Timothy and Elizabeth Capon
Mr Francis Carnwath and Ms Caroline Wiseman
Lord and Lady Charles Cecil
Frank Cohen
Dr Judith Collins
Terrence Collis
Mr and Mrs Oliver Colman
Carole and Neville Conrad
Giles and Sonia Coode-Adams
Cynthia Corbett
Mark and Cathy Corbett
Tommaso Corvi-Mora
Mr and Mrs Bertrand Coste
The Cowley Foundation
Kathleen Crook and James Penturn
James Curtis
Loraine da Costa
Mrs Isobel Dalziel
Sir Howard Davies
Mrs Belinda de Gaudemar
Giles de la Mare
The de Laszlo Foundation
Anne Chantal Defay Sheridan
Marco di Cesaria
Simon C Dickinson Ltd
Ms Michelle D'Souza
Joan Edlis
Lord and Lady Egremont
John Erle-Drax
Stuart and Margaret Evans
Eykyn Maclean LLC
Gerard Faggionato
Mrs Heather Farrar
Mrs Margy Fenwick
Mr Bryan Ferry
The Sylvie Fleming Collection
Mrs Rosamund Fokschaner
Joscelyn Fox
Eric and Louise Franck
Elizabeth Freeman
Stephen Friedman
Julia Fuller
Carol Galley
Gapper Charitable Trust
Mrs Daniela Gareh
Mrs Joanna Gemes
Mr David Gibbons
Mr Mark Glatman
Mr and Mrs Paul Goswell
Penelope Govett
Gavin Graham
Mrs Sandra Graham
Martyn Gregory
Sir Ronald Grierson
Mrs Kate Grimond
Richard and Odile Grogan
Louise Hallett
Mrs Sue Hammerson, CBE
Jane Hay
Richard Hazlewood
Michael and Morven Heller
Robert Holden
James Holland-Hibbert
Lady Hollick
Mr Michael Hoppen
John Huntingford
Mr Haydn John
Mr Michael Johnson
Mr Chester Jones
Jay Jopling
Mrs Marcelle Joseph and Mr Paolo Cicchiné
Mrs Brenda Josephs
Tracey Josephs
Andrew Kalman
Dr Martin Kenig

Mr David Ker
Mr and Mrs Simon Keswick
Richard and Helen Keys
David Killick
Mr and Mrs Paolo Kind
Mr and Mrs James Kirkman
Brian and Lesley Knox
Kowitz Trust
Steven Larcombe
Simon Lee
Zachary R Leonard
Mr Gerald Levin
Leonard Lewis
Anders and Ulla Ljungh
Mr Gilbert Lloyd
George Loudon
Mark and Liza Loveday
Daniella Luxembourg Art
Anthony Mackintosh
The Mactaggart Third Fund
Mr M J Margulies
Mr and Mrs Jonathan Marks
Marsh Christian Trust
Ms Clémence Mauchamp
Mr Klaas Meertens
Mr Martin Mellish
Mrs RWP Mellish
Dr Rob Melville
Mr Michael Meynell
Mr Alfred Mignano
Victoria Miro
Mrs Joyce Misrahi
Jan Mol
Mrs Valerie Gladwin Montgomery
Houston Morris
Mrs William Morrison
Paul and Alison Myners
Mr David Nader
Richard Nagy
Julian Opie
Pilar Ordovás
Joseph and Chloe O'Sullivan
Desmond Page
Maureen Paley
Dominic Palfreyman
Michael Palin
Cornelia Pallavicini
Mrs Adelaida Palm
Mrs Kathrine Palmer
Stephen and Clare Pardy
Eve Pilkington
Ms Michina Ponzone-Pope
Susan Prevezer QC
Mr and Mrs Ryan Prince
Valerie Rademacher
Mrs Phyllis Rapp
Mr and Mrs James Reed
Mr and Mrs Philip Renaud
The Reuben Foundation
Sir Tim Rice
Lady Ritblat
Tim Ritchie
Rupert and Alexandra Robson
David Rocklin
Frankie Rossi
Mr James Roundell
Mr Lyon Roussel
Mr and Mrs Paul Ruddock
Naomi Russell
Homera Sahni
Mr Alex Sainsbury and Ms Elinor Jansz
Cherrill and Ian Scheer
Sylvia Scheuer
The Schneer Foundation
Andrew and Belinda Scott
Neville Shulman, CBE
Ms Julia Simmonds
Mrs Cindy Sofer
Louise Spence
Digby Squires, Esq

Mr and Mrs Nicholas Stanley
Charlotte Stevenson
Mrs Tanya Steyn
The Swan Trust
Mrs Patricia Swannell
Mr James Swartz
The Lady Juliet Tadgell
David and Sayoko Teitelbaum
Sir Anthony and Lady Tennant
Christopher and Sally Tennant
Britt Tidelius
Emily Tsingou and Henry Bond
Melissa Ulfane
Mr and Mrs Petri Vainio
Mrs Cecilia Versteegh
Gisela von Sanden
Audrey Wallrock
Stephen and Linda Waterhouse
Offer Waterman
Terry Watkins
Mr and Mrs Mark Weiss
Jack Wendler
Miss Cheyenne Westphal
Mr Douglas Woolf
and those who wish to remain anonymous

YOUNG PATRONS

HRH Princess Alia Al-Senussi
Ms Maria Allen
Sigurdur Arngrimsson
Kirtland Ash
Ms Myrna Ayad
Rachael Barrett
Mr Fracisco Borrego
Mr Andrew Bourne
Mr Daniel Bradman
Matt Carey-Williams and Donnie Roark
Mrs Laura Comfort
Thamara Corm
Mrs Suzy Franczak Davis
Mr Alan Djanogly
Jane and Richard Found
Michael Freund
Ms Alexandra Ghashghai
Mr Nick Hackworth
Alex Haidas
Mr Benji Hall
Dr Lamees Hamdan
Mrs Samantha Heyworth
Mrs Susanna Hong
Miss Eloise Isaac
Ms Melek Huma Kabakci
Mr Efe Kapanci
Helena Christina Knudsen
Ms Marijana Kolak
Mr Jimmy Lahoud
Mrs Julie Lawson
Mrs Siobhan Loughran
Charlotte Lucas
Mr Fernando Moncho Lobo
Erin Morris
Miss Annika Murjahn
Mrs Annette Nygren
Alberto and Andrea Olimon
Phyllis Papadavid
Ms Camilla Paul
Mr Mauro Perucchetti
Lauren Prakke
Mrs Karin Reihill
Mr Bruce Ritchie and Mrs Shadi Ritchie
Kimberley and Michael Robson-Ortiz
Mrs Sabine Schmitt
Mr Roopak Shah
Amir Shariat
Andreas B Siegfried
Tammy Smulders
Mr Saadi Soudavar
Ms Brigitta Spinocchia
Miss Malgosia Stepnik
Mr Edward Tang

Soren S K Tholstrup
Mr Abdullah Al Turki
Mrs Dita Vankova
Mr Mehmet Erdinc Varlibas
Rachel Verghis
Mr Josh Wyatt
Miss Burcu Yuksel
Mr Fabrizio Zappaterra
and those who wish to remain anonymous

NORTH AMERICAN
ACQUISITIONS COMMITTEE

Beth Rudin De Woody
Dr Kira Flanzraich
Glenn Fuhrman
Marc Glimcher
Margot and George Greig
Monica Kalpakian
Massimo Marcucci
Lillian Mauer
Stavros Merjos
Gregory R Miller
Elisa Nuyten and David Dime
Amy and John Phelan
Liz Gerring Radke and Kirk Radke
Laura Rapp and Jay Smith
Robert Rennie (Chair) and Carey Fouks
Michael Sacks
Randy W Slifka
Donald R Sobey
Robert Sobey
Ira Statfeld
Marla and Larry Wasser
Christen and Derek Wilson
and those who wish to remain anonymous

LATIN AMERICAN
ACQUISITIONS COMMITTEE

Monica and Robert Aguirre
Luis Benshimol
Estrellita and Daniel Brodsky
Rita Rovelli Caltagirone
Trudy and Paul Cejas
Patricia Phelps de Cisneros
Gérard Cohen
HSH the Prince Pierre d'Arenberg
Tiqui Atencio Demirdjian (Chair)
Tania Fares
Fernanda Feitosa and Heitor Martins
Angelica Fuentes de Vergara
Yolanda Garza Santos
William A Haseltine
Mauro Herlitzka
Mrs Yaz Hernandez
Rocio and Boris Hirmas
Anne Marie and Geoffrey Isaac
Nicole Junkermann
Jack Kirkland
Fatima and Eskander Maleki
Becky and Jimmy Mayer
Patricia Moraes and Pedro Barbosa
Victoria and Isaac Oberfeld
Catherine Petitgas
Isabella Prata and Idel Arcuschin
Beatriz Quintella and Luiz Augusto
 Teixeira de Freitas
Erica Roberts
Lilly Scarpetta and Roberto Pumarejo
Catherine Shriro
Norma Smith
Susana and Ricardo Steinbruch
Paula Traboulsi
Juan Carlos Verme
Alin Ryan von Buch
Tania and Arnoldo Wald
Juan Yarur
and those who wish to remain anonymous

ASIA-PACIFIC
ACQUISITIONS COMMITTEE

Bonnie and R Derek Bandeen
Mr and Mrs John Carrafiell
Mrs Christina Chandris
Richard Chang
Pierre TM Chen, Yageo Foundation, Taiwan
Ms Mareva Grabowski
Elizabeth Griffith
Esther Heer-Zacek
Cees Hendrikse
Mr Yongsoo Huh
Mr Chang Il-Kim
Ms Yung Hee Kim
Alan Lau
Woong Yeul Lee
Mr and Mrs Sylvain Levy
Mr William Lim
Ms Kai-Yin Lo
Mr Nicholas Loup
Mrs Yana Peel
The Red Mansion Foundation
Mr Paul Serfaty
Mr Robert Shum
Sir David Tang (Chair)
Katie de Tilly
and those who wish to remain anonymous

MIDDLE EAST AND NORTH AFRICA
ACQUISITIONS COMMITTEE

Mehves Ariburnu
Sule Arinc
Marwan Assaf
Ms Isabelle de la Bruyère
Füsun Eczacibaşi
Shirley Elghanian
Delfina Entrecanales
Noor Fares
Maryam Homayoun Eisler (Chair)
Ali Yussef Khadra
Maha and Kasim Kutay
Lina Lazaar
Fatima and Eskandar Maleki
Fayeeza Naqvi
Basil and Raghida Al-Rahim
Ramzy and Maya Rasamny (Chair)
HRH Sheikha Lulu Al-Sabah
Dania Debs-Sakka
Mrs Sherine Sawiris
HRH Princess Alia Al-Senussi
Maria and Malek Sukkar
Berna Tuglular
Abdullah Al Turki
Beatriz Quintella and Luiz Augusto Teixeira de
 Freitas
and those who wish to remain anonymous

PHOTOGRAPHY
ACQUISITIONS COMMITTEE

Ryan Allen and Caleb Kramer
Tim Attias
Mrs Nicholas Barker
Elena Bowes
Pierre Brahm (Chair)
William and Alla Broeksmit
Elizabeth and Rory Brooks
Michele and Beth Colocci
Mr David Fitzsimons
Eric and Louise Franck
Mr Michael Hoppen
Bernard Huppert
Mr Tim Jefferies
Dede Johnston
Mrs Elizabeth Jordan
Jack Kirkland
Mr and Mrs Scott Mead
Mr Donald Moore
Daniel Pittack
Mrs Rosario Saxe-Coburg
Maria and Malek Sukkar

Michael and Jane Wilson
and those who wish to remain anonymous

INTERNATIONAL
COUNCIL MEMBERS

Doris Ammann
Mr Plácido Arango
Mrs Miel de Botton Aynsley
Gabrielle Bacon
Anne H Bass
Nicolas Berggruen
Baron Berghmans
Mr Pontus Bonnier
Mrs Frances Bowes
Ivor Braka
The Deborah Loeb Brice Foundation
The Broad Art Foundation
Bettina and Donald L Bryant Jr
Melva Bucksbaum and Raymond Learsy
Fondation Cartier pour l'art contemporain
Mrs Christina Chandris
Richard Chang
Pierre TM Chen, Yageo Foundation, Taiwan
Lord Cholmondeley
Mr and Mrs Borja Coca
Mr and Mrs Attilio Codognato
David and Michelle Coe
Sir Ronald Cohen and
 Lady Sharon Harel-Cohen
Mr Alfonso Cortina de Alcocer
Mr Douglas S Cramer and Mr Hubert S Bush III
Mr Dimitris Daskalopoulos
Mr and Mrs Michel David-Weill
Julia W Dayton
Tiqui Atencio Demirdjian and Ago Demirdjian
Joseph and Marie Donnelly
Mrs Jytte Dresing
Barney A Ebsworth
Stefan Edlis and Gael Neeson
Carla Emil and Rich Silverstein
Harald Falckenberg
Fares and Tania Fares
Mrs Doris Fisher
Mrs Wendy Fisher
Dr Corinne M Flick
Amanda and Glenn Fuhrman
Mr Albert Fuss
Candida and Zak Gertler
Alan Gibbs
Lydia and Manfred Gorvy
Mr Laurence Graff
Ms Esther Grether
Mr Xavier Guerrand-Hermès
Mimi and Peter Haas Fund
Mr Joseph Hackmey
Margrit and Paul Hahnloser
Andy and Christine Hall
Mr Toshio Hara
Mrs Susan Hayden
Ms Ydessa Hendeles
André and Rosalie Hoffmann
Ms Maja Hoffmann (Chair)
ITYS, Athens
Dakis and Lietta Joannou
Sir Elton John and Mr David Furnish
HRH Princess Firyal of Jordan
Mr Per and Mrs Lena Josefsson
Mr Chang-Il Kim
C Richard and Pamela Kramlich
Pierre and Catherine Lagrange
Baron and Baroness Philippe Lambert
Agnès and Edward Lee
Jacqueline and Marc Leland
Mr Ronald and The Hon Mrs McAulay
Panos and Sandra Marinopoulos
Mr and Mrs Donald B Marron
Mr Leonid Mikhelson
Aditya and Megha Mittal
Mr and Mrs Minoru Mori
Mr Guy and The Hon Mrs Naggar
Mr and Mrs Takeo Obayashi

Young-Ju Park
Yana and Stephen Peel
Daniel and Elizabeth Peltz
Andrea and José Olympio Pereira
Catherine and Franck Petitgas
Sydney Picasso
Mr and Mrs Jürgen Pierburg
Jean Pigozzi
Ms Miuccia Prada and Mr Patrizio Bertelli
Patrizia Sandretto Re Rebaudengo and
 Agostino Re Rebaudengo
Robert Rennie and Carey Fouks
Mr John Richardson
Michael Ringier
Lady Ritblat
Barrie and Emmanuel Roman
Ms Güler Sabancı
Mrs Mortimer Sackler
Mrs Lily Safra
Muriel and Freddy Salem
Dasha Shenkman
Uli and Rita Sigg
Norah and Norman Stone
John J Studzinski, CBE
Mrs Marjorie Susman
Lady Helen Taylor
David Teiger
Mr Robert Tomei
The Hon Robert H Tuttle and
 Mrs Maria Hummer-Tuttle
Mr and Mrs Guy Ullens
Paulo AW Vieira
Mr Robert and The Hon Mrs Waley-Cohen
Pierre de Weck
Angela Westwater and David Meitus
Diana Widmaier Picasso
Michael G Wilson
Mrs Sylvie Winckler
The Hon Mrs Janet Wolfson de Botton, CBE
Anita and Poju Zabludowicz
Michael Zilkha
and those who wish to remain anonymous

TATE BRITAIN CORPORATE
SUPPORTERS

BP plc
The British Land Company PLC
Courvoisier
Finsbury
Goldman Sachs International
Guaranty Trust Bank
Le Méridien
Louis Vuitton
Sotheby's
Tate & Lyle plc
and those who wish to remain anonymous

TATE BRITAIN CORPORATE
MEMBERS

191

Accenture
Advent International
Clifford Chance
Deutsche Bank
Drivers Jonas Deloitte
Ernst & Young
Freshfields Bruckhaus Deringer
GAM
Hanjin Shipping Co
HSBC Holdings plc
John Lewis
Linklaters
Mace Group Ltd
Morgan Stanley
Nomura
Pearson
Sotheby's
Thames & Hudson
Tishman Speyer
UBS
and those who wish to remain anonymous